DATE DUE

SEP 1 5 2010		
NOV 2 4 2010		
RD		PRINTED IN U.S.A.

THE HORSES
OF
ST MARK'S

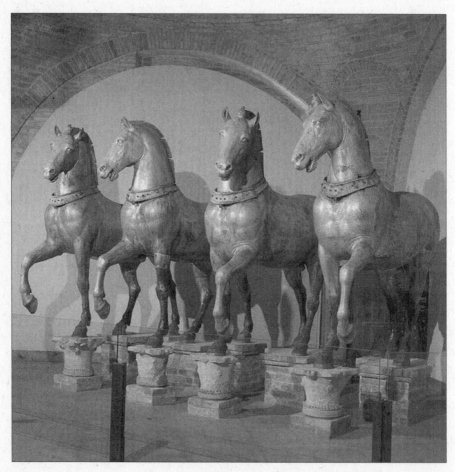

Frontispiece: The four horses of St Mark's in their present setting inside the basilica (Ancient Art).

THE HORSES
OF
ST MARK'S

A Story of Triumph in
Byzantium, Paris and Venice

Charles Freeman

THE OVERLOOK PRESS
NEW YORK

This edition first published in hardcover in the United States in 2010 by
The Overlook Press, Peter Mayer Publishers, Inc.

141 Wooster Street
New York, NY 10012
www.overlookpress.com

Copyright © 2004 by Charles Freeman

Cataloging-in-Publication Data is available from the Library of Congress

Manufactured in the United States of America
ISBN 978-1-59020-267-8
1 3 5 7 9 10 8 6 4 2

For Issie

ACKNOWLEDGEMENTS

I have to thank my agent Bill Hamilton for encouraging me to concentrate on the story of the horses rather than on the more general theme of Venice, which I had at first proposed. His faith that they would have a remarkable history was well placed. At Time Warner, my editor Richard Beswick was instrumental in advising on the shape of the book as it matured. Once the book was written, Gillian Somerscales corrected my clumsier sentences and spelling discrepancies with care and tact, while Linda Silverman tracked down not only those pictures I had requested but many more of interest that we were able to use. Viv Redman oversaw the production process with gentle yet firm efficiency and I am grateful to Sue Phillpott for proofreading and Dave Atkinson for compiling the index.

CONTENTS

PREFACE

I FIRST VISITED VENICE IN 1970, AS A STUDENT, AND I CAN still remember the touch of condescension in the voice of the manager of a small Venetian hotel as he directed me towards the smallest and cheapest of the boxes he offered his guests. Yet despite this qualified welcome, Venice cast its spell. It is above all a city to explore on foot – by far the best way to understand any city if the traffic will allow one, but especially appropriate for Venice with its numerous passageways, unexpected squares, lapping water, and feast of decorated doors and windows. Here was my first chance to catch some of the moods of this most ambiguous of places.

Since then the city has been woven in and out of my life. I have taken A-level art historians there as part of the final week of an Italian summer school (by then, in the heat of August, the Lido won out over art) and over the years have introduced my growing family to the city. It is an especial pleasure to dedicate this book to my daughter Issie, who first came to Venice when she was very small indeed but now can visit it on her own. May the city survive for her to introduce it to yet another generation of the family!

There are, of course, too many books on Venice. Perhaps no other city has so fragmented itself in the imagination. As the historians John Martin and Dennis Romano have recently written, 'There are simply too many Venices, too many unknown dimensions. Just when one believes one is beginning the story line,

Venice transmogrifies and, both in spite of and because of the richness of its archives and artistic treasures, is again a mystery, an enigma, an indecipherable maze of interweaving stories, false and true.'* My only excuse for adding another story, another book, lies in serendipity (it has, above all, been fun to write) and my own interest, primarily as an ancient historian, in how a particular set of artistic treasures from the classical world interacted with two thousand years of European history.

CHARLES FREEMAN,
November 2003

*John Martin and Dennis Romano, *Venice Reconsidered*.

Moreover above the entrance to the temple [St Mark's] there is a wide terrace in the open, in the middle of which can be seen from below four bronze and gilded horses set on little columns making a great show of themselves with such a motion and stride that all of them seem to be wanting to jump down into the square together. A rare and exceedingly ancient work — they were all made for the chariot of the sun — the skill of their construction is amazing. They are all similar to each other, so that you can find nothing in one unlike the others, yet such is their stance with neck and feet that although they strain forward in step together, their stride and movement are wholly dissimilar . . . It is said that they were brought from Constantinople as were almost all the precious marbles on the temple.

BERNARDO GIUSTINIANI, *De origine urbis Venetiarum,* 1493

THE HORSES
OF
ST MARK'S

I

PLUNDERED PLUNDER

TOWARDS THE END OF JULY 1798 AN EXTRAORDINARY procession wound its way through the streets of Paris towards the Champ de Mars, the military parade ground which had been adopted by the Parisians of revolutionary France as the site of major festivals. Much of it consisted of large packing cases whose contents could only be guessed at from slogans on the side which proclaimed them to be art treasures. On open display there were animals – among them caged lions, a bear and even a pair of dromedaries – paraded alongside tropical plants, including palm, banana and coconut trees; but the only art works actually visible to the curious onlookers were four horses of gilded metal, larger than life-size, arrayed on a wagon which was itself drawn by six horses. They were known to have come from Venice, where they had been seized by Napoleon when the city had surrendered to him.

Those familiar with ancient history might have guessed that this was an attempted re-enactment of a Roman triumphal procession, and they would have been right. What they saw arriving in Paris were the victory spoils of one of France's most successful military commanders: Napoleon Bonaparte, who – still only twenty-eight – had recently conquered much of Italy. Napoleon had followed the great Roman conquerors of the past in stripping his enemies of

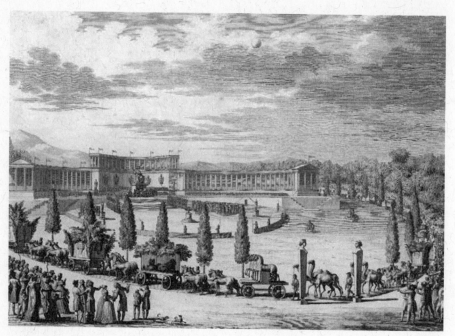

The horses make their triumphal entry into Paris in July 1798. The columned building at the far end of the Champ de Mars is the Temple of the Fatherland where the horses and other trophies were received by the academicians. (Mary Evans Picture Library)

many of their finest works of art and taking them back to his own capital. The city which had suffered most from his looting was, ironically, Rome itself, where the pope, Pius VI, had given up some of the most prestigious of his possessions: world-renowned classical statues, among them the Capitoline Venus, the Laocoön, and the Belvedere Apollo. With this in mind, the assembled Parisian crowds had been given a song to sing:

> *Rome n'est plus dans Rome*
> *Elle est tout à Paris*

— 'Rome is no longer in Rome, it is all in Paris.' And indeed, as well as the statues, which themselves made Paris the most richly

endowed city in original classical art in Europe, the conqueror had brought home a comparable haul of Renaissance treasures. Among the trophies crammed into those packing cases was a startling number of sixteenth-century paintings by masters such as Raphael, Correggio, Titian and Tintoretto.

When news of Napoleon's plunder had first reached Paris, many had wondered whether the French government, the Directory — bourgeois and unimaginative when compared with the fervour of the earlier revolutionary regimes — would accept the treasures into this 'new Rome' with a celebration worthy of the occasion. No one had seemed prepared to put up the money to mount a proper display, and the commissioners who had selected the works in Italy began to worry. 'Will we let the precious booty from Rome arrive in Paris like charcoal barges and will we have it disembarked on the Quai du Louvre like crates of soap?' said one. Then a government official had the inspired idea of asking Napoleon himself to finance the transport and display of the hoard. Napoleon had been assiduous in proclaiming the extent of his gains in letters to the Directory, and it was clear that he saw them as valuable propaganda for himself as much as works of art won for the nation. He would not be able to lead the celebrations himself — he was about to embark on his expedition to Egypt — but a triumphal procession modelled on those of republican Rome could be staged in his absence. So, once the ministry of foreign affairs had announced Napoleon's agreement to the proposal, a formal approach was made by the minister of the interior to the Directory on behalf of the commissioners and, it was claimed, 'poets, philosophers, and public officials', that 'all those who feel the need of restoring public spirit and to increase national pride by having the spoils of conquered peoples pass before the eyes of our people, all join in requesting that the day that these fruits of our victories enter into Paris be celebrated by a festival'.

The date of the festival, however, was continually postponed as the logistics of transporting so many heavy crates were sorted out. The horses and other treasures had come by sea from Venice, while

those from Rome had been loaded on to ships at Leghorn (Livorno); all were disembarked at Marseilles, from where they came by barge up the French canal network. Their reception in Paris was eventually fixed for 27 and 28 July, when it would coincide with the fourth anniversary of the overthrow of an earlier casualty of the revolution, the 'tyrant' Maximilien Robespierre.

That the revolutionary leaders should look to classical Rome for inspiration was understandable. Many of them had received a traditional classical education, and even before 1789 republican Rome – Rome in the period from the overthrow of the king Tarquinius Superbus in 509 BC to the assumption of power by Augustus, Rome's first emperor, in 27 BC – had been upheld as a model of civic virtue in which citizens dedicated their energies to their country in both peace and war. The procession of 1798 was modelled on one held in Rome in 167 BC by the conqueror of Macedonia, Aemilius Paulus. His exploits and the victory procession itself had been described in the *Lives* of Plutarch, a Greek philosopher and biographer of the first and second centuries AD who was widely read in the eighteenth century. According to Plutarch, the triumph had lasted over three days, the first of which had been taken up with a parade of 250 wagons full of works of art. The second day had been devoted to the piles of armour stripped from the enemy, the third to gold plate and coins – and to the display of Perseus, the defeated Macedonian leader, and his family. In the Paris 'triumph' there were again three sections, but this time the divisions reflected not the generic types of booty but the preoccupation of Enlightenment thinkers with the classification of knowledge: Napoleon's prizes were categorized as 'natural history', 'books and manuscripts' and 'fine arts'. Each section was provided with an escort of foot troops and cavalry, and a military band to lead the exhibits. The natural history section included the banana, palm and coconut trees, which came from Trinidad; the lions and dromedaries, from Africa; and the bear, which had had a less exotic home – a zoo in Bern. An early draft of the plans required that the antiquities be dedicated at the Altar

of the Fatherland on the Champ de Mars, in the same way that Roman victors such as Aemilius had offered theirs to the Temple of Jupiter, the Father of the Gods, on the Capitoline Hill in Rome. In the event the suggestion was replaced by a more sober one in which political leaders and members of the august Académie Française, the arbiter of French language and culture, would welcome the antiquities on behalf of the French government and its learned institutions. Only one of the objects – the most sacred of all, a bust of Junius Brutus, the Brutus who had assassinated the 'dictator' Julius Caesar, from the Capitoline Museum in Rome – was to be placed on a pedestal in front of the altar, where it would evoke France's own overthrow of monarchy. The rest were destined for display in the city or in the new museum planned in the former royal palace of the Louvre.

What confirmed the procession as triumphal were the four horses. It was always in a chariot drawn by four horses, a *quadriga*, that a successful Roman commander paraded himself with his booty through the streets of Rome.* Now, even in Napoleon's absence, the four horses from Venice could be seen as a symbol of his military victories. They also carried with them a political message, proclaimed in the slogan on an accompanying banner: 'Horses transported from Corinth to Rome and from Rome to Constantinople, from Constantinople to Venice and from Venice to France. They are finally in a free land.' This storyline echoed the traditional accounts that they were made of Corinthian bronze, had stood on a triumphal arch in Rome and then by the hippodrome in Constantinople before being carried off from there as plunder by the Venetians after the Fourth Crusade of 1204. When Napoleon had seized them in Venice they were gracing the *loggia* above the great central door of the basilica of St Mark's. French intellectuals of the Enlightenment, Voltaire, Rousseau, and

*The word *quadriga* could be used of either the chariot with its four horses or the team of horses alone.

Montesquieu among them, had long derided eighteenth-century Venice as a decadent tyranny, and Napoleon, as a servant of the revolution, could adapt their critique to offer liberation as a specious justification for his seizure of the horses and other Venetian treasures.

Napoleon's argument that art treasures needed liberating was hardly convincing, however, and did not find favour even in France. For educated Frenchmen, the governments of the Italian states may have been corrupt, but Italy remained Europe's cultural centre. In a pamphlet written in 1796 the distinguished French antiquarian Quatremère de Quincy had condemned the idea that property should belong to those most able to grasp it, especially if it meant dismembering the cities of Italy. Works of art could not simply be uprooted from the context in which they stood. The 'museum which is Rome' was much more than its art treasures; 'it is also composed fully as much of places, of sites, of mountains, of quarries, of ancient roads, of the placing of ruined towers, of geographical relationships, of the inner connections of all these objects to each other, of memories, of local traditions, of still prevailing customs, of parallels and comparisons which can only be made in the country itself.' (It was de Quincy who remarked of Napoleon that he was 'devoured by anticipatory lust after the best things in each country, whether masterpieces and precious objects or men of talent and renown'.) He was backed by a petition bearing the signatures of forty-seven prominent artists, among them the most famous artist of the revolution, Jacques Louis David, who also deplored the sacking of Italy. The petition was suppressed and a more supportive one signed by a group of lesser artists was placed in the official government newspaper, the *Gazette Nationale*, in which the modern Romans were denounced as lazy and superstitious barbarians who did not deserve their treasures.

Less crude rationales for seizing so much fine art were soon being formulated. A theory put forward earlier in the century by the German art historian Johann Winckelmann, that great art and liberty went hand in hand, was exploited to suggest that as the

French were now living in liberty all great art should be drawn into France.* Others argued that the major works of antiquity were the birthright of whichever nation had attained glory through force of arms. 'The Romans plundered the Etruscans, the Greeks and the Egyptians, accumulated the booty in Rome and other Italian cities; the fate of these products of genius is to belong to the people who shine successively on earth by arms and by wisdom, and to follow always the wagons of the victors,' as one official speech put it. The impact of art as a transmitter of civilization was not forgotten.

> The Romans, once an uncultivated people, became civilised by transplanting to Rome the works of conquered Greece . . . Thus the French people, naturally endowed with exquisite sensitivity, will, by seeing the models from antiquity, train its feeling and its critical sense . . . The French Republic, by its strength and superiority of its enlightenment and its artists is the only country in the world which can give a safe home to these masterpieces.

Napoleon himself had made an even more astonishing assertion as he began gathering the first of the antiquities in 1796: 'All men of genius, all those who have attained distinction in the republic of letters, are French, no matter in what country they may have been born' – so it was appropriate that Paris should be the new centre of European culture. A more pragmatic excuse was that the works were falling into decay in the hands of the ignorant Italians and that, in the words of one of the commissioners who had selected them, 'it is most fortunate for the cause of Art that it only requires the practised hand of our craftsmen to restore these masterpieces to the true lovers of the arts.' There was a grain of truth in this: French conservationists had evolved methods of dealing with painted surfaces which were the most advanced in the world.

*Winckelmann's theory is explored on pp. 180–85.

The horses from St Mark's epitomized the several strands of these debates. They were symbols of triumph; but they were also plunder itself. Indeed, this dual role had gone with them throughout their long history as they travelled across Europe and Asia, resting at various times in at least three, possibly four, great cities. One of the ambitions of this book is to chart the way in which they took up, bore and shed these and other symbolic roles, sometimes holding more than one at a time. Yet there is much more than this to explore. The horses were and are works of art irrespective of their symbolic significance, and debates over their aesthetic quality have surrounded them throughout their history. These debates were given resonance by the horses' antiquity, especially during the Renaissance, when masterpieces of classical art were particularly prized. Did they, it was asked, represent some conception of the ideal horse? Should they be taken as the model whenever a horse was needed for a painting or monument? Yet the Renaissance was an age of antiquarians as well as idealists. If they were classical sculptures, where did they come from and when were they made? These questions, which were revived in the eighteenth and nineteenth centuries, generated heated controversy. Scholars proposed, with apparent confidence, dates for their casting which stretched over nine centuries; it was not even agreed whether the horses were Greek or Roman.

Thanks to the intervention of the great Venetian sculptor Antonio Canova, the horses were returned to their original position on St Mark's in Venice after Napoleon's downfall in 1815. Their present setting is somewhat less exalted. As the result of a campaign in the 1970s by the Italian company Olivetti to have them removed from the polluted air of the Venetian lagoon, they have been relegated to a brick-lined room behind the western façade of the basilica. Those horses now on the *loggia* are replicas, uninspiring copies. To see the originals we have to climb up a steep and narrow staircase, cross behind the *loggia* and then enter their confined quarters. The light is artificial and sharp. The angles from which they can be seen are limited. Even in their confinement, however, the

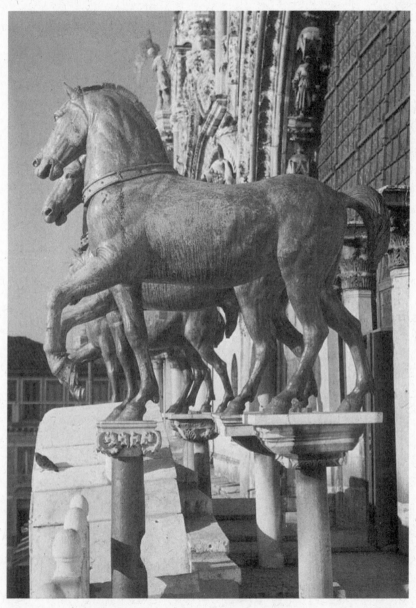

The horses in their original setting in Venice, on the *loggia* of St Mark's, overlooking the square. (S. Marco, Venezia/Scala)

quartet of stallions remain impressive. They are the only team of
four horses surviving from antiquity, but it is not just their age
which is remarkable. The skill with which they were cast is
extraordinary – especially when we note that they were cast in
copper, which has a higher melting point than bronze.

How can we begin to approach the horses? They certainly have
a powerful aesthetic impact. The bodies retain enough of the
original gilding to flaunt an air of tarnished splendour, while their
proud heads radiate a mood of reflection and calm. Each horse
is inclined towards its neighbour, giving them an air of approach-
ability. The mood of restraint is enhanced by their short, cropped
manes, each of which ends with a tuft on the forehead. The tails,
on the other hand, are full and flow gracefully outwards, brought
neatly together at the end by a band. Their collars suggest the
horses are tamed, but they also exude an air of freedom. Perhaps

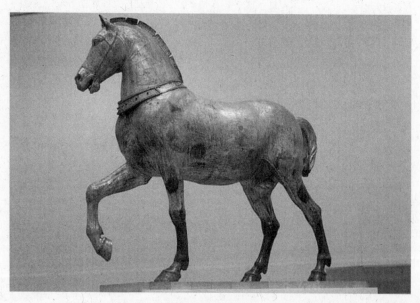

As the horses were designed to be seen from below, the legs are longer than
would be expected and the neck too short. The stance is that of a stallion
displaying his power. (Ancient Art & Architecture Collection)

it is in these ambiguities that much of their aesthetic attraction lies.

With closer observation one can see that there are details which have been copied exactly from live horses, especially around the head, where the degree of accuracy is greatest. It has been noted, for instance, that the 'deep corneal furrow of the eyes is strongly realistic and anatomically correct'. On the legs the chestnut, the horny lump on the inner side whose absence would hardly be noticed, is, in fact, cast, and bones, muscles and even veins have been represented. The stance, with one leg raised, is recognized body language for a display of power, especially for a stallion; one expert consulted for this book saw it also as expressive of

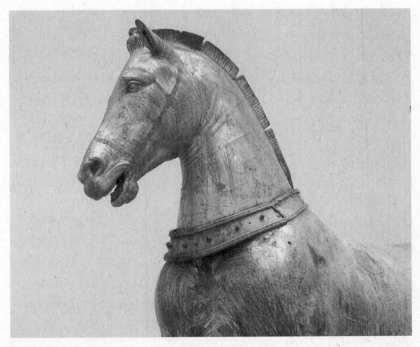

A close-up of one of the heads. Note the short 'Greek' mane and the marks which show where the original bridle fitted. A legend suggests the bridles may have been removed when the horses became identified with the unrestrained power of Venice in the fourteenth century. (Ancient Art & Architecture Collection)

impatience. The well-developed muscles at the shoulders are as one
would expect for a horse trained to draw a chariot, as are those on
the hindquarters. On the other hand, these horses, standing 171
centimetres at the withers, are much bigger than life-size when
compared to the real horses of antiquity, very few of whom stood
higher than 150 centimetres. (One study of skeletons and horse
bones from the Roman era gives a range of 142–152 centimetres.)
Clearly they were made larger to create an impact when on display;
but there are other distortions too. The German romantic poet
Goethe noted in the 1780s how 'up there [on the *loggia*] they look
heavier and from down on the square they look as delicate as deer'.
He had spotted that they had been crafted to be seen from below.
When one compares the proportions of the St Mark's horses with
actual draught horses, the circumference of the neck is much greater
in relation to the body than one would expect, as is the width of the
shoulders. The neck is very short and the backs, too, are shorter
than that of a living draught horse; but the legs are longer, even
though all parts of the leg are in proportion to each other. In real
life, the horses would not be able to graze without straddling their
legs. This is what makes them look 'as delicate as deer' when viewed
from below — as it is now, of course, impossible to do. In short,
while the horses have been expertly observed, they are also idealized.
No one has been able to link them to any known breeds from the
ancient Mediterranean world.

It is worth exploring further why the horses have proved so
interesting and why, as I contend, they deserve a whole book to
themselves. One of the most important developments in our
understanding of classical art is an appreciation of the importance
of public display in the ancient world. The use of the visual image,
particularly sculpture, was fundamental to life in Greece and Rome.
Those living in a city would expect to be surrounded by a mass of
images which would range from a single figure in bronze or marble
to massive public buildings which might themselves be decorated
with sculpture. In short, classical cities diverted a high proportion
of their resources, including the skills of trained craftsmen as well

as precious metals or fine marbles, into images for public display; the philosopher Aristotle is on record as suggesting that a third of a city's resources should be spent on its temples. Even Christians succumbed to this need for display, as the opulence of the early Christian basilicas shows. For the classical historian the interest lies in looking at the contexts in which art is displayed, at who was trying to impress whom and what particular symbols they were using. In short, art is not to be seen as a separate sphere of endeavour, but as a mediator between the maker or patron and the public.

For the ancient observer, a group of four horses would have had an immediate resonance as a symbol of triumph, and this impact would have been far more important than any assessment of them as works of art. Yet as soon as we examine the meaning of 'triumph' we find that the horses could as easily have been celebrating a victory in a chariot race at Olympia as a victory by a Roman general over his rivals for power. In both cases a *quadriga* was an appropriate way of showing off success. So the search for meaning and context is likely to be a demanding one. Another major development in the study of classical art is the blurring of the boundaries between Greek and Roman art once thought to be secure. We have now come to realize that Greek styles were reused by the Romans, often when a specific cultural context was felt to require them. There can be few better examples to make the point than the horses which, over the centuries, have fooled scholars into proclaiming with confidence that they are Greek or Roman.

Partly because of this ambiguity in the style in which they were cast, the origins of the horses have always aroused intense curiosity. As we shall see, virtually every observer creates or restates a legend about their earlier history. Sometimes these legends conflict with one another; in some cases they are placed in a chronological order so that the horses move around the ancient Mediterranean in order to satisfy the demands of each! While everyone accepts that they spent several centuries in Constantinople, the facts of how they came there are probably irrecoverable. As the *quadrigae* were

comparatively common monuments (something often forgotten now that only a single example survives) it means that there are many sites where they could have originated, among them Rome, Delphi or, in one account, the island of Chios. Then there have been the attempts to link them to a particular sculptor, whether Phidias of the Parthenon or Lysippus, the sculptor of Alexander the Great. All this adds to the richness of their history.

However, what makes the story of the horses particularly fascinating is that they have proved transportable. It is the variety and quality of their public settings that make them unique. They have been on display not only in Constantinople but in a major medieval city, Venice, and the capital of Napoleon, Paris. It is hard to think of any comparable work of art whose story is so prominently bound up with its settings. The horses can be linked to many turning points of European history: the founding of Constantinople, its sack in the Fourth Crusade, the years of Venice's greatness, its fall in 1797, the Paris of Napoleon, the revolutions of 1848 and the creation of Venice as the most romantic city in the world. All these stories are to come; but we must start with the origins of the horses in the classical world.

2

CONSTANTINOPLE: THE HORSES' FIRST HOME?

A ROMAN EMPEROR HAD TO COMBINE CHARISMA AND superb generalship with administrative brilliance. The challenge was how to present himself as a focus for the many local cultures of an empire which stretched from the Irish Sea in the west to the Euphrates in the east. If he lost the allegiance of local elites, things could easily fall apart, provinces break away and the borders crumble under the weight of invaders. It was a task that called for enormous self-confidence, and the empire was especially lucky in its emperors in the late third and early fourth centuries. First there was Diocletian (emperor from 284 until his abdication in 305), who, after decades of corrosive barbarian attacks which almost destroyed the empire, reorganized its administration and finances and developed more flexible methods of defence. Then there was Constantine, who clawed his way to power through a succession of military victories, one of which, the battle of the Milvian Bridge in 312, gave him supremacy in the western empire. This victory, he claimed, was due to the support of the Christian God; he responded by extending toleration and patronage to Christians, so setting the religion on its way to dominance in the Mediterranean and eventually far beyond.

After he had fought his way to power in the eastern empire as

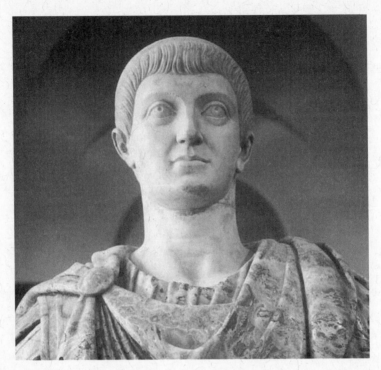

The emperor Constantine. As is typical of portraits of emperors of this period, the face is idealized to suggest the emperor's semi-divine nature. (Ancient Art & Architecture Collection)

well, Constantine founded a new eastern capital, Constantinople, which was dedicated in 330. It was to become the capital of two later empires, the Byzantine and the Ottoman, the second of which survived into the twentieth century. It was an extraordinary achievement and its endurance was largely the result of Constantine's own political genius. Not only was he virtually unbeaten as a general, he recognised the importance of following conquest with reconciliation between the victors and the defeated. In order to achieve consensus and good order among his peoples, Constantine became adept at maintaining the mystique of monarchy through the manipulation of traditional symbols of imperial rule.

The image Constantine used more than any other was that of the

sun, whose provision of the warmth and light vital to human existence had long made it a popular symbol among both philosophers and spiritual leaders. Plato had used it to represent 'the Good', the value which surpassed all others. Apollo, the god of reason and balance, had the sun as one of his emblems. A cult of Sol Invictus, 'the unconquered sun', originally imported from Syria, was very popular among Roman soldiers. A practice of representing the emperor as a sun-god seems to have come into the Roman world via the royal family of Commagene in eastern Anatolia, whose kingdom had been absorbed into the empire in the first century AD. The annexation had been a peaceful one and the Romans maintained good relations with the last king, Antiochus IV, who had been brought back to Rome and treated with respect there. One of Antiochus' grandsons, Philopappus, had been appointed to the ancient post of consul by the emperor Trajan for the year 109 and then made an honorary magistrate in Athens. In Commagenian tradition the king was associated with the sun, and when Philopappus had himself depicted on the monumental tomb he built for himself in Athens he was shown in a four-horse chariot, with rays coming from his head and his right arm raised, as was usual in depictions of the sun-god Sol. The emperors appear to have adopted the theme. By AD 170 the reliefs on the famous Antonine altar from Ephesus (now in the Kunsthistorisches Museum in Vienna), which glorify the Roman emperors as saviours of the east, show a second-century emperor, possibly Trajan, ascending to heaven in a chariot of the sun. By the third century emperors such as Caracalla (AD 211–17) were portraying themselves as the sun itself driving a four-horse chariot.

Constantine followed in this tradition, as one can see in the triumphal arch built in his honour by the Roman Senate in AD 315, which still stands beside the Colosseum in Rome. In reliefs specially designed for the arch, Constantine is shown making his *adventus*, his ceremonial entry, into Rome after his defeat of Maxentius at the battle of the Milvian Bridge. The emperor is seated in a golden carriage drawn by four horses. On a roundel just above the relief and

clearly associated with it, Sol is shown rising, also in a four-horse chariot. An even more precise link between Constantine and the sun is established by a medallion dated to 313, the year after the battle of the Milvian Bridge: here a wreathed Constantine, alongside a radiate Sol, bears a shield on which, again, there appears the sun being carried upwards in a chariot drawn by four horses.

Yet despite these openly pagan allegiances, Constantine was also seen by the growing Christian community as one of their own. Historians disagree as to whether Constantine was a committed Christian himself or whether his main concern was a political one, to use the church with its well-established hierarchy of bishops in the service of the empire. In any case, as a traditional Roman, Constantine may have believed that he could follow a variety of cults without impropriety; in other words, association with Christians

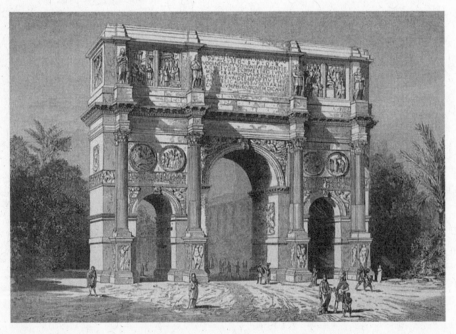

The triumphal arch erected in Rome in 315 in celebration of Constantine's conquest of the city in 312. (Mary Evans Picture Library)

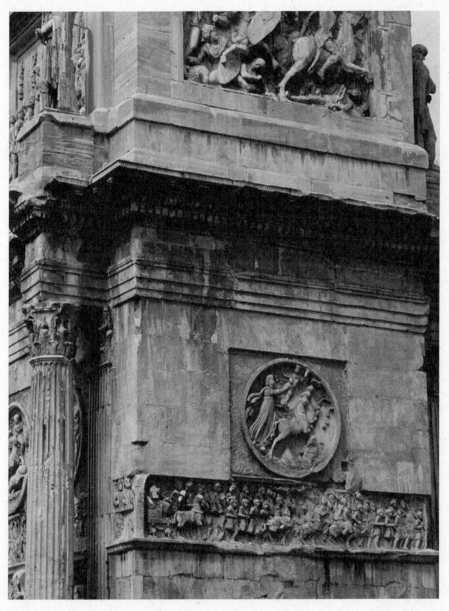

These reliefs from the arch show Constantine making his triumphal entry into Rome, appropriately in a four-horse chariot, with, on the roundel, his symbol the sun, ascending heavenwards on a similar chariot. (The Art Archive)

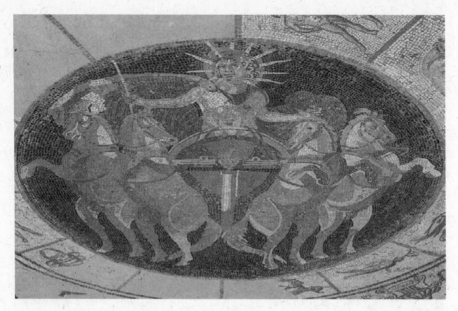

Sol, the Roman sun-god, was always associated with four-horse chariots and
is depicted here in a Roman mosaic. (Ancient Art & Architecture Collection)

did not mean he had to abandon other cults. He was not even
baptized until the very the end of his life. One reason why he could
honour the cult of Sol without offending Christians was that the
sun had also been integrated into Christian worship. There is an
early fresco in Rome of Christ ascending into heaven in the chariot
of the sun-god, and the cult day of Sol Invictus was none other than
25 December, the date Christians were to adopt as the birthday of
Christ. There is even a record of Christians in the fifth century
worshipping the rising sun from the steps of St Peter's in Rome (to
the intense annoyance of Pope Leo the Great, who had hoped they
had moved on from such things). Certainly the bishops were quite
satisfied by Constantine's support. One, Eusebius of Caesarea, even
wrote a panegyrical life of the emperor in which he made an unlikely
analogy between Constantine and Moses.

Constantine's presentation of himself as a sun-god was matched

by other trappings of divinity through which he kept his distance from his subjects. He was never addressed directly by his name, but by an abstraction such as Your Majesty or Your Serenity. Great audience halls were built inside the imperial palaces, their walls lined with varied marbles or shimmering mosaics. (One still stands in Trier in Germany, although it has long since been stripped of its fittings.) Suppliants had to bow before him, presenting their petitions with extravagant formality; the emperor's reply would be passed down through a hierarchy of officials. He was dressed to impress, in purple, a hue produced by a dye which was extracted in tiny quantities from molluscs and so prohibitively expensive. We read of one council of bishops, held in the audience hall of the imperial palace in Nicaea, where Constantine appeared among them 'like some heavenly angel of God, his bright mantle shedding lustre like beams of light, shining with the fiery radiance of a purple robe, and decorated with the dazzling brilliance of gold and precious stones'. Those who beheld him were said to be 'stunned and amazed at the sight – like children who have seen a frightening apparition'.

Constantine's foundation of Constantinople on the Hellespont, the strait which ran between the Mediterranean and the Black Sea, fits well with this policy of keeping himself above his subjects. From a strategic point of view the ancient Greek city of Byzantium was an excellent choice. It was on the junction of major routes between east and west, and also relatively close to the Danube and Euphrates rivers, borders of the empire which were often under threat. Its position on a promontory meant that it could be walled off and so virtually impregnable, as invaders were to find through-out the city's history. Philip of Macedon, a master of sieges, had failed to capture it in 340 BC and an earlier Roman emperor, Septimius Severus, had taken two years to subdue it at the end of the second century AD. So here was Constantine at his most pragmatic; but by choosing a relatively remote site, the emperor was also able to maintain his elevated status. As a man whose family originated in the Balkans, he would never have been fully accepted by the ancient senatorial families of Rome. In Byzantium, on the

other hand, Constantine was left free to craft his own foundation – and he did not even have to compromise with the church. Byzantium had very little in the way of a Christian heritage when Constantine began expanding it into a capital in the 320s. Even then the building of churches was given low priority and the dedications of those planned for the city were to Divine Peace and Divine Wisdom (the famous church of Santa Sophia, still standing in its rebuilt sixth-century form), dedications which would cause no offence to pagans. The only specifically Christian building which had been completed by the time of Constantine's death was the Church of the Holy Apostles but as the emperor chose to be buried in it as the 'thirteenth apostle', with sepulchres representing the original apostles grouped around him, this was in effect a church dedicated to himself. Constantinople, as its name suggests, was a showcase city for the glorification of the emperor.

An audience hall could hold only a limited number and an emperor like Constantine, who had total confidence in himself, needed a larger arena in which to display himself in front of his subjects. The best such setting a large Roman city could provide was its hippodrome, the circuit for chariot racing. The most impressive of these, and the one which provided a model for others in the empire, was the Circus Maximus in Rome, which ran along the southern edge of the Palatine Hill. The site is completely deserted today, just an open space in the shape of an oval, and it is hard to recreate any sense of what it was like in its heyday; but by the time it was finally completed, around AD 105 in the reign of the emperor Trajan, it was over 600 metres long and 140 metres wide with a capacity of 150,000 spectators – three times the number who could fit into the nearby Colosseum.

When the emperor was in residence in the imperial palace on the Palatine Hill he would preside over the races from an imperial box set in the side of the hill, and even if not there himself he would use the games as a means of sustaining his popularity. His chief responsibility lay in providing the horses. In a typical day's racing there would be twenty-four races and, with four horses to each of

twelve chariots (four teams of three), each race would need forty-eight horses, over 1,150 in total. The demand for horses was so heavy, in fact, that whole herds of wild horses were set aside to help the emperors to meet it. Yet there was much more than this to the chariot-racing spectaculars. Along with the games in the great amphitheatre of the Colosseum,* they constituted the only occasion when an emperor could see and be seen by his subjects en masse – and they were not going to miss the opportunity to let him know their feelings. 'The Romans gather enthusiastically in the circus,' wrote the historian Josephus in the first century AD, 'and there the assembled throngs make requests of the emperors according to their own pleasure. Emperors who rule that such petitions are to be granted automatically are highly popular.' Josephus goes on to describe the response of the emperor Caligula (emperor AD 37–41), who sent his men among the crowds to arrest, and put to death, anyone who shouted for favours. Not surprisingly Caligula was himself murdered a few weeks later (although his behaviour in the Circus was only one of his crimes against the people that drove the conspirators to assassination). If emperors did not grant a request they were at least asked to produce a reason for the refusal. On one occasion the crowd demanded of the emperor Hadrian (r. AD 117–38) that a victorious charioteer who happened to be a slave be given his freedom. Hadrian refused with the modest explanation that he had no power to give away the property of another. Any refusal had to be given directly by the emperor himself; the crowd considered it insulting if a message was relayed to them by a herald.

The more confident emperors knew how to use the opportunity offered by a clearly defined area, the imperial box, which was set off from the crowds and above them, giving everyone a clear view of the emperor in his glory. Augustus, who had a highly sophisticated

*In the Colosseum the emperor had some relationship with the crowd; but the hippodrome was much larger and more directly associated with the imperial palace, and so became the main *political* arena in Rome.

approach to crowd management, once countered a protest against new laws encouraging the equestrian class to marry by appearing in the box overlooking the Circus Maximus with a collection of children assembled from his extended family to make the point that marriage had its purposes. Constantine showed the same confidence in his use of the hippodrome. Wherever he made his capital he enlarged the existing hippodrome or built a new one, and in every case it ran alongside his palace with the imperial box as a display area between the two. In 310, at the beginning of his career, when he was in control only of northern Europe and based at the provincial imperial capital of Trier, he had built a hippodrome next to his palace. When he arrived in Rome in 312, after his great victory at the Milvian Bridge, he found that Maxentius, whom he had defeated, had constructed a massive hippodrome to the south of the city (whose ruins can still be seen). Constantine retaliated by showering patronage on the Circus Maximus. It is reported that it was 'wonderfully decorated' by him, with a new portico and golden columns and statuary. An extended seating area from this date has been uncovered in excavations. Between 317 and 323 Constantine was campaigning in the Balkans and based at Sirmium, another provincial capital, and here again he seems to have completed a hippodrome.

The new hippodrome in Constantinople, then, was bound to be something special. It was modelled on the Circus Maximus in Rome to make the point that this was a 'new Rome', and Constantine decorated the barrier (the *spina*) which ran between the turning posts with a mass of statues. The hippodrome was about two-thirds the size of the Circus Maximus, but this was in a city which had, as yet, only a fraction of Rome's population. The fourth-century Christian scholar Jerome tells of whole cities being stripped of their treasures to decorate it and the other open spaces in the city. Among the treasures known to have been taken by Constantine for this purpose were the column commemorating the Greek victory over the Persians in 479 BC, from the oracle site of Delphi (the base still remains today, where it was embedded in the *spina*), and statues

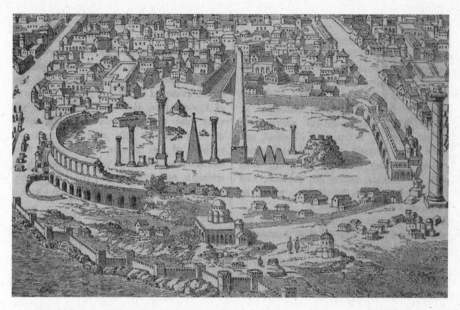

The remains of the Hippodrome in Constantinople *c.*1600. Note the obelisk, an Egyptian symbol of the sun, which was a common feature of hippodrome decoration. The obelisk and the other monuments were placed along the *spina*, the barrier around which the chariots raced. (Mary Evans Picture Library)

of Apollo (one of which may also have been taken from Delphi) and of the Muses (from Mount Helicon in Boeotia). From Actium, in north-western Greece, came another victory monument, that set up by Augustus to commemorate his defeat of Mark Antony there in 31 BC. One motive for building Constantinople was to celebrate Constantine's victory over a rival, Licinius, who had ruled the eastern part of the empire, so bringing in an earlier victory monument put up by a westerner to show off his own defeat of a rival was highly appropriate.

To add to the aura of the hippodrome a massive statue of Hercules was transported all the way from the Capitoline Hill in Rome. Hercules was often associated with chariot racing because he was believed to have shown the same combination of physical strength and cunning in achieving his labours as was needed by a

charioteer. At the Circus Maximus a statue of Hercules Invictus, Hercules the Unconquered, stood near the starting gates, and this part of the Circus was believed to be under his special protection. The Hercules brought to Constantinople was of great aesthetic and symbolic importance as it was said to have been made by Alexander the Great's favourite sculptor, Lysippus. The Romans had looted it from the Greek city of Tarentum in southern Italy in 209 BC and transferred it to the Capitoline Hill in Rome as a reminder of their humiliation of the city.

If one is trying to distinguish a hippodrome from the other monuments one finds depicted on a Roman coin, one clue to look for is an obelisk, a needle-shaped stone monument. Obelisks originated in ancient Egypt as a symbol of the sun, and they were derived from a stone called the *benben* that was placed in the main temple to the Egyptian sun cult at Heliopolis at the southern end of the Nile delta. Augustus, who had conquered Egypt for the Roman empire, brought back an obelisk from Heliopolis and in 10 BC he had it placed on the barrier in the Circus Maximus, adding to it his own dedicatory inscription to the sun.* In doing this he was honouring ancient traditions which linked the sun to chariot racing. The story goes that the word *circus* itself was derived from the name of Circe, the daughter of Helios the sun-god (Sol to the Romans), who had established the first chariot races in his honour. In the Circus Maximus there was an ancient temple to Sol near the finishing line.

The obelisk features prominently in a much later account by a court official, one Corippus, which describes the rituals surrounding the accession of a Byzantine emperor, Justin II, in AD 565 in Constantinople. These included a presentation of the new emperor to the people in the hippodrome. Corippus breaks off his narrative to explain why the circus and the sun were so closely linked.

*This obelisk was found many centuries later buried on the site and is now re-erected in Rome in the Piazza del Popolo.

The Senate of old [in Rome] sanctioned the spectacles of the new circus in honour of the New Year's sun and they believed that by some ordering of the world there were four horses of the sun, which were symbols of the four seasons in the recurring years. Thus the senators of old laid down that there should be in the likeness of the seasons as many charioteers and as many colours [the four teams in any Roman chariot race were known by their colours, Blue, Green, Red and White] and they created two opposing parties, just as the coldness of winter strives against the warmth of summer.

Corippus goes on to explain that a circus itself is designed to represent a whole year divided into seasons. The four equinoxes are represented by the turning posts at either end, the centrally-placed obelisk and the 'eggs', a set of egg-shaped marbles which stood close together in a frame halfway along the barrier and were removed one by one as each lap was covered.* In other words, there were four distinct and equal stretches of the circuit, two either side of the *spina*. Corippus' account has found support in the rare survival of a glass bowl, dating from the middle of the fourth century and probably made in Cologne, where it was found in 1910. It has a central medallion with a bust of Sol in it around which four chariots parade. They are divided from each other by emblems of the circus: an obelisk, a set of 'eggs' and the two turning posts.

After Augustus it became the custom for every circus to have its own obelisk, although in Constantinople the earliest one of which we have direct evidence was placed there by the emperor Theodosius I in AD 390 in celebration of peace treaties with the empire's enemies, the Goths and the Persians. A second was set up early in the following century. Yet even if we know of no obelisk placed in the hippodrome by Constantine, his own close association with the sun

*In some hippodromes the eggs were replaced by model dolphins, believed to be the fastest living animals.

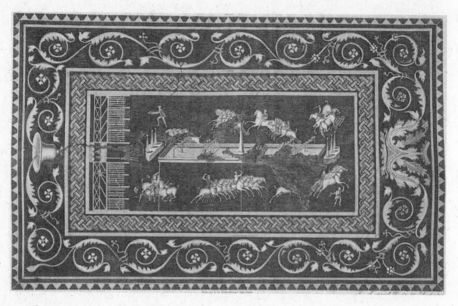

This engraving of 1806 shows a Roman mosaic of a chariot race discovered at Lyon in France. Note the starting gates on the left and, inside the *spina*, the obelisk and the rows of 'eggs', one of which was removed after each lap. (Musée de la Civilisation Gallo-Romaine, Lyon, France/Bridgeman Art Library)

was embedded in ceremonies in the hippodrome, as could be seen in the official inauguration of the city in May 330. The day's events began in the presence of the emperor with the lifting of a great gold statue of him, which had been fashioned from an ancient statue of the sun-god, on to a column (which still stands, in a much battered form, today). Dressed in magnificent robes and wearing a diadem encrusted in jewels, Constantine himself then processed to the imperial box which overlooked the hippodrome. Among the events which followed one stood out: the arrival of a golden chariot carrying a gilded statue of the emperor, again shown as a sun-god, which in turn held a smaller figure of Tyche, the goddess of good fortune. For the next two hundred years the ritual drawing of the statue and chariot through the hippodrome was to be re-enacted on the anniversary of the dedication.

Between anniversaries Constantine's chariot and its statue were

placed at the Milion, a grand imperial building in the shape of a gilded canopy with four arches, which stood outside the hippodrome, but close to its starting gates, where the ceremonial processional route into the city, the Mese, ended. Beside it stood a team of four horses.

Memories of Constantine's inauguration lingered long in the city. In an eighth-century chronicle of Constantinople's monuments, the *Parastaseis Syntomoi Chronikai* (literally, 'Brief Historical Notes'), we read that

> At the golden Milion a chariot of Zeus Helios [Zeus in the guise of the sun-god] with four fiery horses driven headlong beside two statues has existed since ancient times ... And the chariot of Helios was brought down into the Hippodrome, and a new little statue of the Tyche of the city was escorted in the procession carried by Helios. Escorted by many officials, it came to the Stama [the place where the victorious charioteers received their palms of victory] and received prizes from the emperor Constantine, and being crowned it went out and was placed in the Senate until the next birthday of the city.

In the same chronicle the writers, who are assumed to be court officials, describe 'a statue of a woman and an altar with a small calf' in the hippodrome itself. 'With these too were four horses shining with gold and a chariot with a charioteer [possibly Tyche?] holding in her right hand a small figure, a running image.' Victory was often personified as a running woman, but this statuette could also have been of an athlete; female charioteers were rare. 'Some say', they go on, 'that the group was erected by Constantine while others say merely the group of horses, while the rest is antique and not made by Constantine.' This statue too appears to have been hauled in its chariot in procession through the hippodrome by the citizens of Constantinople, who, the chronicle records, were dressed in white mantles and carried candles, on each anniversary of the city's foundation. One assumes that 'the four horses shining with

gold' remained at their base to be rejoined by the chariots when the
ceremony was over.

Later, a century after Constantine, another team of four horses
was set up as a permanent feature in the hippodrome, over the
starting gates where, according to one observer, they still stood in
the twelfth century. These horses were said to have been brought by
the emperor Theodosius II from the Greek island of Chios, close
to the coast of Asia Minor, in the early fifth century. Chios was a
prosperous place, its inhabitants – according to the historian
Thucydides, writing in the fifth century BC – among the most
wealthy of all the Greeks. Its trading networks stretched from the
Black Sea to Egypt and as far east as southern Russia, while at home
its population was sustained by a fertile plain on the east coast.
Unlike much of mainland Greece, Chios would certainly have had
the pasture and wealth to support horses, and it is possible that the
hippodrome horses, if they came from there, were commissioned by
a victor in the Greek games (which will be described in the next
chapter).

So we know of at least three teams of four horses in
Constantinople in the century after its foundation. Of the two
whose chariots were paraded in the hippodrome, either or both
could have been made by Constantine or brought by him from
another site. There is also another possibility: that Constantine
found one or more teams of horses already in place in Byzantium
when he arrived to transform the city. The historian Dio Cassius
(AD 164–after 229) recorded, for instance, that when the emperor
Septimius Severus besieged Byzantium in the 190s 'the stones of
the theatres, the bronze horses and the bronze human figures' were
hurled at him as ammunition. It has been argued that Septimius
Severus might have recreated the horses to atone for their
sacrilegious destruction and that these would have been found by
Constantine when he rebuilt the city. On the other hand, Septimius
Severus, whose regime depended on continuous celebration of
military triumph, may well have commissioned a triumphal *quadriga*
on his own account to celebrate his taking of Byzantium when he

rebuilt the shattered city. If Constantine had found a *quadriga* in the city he may well have chosen to preserve it as a fitting symbol of his own success.

Whatever their origins, it is likely that one of the three teams mentioned in the *Parastaseis Syntomoi Chronikai* is the set of gilded horses described by Bernardo Giustiniani in Venice in the passage quoted on p. xv and said by him to have originally belonged to 'the chariot of the sun' and to have been 'brought from Constantinople'. But before we explore further, we need to understand why horses came in teams of four.

HORSES AND HEROES

IF ONE MOVES WESTWARDS BY SEA FROM CONSTANTINOPLE, out through the Hellespont into the Aegean and then southwards to Greece, one hits landfall on the long coastline of the island of Euboea. The sensible sailor heads inland around Cape Artemisium on the north-eastern coast, so as to reach the sheltered waters between Euboea and the mainland. (A large part of the Persian invasion fleet of 480 BC was lost, driven onshore by a gale, when it tried to edge round the island on the outside.) There had long been trading links between Euboea and the civilizations of the east, but in 1100 BC at the onset of the so-called Dark Age these contacts had been disrupted by what appears to have been an economic collapse followed by widespread conflict. Until recently early Greek history was believed to be almost uneventful between that date and the revival of trade and confidence in the eighth century which marked the end of the Dark Age.

Then in 1981 a remarkable discovery was made at Lefkandi, a site between Chalcis and Eretria on the inner coast of Euboea. Archaeologists found a great hall, some 45 metres long and 10 metres wide, dating from 1000 BC. It was unlike anything known from earlier times. Its mud walls had been built on stone foundations, and around them was a colonnade of wooden posts. More

remarkable still, there was a burial within the walls: of a man, who had been cremated, and a woman, along with an array of goods more extensive than anything that could be expected for the time. There were a spear and a sword in iron, an engraved bronze vessel and, with the woman, gilt hair coils and gold discs which had been laid on her breasts. All this suggested a couple of high status who had the power to organize a large and skilled labour force and who also had access to the goods of the east. But their community seems to have lost its vigour. The archaeological evidence suggests that part of the building at least collapsed soon after the burial, and it appears to have been another century before Lefkandi resumed contact with the east.

In a second compartment next to the main burial chamber there was another extraordinary find: the skeletons of four horses, two still with iron bits in their mouths, which had presumably been sacrificed before being buried alongside their owners. Horses are a rare find in southern Greece because there is so little pasture for them; one has to travel northwards to the plains of Thessaly to find land where horses can be grazed easily. In fact, in Homer's *Odyssey* we read that Telemachus, the son of Odysseus, has to turn down the gift of three stallions from King Menelaus of Sparta because his home, Ithaca, has not enough pasture or 'running room' for them. So anyone who could afford to sacrifice no fewer than four horses at once must have been a figure of impressive wealth and social status, as the hall in which the burials were made suggests.

Teams of four horses appear in the earliest Greek literature. In his epic the *Iliad*, written down some 250 years after the hall in Lefkandi was built, in about 750 BC, Homer tells how Hector, champion of Troy, and Achilles, hero of the Greeks, both advance into battle in four-horse chariots. The vehicles are driven by charioteers, behind whom the heroes stand, ready to jump down into the fighting. Lesser heroes have only two horses to their chariots. What is particularly attractive about Homer's account is that the horses mean something to their owners. Hector's horses are even named – Golden and Whitefoot, Blaze and Silver Flash –

and are said to receive special care from Hector's wife Andromache, who feeds them honey-drenched wheat mixed with wine. These are horses treasured within the family, and they can respond to the affection. When Achilles' charioteer is killed his set of horses 'stood, holding the blazoned chariot stock still, their heads trailing along the ground, warm tears flowing down from their eyes to wet the earth ... The horses mourned, longing now for their driver, their luxurious manes soiled, streaming down from the yokepads, down along the yoke' (Robert Fagles' translation).

We know that any ancient Greek or Roman chariot drawn by four horses always had the horses harnessed alongside one another, not in two sets of pairs as in a stagecoach. It is an unexpected arrangement because it is such an inefficient way of using the strength of the horses. It would have been impossible to have harnessed them all to the same yoke, because if this had broken the team would have collapsed in a dreadful tangle; so the outer two horses are always trace horses, running alongside the inner pair who do have a yoke between them. (The fact that only two of the horses in the Lefkandi burial had bits suggests that they were harnessed in the same way.) The trace horses add nothing to the pulling power of the team and they also make the chariot much more difficult to manoeuvre. A skilled charioteer can just about drive the four along on level ground but it would have been impossible in the dust and noise of an actual battle, and we know that in any real war only two-horse chariots were used.

With two extra horses added on purely for display, the four-horse chariot was a clear sign of status in a land where horses were always rare, and this is why Homer uses it to pick out the two most distinguished heroes of his epic from the others. We know that Achilles and Hector must be truly great men if they have horses to spare. But we also find teams of four horses in many other contexts where the owners are heroes, aristocrats or gods. So in eighth-century BC Athens aristocratic women were buried with pottery containers decorated with four model horses on the lid and chariot wheels on the side. When gods and goddesses are shown in chariots

on pottery, they invariably have four horses. There is a good example in the British Museum of a *krater* (a bowl for mixing water and wine) from Athens, dated to about 580 BC, which shows all the gods of Mount Olympus attending the wedding of Peleus and the nymph Thetis, soon to be the parents of Achilles. The gods stand in pairs on the chariots, each of which is drawn by four horses. On the east pediment of the Parthenon, which shows the rising of the sun-god Helios and the setting of the moon-goddess Selene, both were carved with four horses drawing their chariots. (One of the horses of Selene which survives is considered by many to be among the finest pieces of classical Greek sculpture and will reappear in our story later.) More remarkably, perhaps, in the famous frieze which ran along the upper *cella* walls of the Parthenon in Athens, the

A *quadriga* shown on an Athenian *krater* (a bowl for mixing wine and water) dating from the sixth century BC. The standard representation of a *quadriga* showed the two inner horses facing towards each other, and the two outer facing away from each other. Note that the outer horses are trace horses and have no pulling power. (Ashmolean Museum, Oxford/Bridgeman Art Library)

A mythical scene from an Athenian water jug of *c.*550 BC, with Athena (identifiable by her spear) driving a *quadriga* as is appropriate to her status as a goddess. (British Museum, London/Bridgeman Art Library)

chariots which make up part of the great procession of citizens each have four horses. Here the Athenians are giving themselves the status of heroes by virtue of their belonging to the city they believed, with some reason, to be the greatest of the Greek world.

The Lefkandi burial provides the earliest evidence that four-horse chariots were actually built in Greece, and the *Iliad* suggests that they were associated with aristocratic funerals. When Achilles'

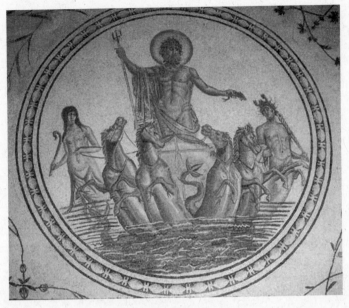

Neptune, the sea-god, rises from the sea in his *quadriga*. Roman mosaic, second to fourth century AD. (Ancient Art & Architecture Collection)

beloved companion, Patroclus, is killed by Hector, Achilles holds funeral games in his honour, and 'with wild zeal slung the bodies of four massive stallions on to the pyre'. Then there is a chariot race. It is a very simple affair – the chariots take off for about a mile, turn round a post and then make for home – and seems to have been contested by two-horse chariots; but only a few years after Homer was writing, in 680 BC according to tradition, four-horse chariot racing appears as an event in the Olympic Games and then in other Greek games. The sudden appearance of four-horse chariots in the games fits well with the decline of the old aristocratic world: battle between great heroes is no longer part of warfare, and it seems that the aristocrats transferred their combative energies into competitive games. Having four horses to each chariot made the point that these were no ordinary competitors but men of high birth, to whom victory in these races brought great acclaim.

Unlike any other Olympic event, however, it was possible to compete by proxy, employing an outsider as charioteer, even though it was the owner of the chariot who enjoyed the kudos* of victory. The Athenian Cimon won the chariot race at three Olympic Games in a row, those of 532, 528 and 524 BC, and celebrated – in an echo of Lefkandi – by having his horses buried in his family tomb. In 416 BC another Athenian aristocrat, Alcibiades, entered no fewer than seven teams in the Olympics and then unscrupulously used his success to manipulate the city's democratic assembly. 'There was a time', he told his credulous audience,

> when the Greeks imagined that our city had been ruined by the war, but they came to consider it even greater than it really is

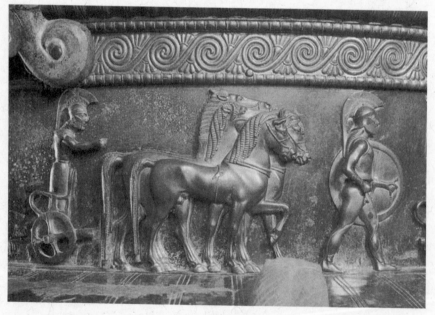

This exceptionally fine bronze relief of a *quadriga* from the sixth century BC comes from the rim of the Vix *krater* found in the grave of a Celtic aristocrat in France. The hoplite (armed foot-soldier) preceding it suggests a battle scene. (Musée Archeologique, Chatillon sur Seine, France/Bridgeman Art Library)

*The word 'kudos' comes directly from the original Greek for 'honour and glory'.

because of the splendid show I made as its representative at the Olympic Games, when I entered seven chariots for the chariot race and took the first, second, and fourth places ... It is customary for such things to bring honour, and the fact that they are done at all must give an impression of power.

There are examples of aristocrats driving their own chariots in the games (and being applauded for doing so) but it was rare. Driving a chariot around turning posts in a race with many others, perhaps as many as forty in Greek games, needed enormous skill. The inner of the trace horses had to be guided around the turning post (which was always passed to the left), taking the two yoked horses and the outside trace horse with it and so on, for twelve laps, ten thousand metres in total. Collisions and falls were common. One can see the challenges from the account of a race at the Olympic Games given by the playwright Sophocles in his play *Electra*. First, the start:

then, at the sound of the bronze trumpet, off they started, all shouting to their horses and urging them on with their reins. The clatter of the rattling chariots filled the whole arena, and the dust blew up as they sped along in a dense mass, each driver goading his team unmercifully in his efforts to draw clear of the rival axles and panting steeds, whose steaming breath and sweat drenched every bending back and flying wheel together.

Then, as must have happened frequently, things went catastrophically wrong.

At the turn of each lap, Orestes reined in his inner trace-horse and gave the outer its head, so skilfully that his hub just cleared the post by a hair's breadth each time; and so the poor fellow had safely rounded each lap but one without mishap to himself or his chariot. But at the last he misjudged the turn, slackened his left rein before the horse was safely round the bend, and so

struck the post. The hub was smashed across, and he was hurled over the rail entangled in the reins, and as he fell his horses ran wild across the course.

The race was made more hazardous by the custom of holding the event at dawn. As we have seen, the sun was linked to chariot racing, and it may have been in honour of the sun that the race was held at first light; but the timing made it even more hazardous, for there would have been places in the course when the chariots were racing straight towards the rising sun.

Driving four horses was challenging enough in itself, but the Greeks, and later the Romans, made things even more difficult by the way they harnessed their horses. The yoke of the two inner horses was attached to a collar which ran around the neck. This must have caused a great deal of discomfort to the horse, which was, in effect, closing its own windpipe as it pulled, and reduced its

A charioteer driving his *quadriga* full speed. Late fifth-century Greek *krater*. (British Museum, London/Bridgeman Art Library)

traction power considerably. (These collars remain in place on the St Mark's horses, whose thick, muscular necks may have been copied from actual chariot horses.) The Greeks may have been ingenious in matters of the mind but were not always equally perceptive in matters of practical technology, and in this case at least the Romans were no better. When the heavy horse collar, which transfers the weight of the chariot or plough to the shoulders of the horse, was introduced into Europe in the tenth century AD it increased the pulling power of a plough horse by three or four times.

The Romans learned the art of chariot racing through the Etruscans, who themselves learned it from the Greeks. The Etruscans, who were settled in the metal-bearing hills of the western coast of central Italy, had close trading relations with merchants from Euboea, who had established a trading base on the island of Ischia in the eighth century BC. These early Greek merchants and those with whom they did business on the Italian mainland were aristocrats, and the Etruscans absorbed all the trappings of Greek aristocratic living. In the cemeteries of the wealthier Etruscan cities, such as Tarquinia, painted tombs show Etruscans enjoying Greek-style banquets, listening to the music of flutes and competing in athletic and wrestling contests. The Etruscans were confident enough to adapt the Greek customs to their own; so, for instance, their wives were allowed to attend their banquets, something unheard of in Athens. They made their own adaptations of chariot racing, too. Their charioteers wore short tunics, in contrast to the Greek *chiton*, a robe which reached to the ground, and bound their reins around their bodies, again in contrast to the Greek custom of holding the reins freely in the hand. The use of the same practices by the Romans tells us that it was through the Etruscans that the Romans absorbed chariot racing. Legend is more specific: according to tradition, it was the Etruscan kings who ruled Rome in the sixth century BC who introduced chariot racing to the city and built the first circuit on the site of the later Circus Maximus.

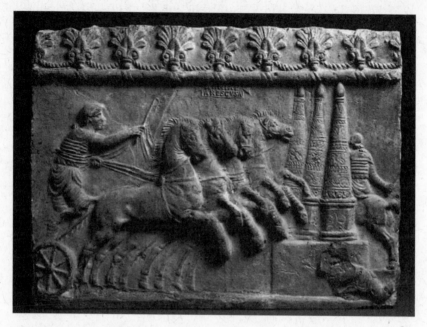

A *quadriga* racing towards the *meta*, or turning post, at the end of the barrier.
Roman terracotta plaque, probably first century AD. (British Museum, London)

The Greek games held at Olympia took place only every four years,
so there was never a need to build a permanent stadium or even any
sophisticated starting gates. The circuit was probably allowed to return
to pasture between each event. The Romans had races much more
frequently, several times a year and with many races on each day; so
they took to building permanent hippodromes. The remains of many
of these survive.

The more stuffy Roman aristocrats could scoff at the enthusiasm
for the races. 'It amazes me', wrote Pliny the Younger, a senator and
provincial governor, 'that thousands and thousands of grown men
should be like children, wanting to look at horses running and
men standing on chariots again and again.' Yet a race-day was an
important social as well as sporting occasion. One of the most
charming vignettes of such a day comes from the poet Ovid, who
describes how he uses the cramped seats of the Circus Maximus to

attempt to seduce the girl he has brought with him. The crowd is so
tightly packed in that Ovid 'has' to defend her from the elbows of
the spectator on her far side and the knees of the one behind her. Her
dress trails in the dust, giving him the opportunity to lift it a little
from the ground to reveal her legs. 'What other treasures may not be
hidden under that summer dress?' he muses, and he eagerly sweeps
away the dust which rises from the arena and settles on her. She
fancies one of the charioteers, so in order to win her approval Ovid
has to shout for him too. At the first start the favoured charioteer
is pushed aside by his competitors, but the crowd appeal against an
unfair start by flapping their togas and the race is restarted, this time
leading to his victory. Now she is happy. 'She smiled, eyes bright,
inviting – That'll do now. Keep the rest for – another place.'

The popularity of the games led to the hippodrome, with its
marble seats, imperial box, richly adorned barrier and monumental
starting gates, becoming one of the grandest buildings of a Roman
city. In Roman games the four teams, Blue, Green, Red and White,
each fielded up to three chariots per race and the starting gates were
built as a row of twelve arches, each with a double lattice gate
beneath it. Some races appear to have had only four chariots
participating, others eight. The chariots lined up behind the lattice
gates, their positions chosen by lot, and when the *mappa*, a
ceremonial cloth, was dropped, ropes were pulled so that the latches
of the gates sprung open simultaneously. The gates were built some
160 metres from the end of the barrier, which itself was set at a
slight angle to the gates so as to create a wider space into which the
chariots charged as they approached the barrier for the first time.
They were required to keep in line at right-angles to the barrier
round the first turning post, then back along the far side of the
barrier until they passed a white line on the track, after which they
could cut in front of each other. A Roman race was about half the
length of a Greek one, perhaps because more were crammed into
each day. Each consisted of seven circuits, some five thousand
metres in total, with a finishing line probably halfway along the
right-hand side of the final circuit.

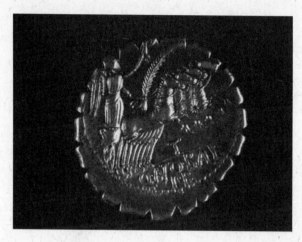

This silver *denarius* from Rome of the first century BC (when Rome was still a republic) shows a charioteer carrying his palm of victory and receiving recognition from heaven. It was minted by a Roman magistrate, presumably as a symbol of victory. (The Art Archive)

Winning charioteers enjoyed enormous prestige. They drew up their chariots at the *stama*, a platform on the barrier, where they were awarded a palm leaf as a symbol of their victory, and then they completed a lap of honour. The crowd would pelt them with flowers and small change, and by the late empire they would be hailed with the cry of '*tu vincas*', 'May you conquer.' It was a richly symbolic moment as this was the same cry that greeted an emperor whenever he appeared in public. The close link between the emperor and the chariot races was sustained by treating the charioteer as if he were a direct representative of the emperor.

And indeed, in some ways he was, because the four-horse chariot had already been developed in a different context altogether as a symbol of imperial triumph. The triumph was another ritual which the Romans adopted from the Etruscans. When an Etruscan commander won a victory he paraded through his native city in a four-horse chariot, and the Etruscan kings of early Rome appear to have done the same. By tradition they wore purple, which had always

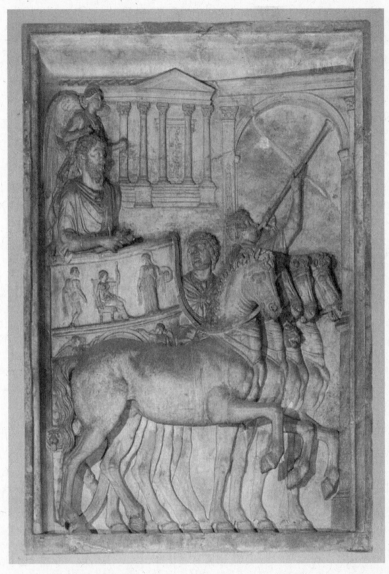

The triumphal chariot. This fine relief shows the emperor Marcus Aurelius celebrating a triumph in Rome in the late 170s AD. His son, the notorious Commodus, originally rode beside him, but his figure was erased after Commodus' damnification. (Museo Capitolini, Rome/Scala)

been a mark of high status, and a gold crown. When the Etruscan kings had been thrown out of Rome and a republic established (the traditional date for this is 509 BC) the ritual of the triumph remained, and was awarded by the Senate to a general for any major victory.

The event was carefully stage-managed. The victor, dressed as if he were the god Jupiter (the Roman equivalent of Zeus) and crowned with a laurel wreath, would enter the city in his chariot, always with four horses (although one general, Pompey, showed off by substituting elephants for horses, with the embarrassing result that his chariot got stuck in the city gateway). Behind him would stretch a procession of his prominent captives and his booty — sometimes, after the sack of a great city, there would be enough of both to fill three days of such parades. The procession would progress through the Forum and then to the Capitoline Hill, where the victor would offer his wreath to the cult statue in the great temple to Jupiter as his captives were led off to be executed.

Yet the glory, though immense, was transitory. Even in the procession itself the victor would be accompanied by a slave, reminding him that he too one day would die, while his troops were allowed, for this occasion, to denigrate him. It was understood that a triumph never led to lasting political status but that the victor would retire from his command once the great day was over.

This was the ritual during the republic. The emperors, the first of whom was Augustus (r. 27 BC–AD 14), were careful not to be upstaged by their military commanders. After 19 BC only members of the imperial family could celebrate triumphs; and even then, when the emperor Tiberius allowed his charismatic nephew Germanicus a triumph after victories in Germany, the adulation shown by the crowds cruelly exposed the declining powers of the elderly ruler. One way round this was for the emperor himself to take responsibility for all victories achieved by his commanders. Thus the emperor Claudius — whose physical handicaps, the result probably of cerebral palsy, ruled out soldiering — awarded himself a truly magnificent triumph in Rome after part of Britain was conquered in AD 43.

The emperors also transformed the function of the triumph. Whereas in the republic it had to be a temporary moment of glory so that any further political ambitions by the victor were defused, the emperors both wished and were able to maintain themselves in a continuous state of glory, and the best way of doing this was to record their triumphs in some permanent form. So the triumphal arch was invented, and first used as a symbol of victory by Augustus. The advantage of the arch was that it could be built anywhere. Italy, Gaul and north Africa were the most common sites, although, of course, Rome was the most popular choice for an emperor. One could hardly do better than to have a great victory permanently commemorated in the Forum, the heart of the empire's political and ceremonial life.

One of the earliest arches was that erected by Augustus in the Forum in 19 BC to celebrate the diplomatic coup by which the Parthians had been forced to surrender standards they had captured in an earlier defeat of the Romans. On the summit of the arch Augustus was shown as a conqueror in his chariot – which was, of course, drawn by four horses. The theme was continued within the magnificent new Forum which Augustus built in Rome alongside the original one. Its imposing temple, dedicated to Mars Ultor, Mars as a war-god who had achieved revenge (in reversing the earlier defeat by the Parthians), housed the returned standards and was also crowned by a *quadriga*. In the centre of the Forum was another *quadriga* carrying Augustus himself, and here he is portrayed as the culmination of the heroes of Rome, statues of whom stood in an adjoining 'Hall of Fame'. To emphasize his status even more explicitly, works by the fourth-century BC artist Apelles, the most famous painter of antiquity, depicting Alexander the Great in *his* four-horse chariot, were displayed in the Forum. The message was clear: Augustus is the new Alexander, conqueror of the world.

A particularly famous triumphal arch of the first century AD was that erected by the emperor Nero in Rome in 62 to celebrate another victory over the Parthians, although on this occasion the fruits of an initial victory had been lost by incompetence and the

signed peace represented a compromise. This did not deter Nero, who built his arch on the most sacred spot of all, one even more prestigious than the Forum: the Capitoline Hill which overlooked it. Its sides were covered by a mass of sculpture and statues, all focused on the theme of war and victory. On its top was, typically by now, a *quadriga*, and it was driven by Nero himself, flanked by personifications of Peace and Victory. (The representation is all the more absurd given the existence of an account by the historian Suetonius of Nero actually attempting to drive a chariot during games in Greece but falling out.) The arch was dismantled after Nero's suicide and disgrace, but coins issued between 64 and 67 show it clearly, and some four hundred of these have survived. In the sixteenth century it was claimed by some Venetian scholars who had seen the coins that the horses from this *quadriga*, possibly transported to Constantinople from Rome by Constantine, were the ones then adorning St Mark's.

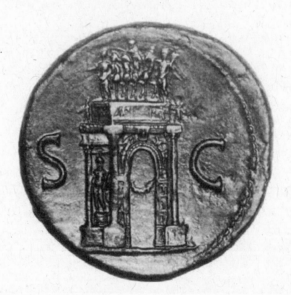

This arch erected by Nero in Rome in the early 60s AD, and shown here on a *sestertius*, was believed by sixteenth-century scholars to show the original setting of the horses of St Mark's. The placing of the horses' front legs does not correspond with that of the horses in Venice and there is no significant evidence to sustain any link. (British Museum)

4

CREATING *QUADRIGAE*

WITHIN A CENTURY OR SO OF THE EARLIEST RECORDED chariot race in Greek games, that of 680 BC at Olympia, chariot races were also being included in the other games which had been established in the Greek world. The most prestigious were those held on the Isthmus near Corinth, at Nemea in the Peloponnese and at Delphi (the Pythian Games). As we have seen, victory brought enormous kudos to the victor, who would often commemorate his success in some permanent form by dedicating a statue of himself or his chariot, usually in bronze, either at the site of the games themselves or in his home city. According to the Greek traveller Pausanias, writing in the second century AD, the earliest monument to horses bred in Greece was that erected by Cleosthenes of Epidamnus at Olympia in 512 BC. It represented Cleosthenes standing alongside his charioteer and his horses, whose names – Phoenix and Corax, Caecias and Samus – were inscribed on them. Virtually nothing remains of these commemorative works. It is one of the great tragedies of European history that virtually all the bronzes from antiquity have been lost, most of them melted down by sackers of sanctuaries, whether Christian iconoclasts who saw them as pagan idols or looters anxious to recycle the metal. (When he first saw the horses on St Mark's, Goethe exclaimed: 'What a

magnificent set of horses. Praise God that Christian zeal did not melt them down to make candelabra and crucifixes.') Those that have survived usually come from ancient shipwrecks, many of them off the coast of Italy, the ships presumably having foundered when on their way from Greece to Rome with cargoes to adorn the villa of a Roman emperor or connoisseur. Nero is known to have carted off five hundred statues from Delphi alone in anger when the oracle was unwise enough to condemn him for the murder of his mother. There was, however, one statue he missed in Delphi: a bronze charioteer which had been buried in a ditch in an earlier earthquake and never recovered in ancient times. It was eventually found by French excavators in the nineteenth century; but by then the chariot and its horses had long disappeared. They had probably been dug out after the earthquake and may even have been among Nero's loot.

The Delphi charioteer was dedicated by a ruler from Syracuse, one of the Greek cities of Sicily, in about 470 BC. It is a superb piece of work. The charioteer stands in his long *chiton*, his reins in his hand and gazing forward, so serene in his moment of triumph that one can hardly imagine him caught up in the turmoil of the race he has just won. The serenity suggests that victory had brought him close to the gods, and the original placing of the *quadriga* within the sanctuary of Apollo at Delphi reinforces the point. A cluster of reins, also in bronze, has survived with him. The body is slightly elongated, suggesting that it was to be placed high on a monument and viewed from below. The quality of the work can be seen in the feet, which have been cast with precision even though they would not have been seen by onlookers when the charioteer was in his chariot.

The casting of life-size figures in bronze was a comparatively new development in ancient Greece, but it was a technique which had been perfected remarkably quickly. Bronze, a mixture of copper and tin, had, of course, been known for centuries and it was the metal normally used for armour, which could be hammered into shape by skilled metalworkers to fit a particular body. At many Greek shrines, including Delphi, a mass of smaller solid bronze

This superb bronze charioteer from a victory monument in Delphi dates from the fifth century BC. His serene gaze suggests that his victory has placed him close to the gods. (Scala)

figurines, offerings to the gods, have survived. The problem with solid bronze figures is that the larger the figure the more likely it is that the bronze will crack when it cools. Life-size statues were also very heavy to move. It was important for the Greeks to learn how to cast hollow bronzes.

The breakthrough came on the island of Samos in the Aegean. Samos was an important trading centre, with links to Egypt and the Near East. In the seventh century BC Samian traders began to

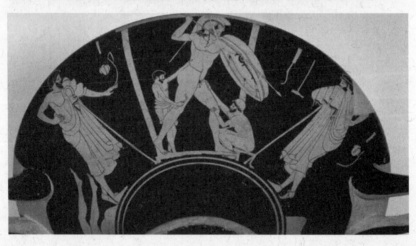

import hollow cast bronzes from Egypt – and with them the technique used to make them, the lost-wax process. By the sixth century life-size figures were being cast. This is how the process worked. First the craftsman had to create a model of the planned figure (or each part of a larger figure) out of clay or sand or a sand-and-plaster mix. The model was then covered in a layer of wax sculpted in the shape of the intended work. Another clay covering was moulded over the wax and this was attached to the inner model by pins pushed through the wax into the core, so that the gap between core and outer covering would stay constant when the wax was melted out. A funnel was left in the outer mould along with vents for gases to escape. Then the wax was melted out and molten bronze poured in. Once the metal had cooled and solidified, the outer mould could be broken off and the inner figure either pulled out or broken up, leaving a hollow bronze. Typically, the thickness of these Greek bronzes was about 5 millimetres, although there are surviving examples as thin as 2 millimetres and as thick as 25 millimetres. What this meant was that large statues that were also relatively light could be made in one place and easily transported to another. Also, if it was possible to preserve the inner model, one could reuse it to create duplicate statues. Large statues would be made up of individual parts which were fitted together and the joins burnished over to make them invisible.

The lost-wax method of casting proved so successful that it has survived until modern times. In the Renaissance it was valued for this very reason, as a direct link back to classical antiquity, and it is from the sixteenth century that the most famous description of the process comes, in the autobiography of the Florentine sculptor and goldsmith, Benvenuto Cellini. Cellini, a brilliant but tempestuous craftsman, wanted to show that he was the equal as a sculptor

Opposite: This red figure Greek drinking cup (fifth century BC) provides a superb illustration of bronze casting, especially the process of finishing off a cast statue. (Staatliche Museum/Bildarchiv Preubischer Kulturbesitz)

of his great predecessors in Florence, Michelangelo and Donatello. Cosimo de' Medici, the ruler of the city between 1537 and 1574, gave him his chance in 1545 by commissioning a life-size bronze of Perseus. This son of Zeus and Danaë, whom the god impregnated with a shower of gold dust, is remembered in mythology as the slayer of the Gorgon, Medusa, whose severed head he then turned against his enemies to transform them into stone. He was a fitting hero for Cosimo, who faced intense opposition from enemies both inside and outside Florence in the first two decades of his rule, and the finished bronze, with the head of Medusa flaunted at the onlooker, was to be on public show in the Piazza della Signoria in Florence as a symbol of his determination to survive. It was eventually unveiled in 1554 and still stands there today.

Technically the Perseus posed a daunting challenge, in that Cellini wished to cast in a single piece a large standing figure holding the head of Medusa at arm's length. It was to be placed on the dismembered remains of Medusa, a figure Cellini modelled on the body of his mistress, Dorotea, and which was to be cast separately. The statue itself was to be 320 centimetres high – still a dwarf compared to Michelangelo's great marble David, which was already installed in the Piazza, but for a single piece of cast bronze, enormous.

We know that Cellini visited his fellow Florentine Jacopo Sansovino in Venice, where the latter was city architect in these years, and it is inconceivable that he did not inspect the St Mark's horses while he was there. (Sansovino cast a bronze door for the sacristy of St Mark's in the 1540s.) Cellini had spent several years in Rome and would also have come to know the equestrian statue of Marcus Aurelius which one of his patrons, Pope Paul III, had moved to the Capitoline Hill in 1538. He certainly had great models from the past to inspire him.

In his *Life* Cellini describes how he set about his task. First he created a framework of iron rods which was then covered with clay to make the core of the body; over this the wax was sculpted so as

to highlight the finest details. The wax was carefully covered with a layer of clay about an inch thick, which was then bound in by a thicker mantle of clay strengthened by rings and wire. Every step of the process needed skill, not only in sculpting but in the placing of the channels through which the molten bronze would be poured into the cavity and the air vents through which gases would escape as the bronze cooled. An intuitive understanding of the cooling process was vital so that each part of the mould would be filled before the bronze had solidified, otherwise there would be gaping holes in the finished figure.

At last the melting of the wax could begin. It was done slowly over two days in a furnace fired by seasoned pine; one of the side-effects of this slow firing was to carbonise the clay core, which became porous and provided another means by which gases could escape. This was very important, for any bubbles left in the bronze would disfigure it.

By December 1549 Cellini was ready for the final stage, the pouring of the molten bronze into the mould. First a pit had to be dug under the brick furnace and the clay figure placed upright inside it. Here it was settled in place with earth around it, the vents preserved by running terracotta pipes from them into the open air. The mould had to be under the furnace so that the metal could run into it when it was at its most liquid – and in any case, it would have been too hazardous to carry the molten metal any distance. Then quantities of copper and already smelted bronze were gathered to be placed in the furnace, broken up into smaller pieces so that they would melt down more easily.

By now the tensions of the enterprise were taking their toll on the sculptor. Cosimo was proving a difficult and fussy patron, any request for more help was delayed by his court bureaucrats and, to make matters worse, Cellini's brother-in-law died and he found himself suddenly responsible for his sister and her six children. All this when his reputation and self-esteem depended so heavily on success in this one great project. Racked with tension, as the heating of the metal began he was struck down by a severe fever and

even believed himself to be dying. It is probable that Cellini dramatizes what happened next, but it is a good story. One of his workmen rushed into the room where he lay sweating, to tell him in despair that the work was ruined. As Cellini struggled to the furnace, cursing and kicking his workmen, he found that the fire was simply not hot enough: the bronze lay in a congealed mass which would never have flowed into the recesses of the mould. (There is a kind of chestnut cake, *castagnaccio*, still made in Italy, which remains sticky after baking, and Cellini compared his bronze to this.) He desperately called for oak to be thrown on the fire to raise the temperature, and it worked – but the furnace now became so hot that its top exploded and bronze began to trickle out. Even now it was not liquid enough, and in his frenzied and fevered state Cellini began wondering whether someone had interfered with the alloy. (He may have been right. The more tin is added to the copper, the lower the melting point – it takes 13 per cent tin to lower the melting point by 100 degrees Celsius, and 10 per cent is a usual mix. Recent tests on the Perseus have shown that Cellini's original mix contained only 3 per cent tin.) The only solution was to add more tin. There was no time to lose, and in desperation Cellini called for all his household pewter, 200 pounds of it, in platters and bowls, to be thrown on the furnace. At last the metal began to flow easily and he was able to guide it into the mould, which gradually filled to the brim. Then there were two anxious days of waiting while the metal cooled before the statue could be exposed; but Cellini's judgement had been exact. The bronze had not only filled the cavities of Perseus' and Medusa's heads perfectly, it had flowed so successfully downwards that only at the very bottom of the statue, at the toes of the right foot, had the bronze not filled the mould. These missing details could be crafted on separately.

It might be thought that with this triumph Cellini's work was virtually complete. Yet it took him a further three or four years of labour on the bronze to perfect it for display. Each hole left by the pins which held the mould together had to be filled in and burnished over; minor blemishes left by gases had to be erased and

some details of the statue slightly recast. Wings were added to Perseus' head and a realistic 'flow of blood' from Medusa's. An iron sword was fixed to Perseus' hand. Then the whole was given a protective patina, made up of a mixture of alkaline sulphides, which darkened it, in this case so successfully that the statue has never been penetrated by rain or damaged by corrosion, even though it has stood for four and a half centuries in the open air.

Cellini says virtually nothing about these years of painstaking work, and it is only a recent restoration of the statue which has

Cellini's famous statue of Perseus, which still stands in Florence. Its casting, as recounted by Cellini, provides one of the most vivid accounts of the dramas and difficulties involved in the process. (Loggia dei Lanzi, Firenze/Scala)

revealed what was involved. The Perseus is quite exceptional in its size and detail; even so, the whole episode shows just how skilled the casters of such statues had to be. A whole range of skills and processes had to be mastered and performed, often in quick succession, without mishap. It was as important to understand, albeit perhaps intuitively, the science of metallurgy as it was to be able to conceive and sculpt such a masterpiece.

There is a variation of the lost-wax method that Cellini also describes in his writings, used when a bronze original was to be copied or when a particularly large bronze was to be cast. This is known as the indirect method. An original figure, say an existing bronze of a man on horseback, was taken and a series of rows of soft plaster blocks piled up around it, each one moulded around the part of the original figure that it touched. When the blocks were dismantled, each one bore a concave impression of part of the horse and rider. The inside of each plaster block was coated in wax which was then prised off the plaster when cold. The wax sections were then assembled carefully from the bottom up around a core made of clay or plaster which resembled the shape of the existing sculpture. Eventually one would have a complete wax model assembled around a core; and if the shape of the wax had been kept undistorted, this model would correspond to the original figure. Next the wax would be coated with a clay mixture (in an eighteenth-century example of a large equestrian statue of Louis XIV, this is recorded as earth mixed with dung and broken white pottery). As in the original method, this outer mould would have to be fixed to the inner core with pins or nails which ran through the wax. A wall would be built around the construction and the gap between the outer mould and the wall filled in with broken earthenware. The whole would be heated for a period – in the eighteenth-century example, fifteen days – during which the outer mould would harden and the wax flow out. This left an outer mould, the inner wall of which bore an exact concave copy of the original statue, and a core, pinned together so that the gap between the two was maintained. The worry was that when molten metal was poured into the cavities left by the wax the

outer mould would crack and everything would be lost; so the mould would first be buried below ground level in a mixture of earth and stones. Now secure, the mould could receive the bronze poured in from above. Finally, the outer mould would be broken and the plaster core chiselled out, and one would have a bronze figure which was a close copy of the original.

It is usually possible to tell when this variant of the method has been used because the process leaves its mark on the bronze. When the wax is poured into the plaster it is then smoothed into every cavity with strips of wood. These leave their mark on the wax, which also varies in thickness. These variations are often reproduced on the plaster core and then reappear on the inside of the completed bronze. The indirect method was in use in Greece as early as the fifth century BC – the Riace warriors of *c.*460 BC, two male nudes possibly originally from an Athenian victory monument at Delphi, were cast in this way. So, too, were the horses of St Mark's – a discovery which raises the possibility that they are direct copies of earlier statues; but, as we shall see in later chapters, there are far more remarkable features of their casting than this alone.

Metal sculptures pose a particular problem for archaeologists in that metal is not in itself datable. The dates at which particular processes are known to have begun or to have fallen into disuse provide only broad guidelines. We know that the Greeks of Samos learned of the lost-wax process in the seventh century BC, though there is no large Greek bronze statue which survives from before the late sixth century (an Apollo, dated to 525, which was buried for safety in the Piraeus, the harbour of Athens, before the Persian sack of the city in 480 BC); thereafter the method continued to be used for centuries, both in ancient Greece and then under the Romans after their conquest of the eastern Mediterranean. Both Greeks and Romans cast *quadrigae*, albeit for different contexts – the Greeks as commemorative monuments to victors in the games, the Romans as symbols of imperial triumph. The impossibility of any direct dating of the metal in which they were cast has meant that the St Mark's horses have been attributed to some of the great sculptors

of the ancient world — Phidias of the Parthenon, working in the late fifth century BC, and Lysippus, the favourite of Alexander, working in the late fourth century — as well as to specific emperors such as Nero (first century AD) and Constantine (fourth century AD). Altogether, as a result of the lack of other evidence, the horses have, as we noted earlier, been provided with dates for their casting which have spanned nine hundred years.

For the moment we must leave the mystery of the horses' origin unresolved as we turn to their first known setting, in or near the hippodrome of Constantinople.

These plates, from a study of bronze casting published in France in 1743, show where the conduits for the casting of a large equestrian statue were placed (here for a statue of Louis XIV) and the process by which the wax model was bound and then heated from below to allow the wax to run out so that the bronze could be poured in to replace it. The horses of St Mark's must have been cast by a similar process. (*Above:* Procuratoria di San Marco: Archivio Fotografico. *Opposite:* The Art Archive)

5

WATCHERS IN THE HIPPODROME

THE BYZANTINE EMPIRE HAS NOT ALWAYS HAD A GOOD press. 'The universal verdict of history is that it constitutes, with scarcely an exception, the most thoroughly base and despicable form that civilization has yet assumed.' So wrote the Irish historian William Lecky in 1869, echoing the English historian Edward Gibbon's thoughts of a hundred years earlier. The image of a corrupt and stagnant society prevailed into the twentieth century. Lecky's compatriot W. B. Yeats' poem, 'Sailing to Byzantium' (1927), is an evocative account of a lethargic imperial court set against a backdrop of 'hammered gold and gold enamelling' – and even now the term 'Byzantine' conjures up an atmosphere of tortuous political plottings in gloomy palace passageways.

Today's historians, however, have a great deal more respect for the empire. If we date its beginning from Constantine's foundation of Constantinople in AD 330, it survived for over eleven hundred years until the fall of the capital to the Ottoman Turks in 1453. For much of its history it had to keep itself intact as a multicultural society while defending itself against a mass of different enemies. Its boundaries shifted so often, as territory was lost or gained, that it was in a continual process of administrative reorganization. It is hardly surprising that the sources are dominated by intricate

accounts of warfare and court intrigue – the remarkable fact is that it survived despite them.

Byzantium was a theocratic empire. From the 380s the emperor Theodosius I enforced Christianity as the state religion through a series of decrees. As the empire consolidated itself, the emperors elevated themselves to a position closer and closer to God, and their imperial authority became intertwined with their status as God's chosen representative. Constantine had envisaged himself the 'equal of the apostles', and his successors expected actively to convert their subjects. Justinian (AD 527–65) did this by ordering all citizens to come forward for baptism with their wives, children and households on pain of being stripped of their possessions. Although we know that many non-Christians, Jews and pagans, maintained their beliefs – no state in this period would have been able to assert a uniform authority effectively over so much territory and so many disparate cultures – any form of significant public participation in society was reserved for Christians.

As the 'divine' emperors became ever further removed from their subjects, the only contact they retained with the people was in the hippodrome. It was comparatively easy for an emperor to assemble an audience, for himself or for the games, and to step into the imperial box, to which he had direct access from the palace, to be seen by the masses. However, large crowds and remote emperors did not always mix well. Whether our horses were originally in the hippodrome, above it on the starting gates or close by at the Milion, they certainly watched over a bewildering variety of events in the coming centuries, some of which, as we shall see, left blood pouring through the ransacked streets of the capital.

Perhaps the most important ceremony that took place in the hippodrome was the presentation of a new emperor to his people so that they could acclaim him in his role as the chosen of God. In the third and fourth centuries, when the empire was under almost constant attack, most emperors emerged from within the army, and their initial acclamation had been by their own troops. Constantine, for instance, had been acclaimed as 'Augustus' by his

father's troops in York when his father had died there in 306. The ceremony of acclamation involved placing the new emperor on a shield and lifting him above his men. By the fifth and sixth centuries the Byzantine emperors tended to emerge from within the court, often from within the imperial family, and they employed generals to do their fighting for them; but the ceremony of acclamation was preserved, and it was in the hippodrome in Constantinople that it was enacted. When the emperor Justin II was proclaimed there in 565 he was lifted on to a shield by soldiers before the assembled crowds. 'The crowds sang "May you conquer, Justin."' Then:

> the huge uproar grows, and mourning departs from the palace as new joy comes. The sound arouses everyone. All the elements support Justin, everything rejoices with him. Called forth by the clamour, all the Senators approach. Light fills the sacred palace ... God Himself gave clear signs and confirmed the election, to place on Justin's head the glorious crown of empire.

In short, the emperor is God's representative on earth and obedience is expected from the people for that reason alone. The hippodrome is the place where he displays his power. When Justinian's general Belisarius arrived back from a successful campaign in north Africa it was in the hippodrome that he held his triumph – but the event was carefully staged so that Belisarius remained on foot and offered his captives and booty to the emperor, who had to be acknowledged as the true victor.

Throughout these years the hippodrome continued to be used for sport as well as ceremony; but all too often the intense rivalry between what were now the two main chariot-racing teams, the Blues and the Greens, led to serious riots. The hippodrome had become the only venue in Constantinople where large crowds could gather, and when there was social or political tension in the city the atmosphere became very unsettled. It was common for scuffles to break out at the end of each games as the supporters

of the two teams taunted each other, and if the authorities mishandled things these could quickly degenerate into mass violence.

The most horrific such event, the Nika riots, took place in 532 in the reign of Justinian. After a minor fracas two supporters, one Green and one Blue, were to have been executed. The hanging was bungled and both men dropped to the ground unharmed. In the excitement of the moment word spread of a miracle; the men were rescued by the mob and hurried off to the safe asylum of a church. Justinian was still determined to carry out the executions, but at the next race meeting the crowd yelled for the men to be pardoned. The shouting went on through the afternoon, up to the twenty-second of the twenty-four races. Then, suddenly, something unheard-of happened. Blues and Greens swallowed their differences and started shouting together: 'Long life to the merciful Blues and Greens!' Centuries of rivalry had dissolved in a moment and the crowds took to the streets, burning and looting with cries of 'Nika!', victory. They released all the prisoners they could find and then began demanding the resignation of the emperor's chief ministers. Justinian, panicking, gave in to the demands, but this was now seen as a sign of weakness. The crowd sought out one Hypatius, the nephew of a former emperor, Anastasius, and dragged him off to be crowned in the hippodrome as the new emperor.

Everything seemed lost – until a remarkable intervention by Justinian's empress. Theodora, who had made her way into the imperial bed after a notorious career as a sexually voracious circus artiste, refused to surrender her gains, announcing: 'May I never be separated from this purple, and may I not live that day on which those who meet me shall not address me as mistress.' As for her husband, she proclaimed that once one has been an emperor one could never endure being a fugitive: 'The royal purple was as good a burial shroud as any.' Confronted by this extraordinary outburst the beleaguered courtiers took courage, and Belisarius himself was sent into the hippodrome to confront the rioters. The historian Procopius relates that some thirty thousand of them were killed in

the vicious suppression that followed. The horses had watched over a massacre.

The Nika riots had been made worse by Justinian's capitulation to the rioters' demands. It is likely that the proclamation of Hypatius in the hippodrome was engineered by senators determined to find some way of restoring order through an imperial figurehead when it appeared that Justinian had in effect abdicated. Either way an imperial state would have survived. Even so, it had been a frightening moment and showed just how active the emperors had to be if they were to control the crowds. Justinian and his successors learned their lesson (Justinian himself ruled for over thirty more years), and in the years to come there is an interesting shift in the use of the hippodrome. We find both the number of games and the number of races held in each session being gradually reduced, with stage-managed imperial ceremonies filling the gaps.

There is a fascinating record from the eighth century which shows how a confident emperor could now 'use' a crowd. It describes a ceremony conducted in the hippodrome by the emperor Constantine V (r. 741–75) in 763. This Constantine was a fervent iconoclast, determined that representations of divine figures be expunged from the churches. One of his opponents was an influential monk, Stephen, abbot of a monastery near Nicomedia. A courtier of Constantine's, George Syncletus, had gone, either of his own accord or on the emperor's orders (the sources disagree), to Stephen's monastery and there been admitted as a monk. Constantine appeared in the hippodrome and announced to the crowd that he would 'have nothing to do with that band hated by God [the iconophiles]'. The crowd in the hippodrome chanted, from what seems to have been a planted text, that none [of 'that band'] remained in the city. The emperor then went on to outline his complaints, culminating in the charge that his opponents had snatched his favourite courtier, George. Two days later the citizens were called back to the hippodrome. Constantine announced that God had heard his prayer and that he was now victorious. (The crowd: 'When does God not hear you?') God, Constantine went on,

had revealed George to him. 'Punish him!' shouted the crowd. Again it must have been a planted response, as George was immediately produced, still in the habit of a monk. This was stripped from him; then he was given a new baptism, as if to wipe away his admission as a monk, and was dressed as a soldier. No further harm was done to him. Two years later, when Stephen himself came to Constantinople he found himself set upon by a mob and lynched. The emperor appears to have manipulated the crowds in his favour and in such a way as to transfer the responsibility for dealing with his enemies to the people.

The process of replacing races with rituals continued. A Book of Ceremonies dating from the tenth century tells us that by then the imperial rituals took so long that there was time for only eight races in a day instead of the usual twenty-four. By the twelfth century chariot races were usually held only when the emperor had a victory to celebrate, in other words at a time when he could be sure that his authority would not be challenged. So we can see that the horses presided over an arena which was gradually transformed over the centuries from a cockpit of potential unrest into an ordered ceremonial stage.

The fortunes of Constantinople declined dramatically. In the early years of Justinian's reign there may have been half a million inhabitants, but by 750 this seems to have dwindled to forty thousand. As the prosperity of the classical world had faded and the ancient trade routes of the Mediterranean atrophied, the resources needed to sustain such a large city were no longer available. Disease played its part, too: plague became a permanent feature of urban life, a single visitation often wiping out a third of a city's population. Justinian himself almost died in its first appearance of 542. Gradually whole sections of Constantinople were abandoned, and after 600 there is virtually no record of any public building beyond the renewal of essential defences. Matters were not helped by an intense distrust of profit on the part of the most influential elites. Even as Mediterranean trade revived after 1000, it was the clergy rather than the merchants who extended their hold over

Constantinople, and their priority was not the expansion of commerce but the rebuilding of ancient churches and the spread of private monasteries into deserted parts of the capital. Constantinople was increasingly a city whose opulence lay in the relics and treasures of its churches, the most dazzling of which was Santa Sophia, rebuilt by Justinian after the Nika riots and still intact today.

By the tenth century it was the enterprising merchant cities of Italy – Amalfi, Pisa, Genoa and Venice – that were seizing the initiative in the eastern Mediterranean. They managed to get toeholds in Constantinople itself, where they were eventually given walled enclaves from which they could conduct their business. The city's relationship with one of these communities, the Venetians, was particularly important because Venice was technically part of the empire; and yet it was from Venice that the first successful attack on Constantinople since its foundation was to take place, in 1204.

Up to now the horses had been watchers of events; now they were to find a starring role.

6

THE FOURTH CRUSADE AND
THE SACK OF CONSTANTINOPLE

This race did not seek refuge in these islands for fun, nor were those who joined later moved by chance; necessity taught them to find safety in the most unfavourable location. Later, however, this turned out to their greatest advantage and made them wise at a time when the whole northern world still lay in darkness; their increasing population and wealth were a logical consequence. Houses were crowded closer and closer together, sand and swamp transformed into solid pavement . . . The place of street and square and promenade was taken by water. In consequence, the Venetian was bound to develop into a new kind of creature, and that is why, too, Venice can only be compared to itself.

J. W. GOETHE, *Italian Journey* (1786–8)

THE CITIZENS OF VENICE HAVE ALWAYS BEEN INDEPENDENT in spirit, their self-reliance and industry encouraged by the birth of the city as a refuge for mainlanders. The first permanent inhabitants of the scatter of islands were probably driven there by the Lombard invasions of northern Italy in the sixth century, although the Venetians themselves preferred more romantic stories of origin. Stung by taunts that theirs was not a classical foundation, they put about a tale that the Rialto — the *rivo alto* or 'the high

bank', later the commercial centre of the city – had been settled by
refugees from the fall of Troy (traditionally dated, if it took place
at all, to about 1250 BC), thus giving the city a heritage even older
than that of Rome! Another legend told of the early Venetians
fleeing Gothic invaders and setting up their city on 25 March AD
421, precisely at midday – 25 March was the feast day of the
Annunciation, and so this legend explains the role of the Virgin
Mary as a special protectress of the city. Those who wished to
highlight the Christian origins of Venice developed a story
concerning the ancient Christian city of Aquileia, on the Adriatic
coast east of Venice, where, by tradition, the evangelist Mark had
preached. It was said that when the city had been sacked by the
pagan Attila the Hun in 452, Christianity had been preserved by
certain of its pious inhabitants who had taken their faith with them
to the Venetian lagoon. A medieval legend strengthened the link
between the city and Mark by telling how the evangelist had spent
a night on an island in the lagoon and had been told in a dream that
his body would finally rest there. All these stories jostled in the
Venetian consciousness, one myth gaining prominence when the city
wished to highlight its antiquity, another when it wanted to show
off its Christian credentials. The Venetians had a flair – shared,
perhaps, with Constantine – for manipulating the symbols of the
past to their advantage.

Venice had in fact been from its earliest years part of the
Byzantine empire. Constantine had successfully preserved the
Roman empire as a vast single political unit in the early fourth
century, but thereafter it began to crumble under the weight of
barbarian invaders. In the fifth century the western empire finally
disintegrated – but parts of Italy and north Africa were reconquered
in the sixth century by Justinian. Among the territories newly
subject to him was north-eastern Italy, the Veneto, its people loosely
controlled by the exarch of Ravenna further south on the Italian
coast. In the eighth century, the inhabitants of the growing
settlement of Venice acquired their own resident official, who was
given the customary name of a local governor: *dux*. This is how the

office of doge, the name given to the chief magistrate of Venice, originated, although contrary to what the Venetians themselves liked to believe, the first doges were not Venetians but Byzantine officials.

In the ninth century, a time of turmoil in Italy, the Byzantine empire negotiated a semi-independent role for Venice: it remained part of the empire, but paid tribute to the neighbouring Frankish kingdom of Italy in return for a guarantee of its 'borders' and freedom to trade. One of the turning points in the city's history was the seizing of the supposed body of St Mark the Evangelist from Alexandria by Venetian sailors in 828. (They concealed the body in a drum of pork to deter inspection by Muslims.) The first patron saint of the city had been the Byzantine Theodore; now he was discarded in favour of Mark, whom, as we have seen, legend linked to nearby Aquileia.

It was the freedom to trade that underlay the survival and growing prosperity of the city. Although the Adriatic coast itself can be treacherous, Venice itself was well protected and proved an ideal staging post between the eastern Mediterranean and northern Europe. Its merchants could exploit trade routes across the Alps which had been in use for centuries. The special status of Venice within the Byzantine empire was recognized by a treaty of 992 in which Venetian ships were given privileges at Constantinople in return for Venice's promise that it would remain a loyal servant of the empire. It had few obligations in return, and in any case was much too distant from Constantinople for any effective control to be exercised by an empire which was itself constantly under threat from hostile neighbours closer to home.

By the time of this agreement the tentacles of Venetian trade stretched through the eastern Mediterranean and even into the Islamic world, which had devoured much of the Byzantine empire in the seventh and eighth centuries. Motifs from Arabic architecture can be found in Venice alongside Greek influences from Byzantium — all woven into styles and themes which were distinctively Venetian. So begins the almost fairy-tale magic of Venetian architecture, the

spell enhanced by the contrast of light and shade and glitter of the water. 'While the burghers and barons of the north were building their dark streets and grisly castles of oak and sandstone,' wrote John Ruskin in his *Stones of Venice* (1851–3), 'the merchants of Venice were covering their palaces with porphyry and gold.'

The first inhabitants of Venice had shifted the nucleus of their city from island to island as conditions dictated. (The isolated and atmospheric 'cathedral' on the island of Torcello, an island from which the Venetians were driven by malaria, remains as a reminder of their changing fortunes.) Eventually a piece of firm land in the central lagoon, well placed on the edge of a deep basin, the Bacino, was selected as a foundation for the first doge's palace, which in these early, unsettled days was built as a fortress. Behind it was a small church, in effect the doge's private chapel, which had originally been dedicated to Theodore. It was here that the relics of St Mark were laid to rest in the ninth century; the church was rededicated in his name, and the area became the ceremonial centre of the city. In the eleventh century St Mark's itself was rebuilt in its present form, in the shape of a Greek Orthodox church – almost certainly modelled on the Church of the Holy Apostles in Constantinople, the burial place of Constantine, with its five mosaic-adorned domes. Around it and what had by now become the palace rather than the fortress of the doges, new public areas were set out. As entry to the city was from the Bacino, a proper landing ground with a pavement, the Molo, was built along the seafront. This new space, the Piazzetta, was soon dominated, as it still is, by two huge granite columns from Alexandria, set up there in the twelfth century, on top of which were later placed statues of St Theodore with his crocodile and a winged lion, the emblem of St Mark. The visitor would look down between them to the corner of St Mark's, where an official entrance through the narthex led into the church.

The Piazzetta was always a political space. The Grand Council of Venice would meet in the Doge's Palace and spill out into the open air for less formal discussion; foreign dignataries would be greeted on the quayside. However, again in the twelfth century,

another great open space was being laid out to the west of St Mark's. Impediments such as the chapel of San Gemignano and an orchard belonging to a nunnery were cleared away – though the chapel was rebuilt further to the west after the pope protested at its wanton destruction – and a rectangle some two hundred metres long was marked out. This was to become the Piazza San Marco – St Mark's Square.

A direct source of inspiration for this new feature may have been the courtyards of the mosques of the Islamic world; certainly that of Damascus was well known to Venetian traders and very similar in size to St Mark's. Another may have been the imperial forums of Constantinople, twelve of which still stood in the twelfth century. The Venetian traders knew Constantinople well – as we have seen, they had their own resident community there – and from the tenth century it was the custom for the doges' sons to be educated in the imperial capital. A hinge between Piazza and Piazzetta was formed by the Campanile, the famous bell tower, originally set up in the ninth century, and visible far out to sea. The bells would ring daily to mark the start and end of the craftsmen's day and the offices of the church, as well as less regularly to summon the nobles to vote in council and to announce public executions.

Whatever the contemporary inspiration for the ceremonial areas of Venice, the Venetians adopted many of the features of the forums of the ancient world. Venice's rivals on the mainland, such as Padua and Verona, could boast their descent from Roman cities; Venice could not, but it could create an artificial heritage by constructing a dignified square and embellishing it with imported antiquities. These were not difficult to find, as many of the great classical cities of the east had fallen into ruin as a result of earthquakes, Arab invasions and abandonment. As early as the ninth century ancient columns were being brought back to Venice, and in the eleventh century an order went out to look for marble for the rebuilding of St Mark's. One fourteenth-century decree ordered a captain to search out medium-sized columns and shafts of any variety of

marble so long as these were 'beautiful' and could be brought back as ballast without overloading his galley. Of the six hundred marble columns in St Mark's today, half are from outside Venice and all but fifteen of these from outside Italy. The effect, in the entrance to the west door, of the patterns of so many varied marbles is stunning; as the sun moved across them, enthused John Ruskin in the nineteenth century, it was as if the colours of the artists Rembrandt and Veronese had been united.

The other centre of medieval Venice was the Rialto, mentioned for the first time as a commercial centre in 1097. As in many other European cities of the time – London, with its distinct City and Westminster areas, is a good example – the ceremonial part of the city was kept well separate from its commercial area, and it was only gradually that the space between them was filled in and built on. The Grand Canal was preserved as the city's main artery, echoing the rivers that ran through most European cities: the Seine through Paris, the Thames through London. It was, like them, crossed originally by only one bridge, at the Rialto, where the canal bordered the commercial area on its western bank. Lesser canals were the main means of transport in the city and Venice never needed to develop wide streets. Tourists still struggle today in their masses along the narrow Merceria, the medieval thoroughfare between St Mark's and the Rialto which was first paved in 1272.

Any Christian inhibitions Venetians might have shared with their Byzantine overlords about indulging in trade were soon dissolved. In the twelfth century the standard rate on a loan in Venice was 20 per cent, which was justified as 'an old Venetian custom'. Even when the church tightened up the laws on usury, the Venetians developed forms of contract which ensured that borrowing money cost the borrower money – and just to make sure that there was no divine disapproval, God himself was accorded the responsibility for the city's success.

Since by the Grace of God our city has grown and increased by the labours of merchants creating traffic and profits for us in

diverse parts of the world by land and sea and this is our life and that of our sons, because we cannot live otherwise and know how to survive except by trade, therefore we must be vigilant in all our thoughts and endeavours, as our predecessors were, to make provision in every way lest so much wealth and treasure should disappear.

Thus a fourteenth-century decree from the Senate. However magnificent the ceremonial centres of the city, it was never forgotten that it was the commercial areas at the Rialto, 'that sacred precinct' as one document of 1497 put it, which sustained their grandeur. Those who wanted scriptural support for Venice's success could turn to chapter 28 of the prophet Ezekiel, where God talks of 'that city standing at the edge of the sea, doing business with the nations in innumerable islands . . . your frontiers stretched out far to sea, those who built you made you perfect in beauty . . . Then you were rich and glorious surrounded by the seas.' The fact that these apparently celebratory words come in the middle of a lamentation on the fall of Tyre, which had indeed been a great trading city like Venice, was no doubt passed over.

By the twelfth century, then, Venice was a vibrant and expanding city-state, although still technically subordinate to Constantinople. The relationship between the old empire and the increasingly self-confident city was bound to be uneasy, and in the late twelfth century it broke down completely. In 1167 a crushing victory by the emperor Manuel over the Hungarians allowed the Byzantines to expand down to the Dalmatian coast of the Adriatic. The Venetians, always obsessive about their control of the Adriatic, feared that this imperial advance might threaten their cherished freedom to trade without interference; so they began negotiations with the Hungarians to help them regain their lost territories. Doge Vitale Michiel then made the highly provocative move of placing a ban on trade with Constantinople. From this point things went quickly downhill. In retaliation for the ban, Manuel granted trading concessions to Venice's great trading rivals, the Italian cities of Pisa

and Genoa (It was now that the Genoans were given their own quarter of the imperial capital.) The outraged Venetian community in Constantinople rioted and then refused to pay for the damage. On 12 March 1171 Manuel ordered the arrest of all Venetians in Constantinople and the seizure of all Venetian shipping in the empire. The doge reacted by launching a Venetian fleet to do what damage it could do in the empire, and the cities along the Dalmatian coast were bullied back into Venetian control.

All this was self-defeating. Both cities stood to lose heavily from a breakdown in trade, and in the midst of all the tension and turmoil the Venetians sent envoys to Constantinople to negotiate. One of them was a worldly-wise and manipulative diplomat by the name of Enrico Dandolo. He was given no chance to use his skills, for by the time he arrived in Constantinople news had reached Manuel through his agents that the Venetian fleet was decimated by plague and paralysed; there was no need for the emperor to make any concessions. As Dandolo and his fellow envoys waited in the city, their mission in limbo, a strange incident took place. It appears that when Dandolo was out in the city one day he became involved in a fracas and his sight was damaged. (A story was later put about, perhaps by Dandolo himself, that the emperor himself had blinded him.) For the rest of his long life Dandolo was to manipulate his apparent sightlessness to his advantage; but whatever the truth of the episode, there is no doubting his real hatred of the Byzantines, and he harboured it for the rest of his life.

When Manuel heard that the Venetian fleet had struggled back home, he pursued his advantage with withering scorn.

Your nation has for a long time behaved with great stupidity. Once you were vagabonds sunk in abject poverty. Then you sidled into the Roman [i.e. Byzantine; the emperors always claimed, with some justification, to be direct successors of the Roman emperors] empire. You have treated it with the utmost disdain and have done your best to deliver it to its worst enemies [the Hungarians] as you yourselves are well aware. Now,

legitimately condemned and justly expelled from the empire, you
have in your insolence declared war on it – you who were once
a people not even worthy to be named, you who owe what
prestige you have to the Romans; and for having supposed that
you could match their strength you have made yourselves a
general laughing stock. For no one, not even the greatest powers
on earth, makes war on the Romans with impunity.

He could not have been more wrong. Dying in 1180, he did not
live to see the Venetian revenge; and indeed, at first there seemed no
chance that any would be exacted. Manuel's successors, shrewd and
realistic diplomats in the best of Byzantine traditions, realized the
importance of getting trading relationships back to normal, and in
1187 a new treaty was negotiated with Venice in which the city's
privileges were restored and the Venetians' rivals, the merchants of
Pisa and Genoa, excluded from imperial trade. Enrico Dandolo, who
could be trusted by the Venetians never to betray their interests,
travelled back to Constantinople as one of the envoys in the complex
and tricky negotiations which any treaty with the Byzantine empire
involved. His achievements were well appreciated by his city and in
1192, probably aged well over seventy and with little or no sight left,
he was elected doge. Few suspected that the ambition to humiliate
Constantinople still consumed the old man.

 This was the age of the crusades. The Second (which dragged on
from the 1140s to the 1180s) and Third (1189–92) had ended in
failure and in 1201 a new, comparatively young (aged thirty-seven
at his accession three years earlier) and untested pope, Innocent III,
called a fresh crusade. A band of European noblemen, most of them
from France and the Low Countries, gathered under the leadership
of one Baldwin of Flanders, and another contingent of barons and
supporting troops assembled in southern Italy. The overland route
to Jerusalem being considered too hazardous for a large army, the
decision was made to invade the Holy Land through Egypt. This
meant that a fleet had to be found to convey the crusaders to the
Egyptian coast – and here the Venetians found their role. They had

well-equipped shipyards and could meet the demand for transport. So Dandolo agreed to provide the ships, but the harsh contract he demanded made no concessions to the ostensibly spiritual motive for the enterprise. Yes, a fleet and a year's supplies would be provided; but it would cost 85,000 silver marks, payable in any circumstances. The crusaders agreed.

Then every organizer's nightmare occurred. The Venetians fulfilled their side of the bargain and the boats were ready by the agreed date of June 1202 – but the crusaders had been hopelessly optimistic and only a third of the hoped-for 33,000 knights turned up to fill the boats. There was no way they could honour the contract, even through raising loans on the Venetian exchange to pay in instalments. From June to November 1202 the knights waited in some embarrassment on the Venetian Lido, until Dandolo, who may well have realized all along that he could manipulate the contract to his own advantage, made a new proposal. Some of the sum could be remitted if the crusaders would stop off on the way to Egypt to recapture the city of Zara, on the Dalmatian coast, which had rebelled against the Venetians and placed itself under the protection of the Hungarians. It was a particularly cynical ploy in that the king of Hungary had been one of the few Christian monarchs to have given support to the crusade. In Rome, Innocent III was now becoming aware that he had entangled himself in political manoeuvres over which he had no control, and he announced in some desperation that he could support the crusade only if no Christians were attacked on the way to the Holy Land. But events overtook him when the Doge, with an instinct for the theatrically effective gesture, took centre stage. He knelt at the high altar of St Mark's, where a pilgrim's cross was fixed to his hat, and then, in the Piazza outside, he proclaimed that despite his age and disabilities, he was the only one able to lead the crusade effectively. He would provide fifty galleys of his own, and he called on Venetians to come with him. There was to be, however, no renegotiation of the original contract with the crusaders. The money, whether offered in cash or military service, was still to be paid.

The fleet set off in October, priests chanting from the mast tops as it left. 'Never before had such rejoicing or such an armada been heard or seen . . . verily did it seem that the whole sea was aswarm and ablaze,' wrote one of the crusaders. Progress down the Adriatic was at a stately pace, Dandolo stopping off at ports to display his great fleet to subject cities. Zara was eventually reached and reconquered after a five-day siege. It was now too late in the year to risk a crossing of the Mediterranean, and the crusaders spent the winter of 1202–3 in the city. By now many were becoming uneasy about the enterprise, especially when they learned to their horror that the Pope was threatening to excommunicate them all for their attack on fellow Christians in Zara. In the end, Innocent, who was learning fast about the realities of political life, confined his bull of excommunication to Dandolo and the Venetians alone – and even then the papal legate who was accompanying the fleet, knowing that if the verdict were delivered it would bring the collapse of the crusade, suppressed the bull when it arrived.

Then another diversion presented itself. The throne of the Byzantine empire was in dispute; one of the contenders was Alexius Angelus, the son of an earlier emperor, Isaac II, who had been deposed, blinded and imprisoned by his own brother, Alexius, now the emperor Alexius III, in 1194. Alexius Angelus naturally felt that his claim to the throne was strong and realized that the Venetians and the crusaders might be able to help him. He put forward his own proposal to them. If aid were given him to take the throne, he would support the crusade with 10,000 troops and 200,000 marks, well above what was needed to settle the Venetian contract. Perhaps the most attractive part of the offer, however, was his promise to reconcile the east to Rome, in effect to accept the supremacy of the pope over the Byzantine church.

Attractive as they were, Alexius' promises did not convince everyone. 'Wild promises of a witless youth' was the opinion of Niketas Choniates,* an official at the Byzantine court whose record

*The name 'Choniates' comes from his home town Chonai in Phrygia.

of these years is invaluable. It is probable that Enrico Dandolo, who knew Constantinople, its resources and its ways very well indeed, understood from the outset that all these promises were unlikely to be fulfilled, even if Alexius were enthroned. So did the pope. While the bishops in the fleet, eager to see a reunion of east and west, supported the new enterprise, Innocent condemned it. He recognized that the offer of reunion was likely to get nowhere – a young emperor could not simply slice through the tangle built up by centuries of suspicion and disagreement between east and west over Christian doctrine and sign his church over to Rome – and so he refused to rescind the excommunication of the Venetians. But it was all too late. The fleet, now with Alexius himself on board, had left Zara before the papal condemnation had arrived, and had since reached Corfu. Ominously, however, a demonstration here against Alexius was a forewarning that his elevation to emperor could not be taken for granted.

Now beyond papal control, the fleet sailed on, round Greece and up through the Aegean. In June 1203 it entered the Hellespont and soon the great walls of Constantinople, built some eight hundred years before by the emperor Theodosius II, were in view. Adorned with icons of the Virgin Mary, which were believed to protect the city in times of crisis, they had repelled all invaders in the past and the 'sitting' emperor', Alexius III, must have hoped they would do so again. He was unpopular with his people, he had little in the way of a fleet and his army was made up largely of mercenaries; but his hopes of survival were raised when Alexius Angelus was cere-monially paraded before the walls in Dandolo's grand barge. The pretender's rash promises must have gone before him as he was greeted with abuse from the walls and stones were rained down on him.

Dandolo now took the initiative in proclaiming that the throne would have to be fought for. This may have been what he was hoping for all along; certainly his was the first barge to land beneath the walls. While the crusaders stayed encamped further from the city, the Venetians stormed the walls and to everyone's surprise had

soon captured many of the towers. This dealt an immense psychological blow to the defenders, and resistance collapsed. Alexius III fled with his jewels and the people brought out Isaac from prison as his replacement. Blind and by now senile after nine years in prison, he had no chance of holding the throne – and so it was that his son, Alexius Angelus, despite being no more popular than his predecessor, became the emperor Alexius IV.

Now Enrico Dandolo tightened his grip. He insisted that all Alexius' promises be fulfilled. Alexius scoured the treasury and managed to settle the debt the crusaders owed to Dandolo; but this sum was still far below what had been promised, and the crusaders were left without even the provisions to go further. Alexius found himself in yet deeper trouble when his attempts to bring the Greek church under the authority of Rome were greeted with outrage. Serious rioting broke out between the Catholic Latins – the Venetians and other Italians living in Constantinople – and the Orthodox native Greeks. Alexius could not survive without the support of the crusaders – but they were insisting that he honour his promises before they helped him further. He ended up isolated, and in January 1204 he was in his turn deposed and then strangled. The Greeks proclaimed a new emperor, the son-in-law of Alexius II, who took office as Alexius V. This Alexius decided the only way out of the stand-off was to clear the Latins out once and for all. In the rising tension, many fled the city to the crusaders' camp.

The battle lines were now drawn. The crusaders had lost the man they had come to install as emperor, while any religious justification for the expedition to Constantinople had been jeopardized by the determination of the Greeks not to surrender to the supremacy of Rome. Lacking even the means to sail home, the crusaders threatened to fight to win what they were owed. Once again it was Dandolo who saw his opportunity to shape the outcome, in fact to transform the expedition into an instrument for destroying the Byzantine empire itself. It was he who crafted a treaty between the Venetians and the crusaders to provide for its dismemberment. Constantinople would be conquered, the doge would have first call

on the spoils of the opulent city, up to three-quarters of what was taken, and a joint committee of crusaders and Venetians would elect a Latin emperor (who would, of course, then transfer the religious allegiance of the empire to Rome). The new emperor would be left in charge of a truncated empire, only a quarter of the existing provinces, while the remaining three-quarters would be distributed between the crusaders and the Venetians. There was never any doubt that the Venetians would select territories which would sustain their trading networks. Any qualms the crusaders might have had in serving the interests of the Venetians were settled by their priests, who told them of the glory they would gain by extracting the many relics of the city from heretics, as the Greek Orthodox Christians certainly were in Roman eyes.

The attack was launched on 9 April 1204. Despite some resistance by the new emperor, several of the great gates of the city were forced and by 13 April Alexius V had fled. The leaders of the crusade moved into the imperial palaces and gave their men leave to pillage the city. Their booty was supposed to be collected for orderly dispersal, but discipline soon broke down and Constantinople was given over to chaotic looting. Three disastrous fires swept through the city. Churches, including Constantine's resting place, the Church of the Holy Apostles, were sacked; even the corpse of the great emperor Justinian was violated, the jewels around the well-preserved body snatched from it. Perhaps two thousand died in the violence.

There is a heart-rending account of the sack from Niketas Choniates. As an official who had worked his way to the top of the imperial household, Niketas had acquired his own palace, three storeys high and embellished with gold mosaics. At first he sheltered there, but it was destroyed in the second great fire. Deserted by his terrified servants, Niketas and his young family (he had one son small enough to need carrying and his wife was pregnant) had to struggle through the streets in the company of a few loyal officials and friends.

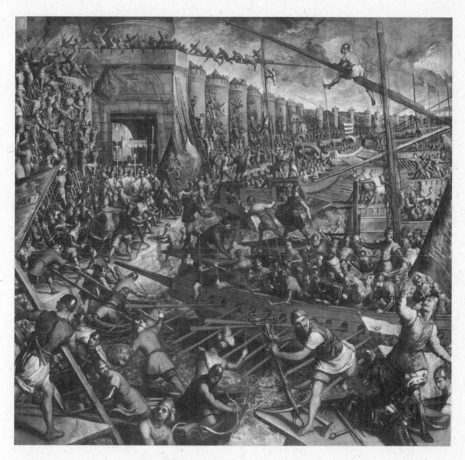

The Fourth Crusade, 1204. The elderly doge Enrico Dandolo urges the crusaders on from his barge as they attack the walls of Constantinople. A sixteenth-century reconstruction in the Doge's palace by Palma il Giovane. (Palazzo Ducale, Venezia/Scala)

We were like a throng of ants passing through the streets. The troops [the crusaders] who came out to meet us could not be called armed for battle, for although their long swords hung down alongside their horses, and they bore daggers in their sword belts, some were loaded down with spoils and others searched the captives who were passing through to see if they had wrapped a splendid garment inside a torn tunic or hidden silver or gold in their bosoms. Still others looked with steadfast and

fixed gaze upon those women who were of extraordinary beauty with intent to seize them forthwith and ravish them. Fearing for the women, we put them in the middle as though in a sheepfold and instructed the young girls to rub their faces with mud to conceal the blush of their cheeks ... We lifted our hands in supplication to God, smote upon our breasts with contrite hearts, and bathed our eyes in tears and prayed that we all, both men and women, should escape those savage beasts of prey unharmed.

Later Niketas describes how he managed to save one girl from rape by shaming her attacker in front of a leader of the crusaders.

In a later section of his account Niketas tells how, after he had found refuge and his wife had been delivered of their child, he returned to the city to find a systematic destruction of art treasures under way. The hippodrome appears to have been the scene of the greatest depredations. Many of the statues set up there by Constantine were dragged off by the crusaders to be melted down, among them the Hercules, a she-wolf with Romulus and Remus, and an eagle and serpent. A head of Hera, the wife of Zeus, alone needed four yokes of oxen to cart it off. Nothing seemed able to quell the rapacity of the crusaders – even a most beautiful bronze of Helen, relates Niketas, was unable to exercise her charms on those who consigned her to the flames. Perhaps, he suggested, the Venetians, playing on their supposed Trojan origins, wanted revenge for the destruction of Troy which her presence there had brought about.

Niketas had no doubt that Enrico Dandolo was the driving force behind the sack and what followed. He was 'not the least of horrors ... a creature most treacherous and extremely jealous of the Romans, a sly cheat who called himself wiser than the wise and madly thirsting after glory as no other'. Dandolo, says Niketas, had grasped the fact that any attack on Constantinople by the Venetians alone would have brought disaster down on his head, and so he involved others 'whom he knew nursed an implacable hatred against

the Romans [i.e. the Byzantines] and who looked with an envious and avaricious eye upon their goods'. From the beginning, Niketas was convinced, the crusade had been a mask for Dandolo's ambitions for revenge upon the empire that had treated him with contempt nearly thirty years earlier.

What happened next bore out Niketas' suspicions. Once again it was Dandolo who took the leading part in enforcing the treaty he had made with the crusaders to Venice's advantage. He did not wish to become emperor himself, preferring to see an acceptable candidate appointed from among the leading crusaders, and, after some wrangling between rival claimants, Baldwin of Flanders was elected. (Dandolo's influence is suggested by the use of an election; such a procedure, well established in Venice, was unknown in northern Europe.) The Venetians then insisted that in return for acquiescing in a Latin emperor they should have the right to appoint the patriarch of the city; and a Venetian, Thomas Morosini, 'of middle age and fatter than a hog raised in a pit', as Niketas described him, duly took office. The doge was to receive the title of 'despot' and to have the privilege of not having to pay homage to the new emperor and his successors.

Now the conspirators could move on to the division of the empire, and here Dandolo used his intimate knowledge of the Aegean to gain vital staging posts for Venice. Of the city itself three-eighths, including the docks, was to be Venice's, the other five-eighths the Latin emperor's. To the west of the city a stretch of Thrace across from Adrianople up to the Sea of Marmara went to Venice, as did all the islands of the west coast of Greece, much of mainland Greece including the peninsulas jutting out from the Peloponnese, and several well-placed Aegean islands: Salamis, Aegina, Andros and, most significant of all, Crete. Supremacy in western Greece gave Venice full control of the entrance to the Adriatic, a vital strategic advantage. The crusaders gained much of the rest of the empire.

The outside world had to come to terms with these events as best it could. One of Baldwin's first tasks was to feed the pope with

a version of events which stressed the happy reunion of the long-separated Christian churches. Innocent's initial joy did not survive the details of the terrible destruction that had accompanied the reunion and the news that his own legate had not only lifted the excommunication of the Venetians but absolved the crusaders from continuing to the Holy Land. He was particularly stung by the appointment of Morosini as patriarch by a Venetian doge who had still been under excommunication at the time. But realpolitik soon took over. In 1205, after some sober reflection, Innocent announced that now he had heard the 'true' version of events it was clear to him that Morosini had been fairly selected as patriarch, that his legate had had the right to lift the excommunication and that Dandolo had indeed done such great service to the Christian world that God would release him from any further duty to carry on the crusade. Meanwhile many of the subjects of the empire resisted their new overlords and its neighbours took the opportunity to settle old scores. In April 1205 Baldwin was captured by the Bulgars at Adrianople in Thrace, and when news of his death in captivity came through one of Morosini's first official engagements was to crown Baldwin's brother, Henry, as the new Latin emperor in 1206.

With the sack completed, it might have been considered time for Dandolo to return home. He had achieved all he had plotted for and the fruits of victory had been immense, not only in terms of immediate booty but in the consolidation of Venice's trading empire for the future. His vigour, however, remained undiminished and he even led his own troops in an expedition to help Baldwin's shattered army extricate itself from its entanglement with the Bulgars. It may be guessed that in these last months of his life Dandolo relished the freedom to dictate events in a way that the Venetian constitution, which, in the middle of the previous century, had reduced the powers of the doge considerably and transferred power to a Great Council, would never have allowed him to do at home; and so he appointed his son Raniero as regent in Venice and stayed in the east. Even after his death in 1205 his body was never returned to Venice, and still lies in the church of

Santa Sophia, its burial place marked by a simple engraved slab.

Before his death Dandolo had made a selection of some of the treasures of Constantinople that he would like to send back to Venice, and these were to be followed over the years by a steady stream of plunder as the Venetians abused their control over their part of the city. Studies of the documentary records and evidence from what actually survives in Venice allow us to compile a list of the loot. First, there were the sacred relics which Constantinople, as the capital of a Christian empire, had accumulated over the previous nine centuries. Dandolo himself is associated with the choice and removal of the head of John the Baptist, drops of Christ's blood, a nail from his cross, part of the pillar at which he was flagellated, St George's arm, and a cross carried into battle by the emperor Constantine. (Another relic, the crown of thorns, was used as security for a loan to the crusaders until the saintly King Louis IX of France was persuaded to redeem it. He housed it magnificently in the Sainte-Chapelle in Paris.)

Among the bodies of saints that were dispatched to Venice in the next few years were those of St Lucia, St Agatha, St Symeon, St Anastasius, St Paul the Martyr – even, according to some reports, St Helena, the mother of Constantine (although, unlike most of the others, this cannot be traced in Venice). Then there were other items of treasure: jewelled caskets, precious vessels, even ancient Egyptian vases of polished stone, which were probably chosen because of their quality and rarity and the ease with which they could be shipped home. These treasures, many of them pagan, came to rest with the relics in the Treasury of St Mark's. Other treasures of pagan origin were taken to Venice and then transformed into Christian symbols. A head of the Hellenistic period (323–31 BC) was joined to a Roman torso to form the statue of St Theodore which, as described earlier in this chapter, was later placed with his symbol, a crocodile, on one of the ancient columns from Alexandria in the Piazzetta. The neighbouring column was topped by a winged lion of St Mark which was created from a chimaera brought from Constantinople, possibly of Persian origin and dating from perhaps

300 BC, to which wings were added by the Venetians. Then, in the established tradition of finding marble to embellish Venetian buildings, there were superior 'building materials'. Two finely decorated columns, later to be placed at the southern entrance of St Mark's, where they still stand, came from the sixth-century church of St Polyeuktos which, although disused by the twelfth century, had originally been one of the most sumptuous in Constantinople. Excavations in modern Istanbul have discovered similar carvings on the site of the church and have also shown that it was stripped of its marble at just about the time of the Venetian conquest. Then there was a mass of sculptured reliefs, depicting subjects ranging from Hercules to the Christian saints, and pieces of beautiful marble from Santa Sophia and other churches. (The Dandolo family allocated much of the marble to the rebuilding of their family palace in Venice.) With all this went a set of bronze doors, datable to the sixth century, which were to be placed in the central doorway of St Mark's. The Venetians knew quality when they saw it.

Another group of seized statues was linked specifically to Constantinople's imperial past. A large bronze of a ruler – one of the early Christian emperors, possibly Marcian (emperor 450–7) – never reached Venice: the ship carrying it from the east was shipwrecked off southern Italy and the statue still remains where it was rescued, at Barletta. Then there are the four soldiers in porphyry which are now embedded in the southern wall of St Mark's, on the outside of the Treasury. There are two pairs; each soldier has one hand on his sword while the other clasps his fellow on the shoulder. Byzantine sources suggest that they came from a building known as the Philadelphion, and excavations in Istanbul again confirmed the provenance when a piece of porphyry which proved a perfect match was found close to where this building had stood. The soldiers are now considered to be Diocletian and his fellow tetrarchs, joint rulers of the empire in the late third century, although it appears that when they were in Constantinople they were believed to be the four sons of Constantine. Either way they

are linked to Constantine's family for his father, Constantius, was one of the tetrarchs. On the same wall of St Mark's, up on the railing at the south-western corner of the *loggia*, is another of the spoils of 1204: a porphyry head of an emperor, believed by many to be Justinian. Marbles and jewels were also taken from the Church of the Holy Apostles, the burial place of Constantine and many of his successors, although none of these can be identified in Venice today.

The accounts of the sack tell us that Dandolo himself picked out the four horses which were to come to rest at St Mark's. There is one possible reason, apart from their obvious quality, why Dandolo may have been drawn to the horses. In the fifth century BC the Veneto was considered one of the best areas in which to find chariot horses; it is possible that memories of this trade were still alive and were known to Dandolo, perhaps having been passed on to him on one of his visits to Constantinople.* If this was what attracted him to horses, which horses might he have chosen? Many commentators have assumed without much discussion that he chose the team which had been set up on the starting gates of the hippodrome by Theodosius II. We know that these were still in place in 1162, when Niketas Choniates wrote of 'four gilt-bronze horses, their necks somewhat curved as if they eyed each other as they raced round the last lap', and at first sight they do seem the most likely choice. There are four horses, apparently without a chariot, and they are gilt. Unlike many of the more accessible bronzes in the hippodrome itself, they would have been difficult to reach, so the mob may have spared them and left them available for Dandolo to take.

However, there are also grounds for doubt. The horses now in St Mark's can hardly be described as 'racing' – they are clearly, with three feet on the ground, standing – and on these grounds as early as the eighteenth century a Göttingen professor, Christian Gottlieb Heyne, dismissed the claim that the starting-gate horses were the

*I am grateful to Michael Vickers for this suggestion.

same as those on St Mark's. It has also been claimed, by the Italian scholar Vittorio Galliazzi, that in their original setting the horses were in two pairs with the heads of each looking outwards, and that it was only when they were placed on St Mark's that the heads of the two outer horses were detached (they are separate castings, so this would not have been difficult) and transposed to make two pairs, each with their heads looking inwards towards each other. As we shall see in the next chapter, the art historian Michael Jacoff provides a reason why the heads needed to be changed over when the horses were set up on St Mark's. If Galliazzi and Jacoff are right, then these horses would not have been 'eyeing each other' in their original setting and so could not have been those on the starting gates.

One can take a different line and highlight Dandolo's own obsession with the humiliation of Constantinople. If he merely wanted high-quality statues for their own sake, there would have been many, especially from the area of the hippodrome, that he could have saved from destruction. We may guess instead that he wanted to appropriate something which was symbolic of the core of the city's identity. The most prestigious *quadriga* of the three recorded in the eighth century was surely that at the Milion which accompanied the statue of Zeus Helios (or Constantine in that guise). This set of four horses, with all its associations with the founding of the city and its founder himself, would have provided all the resonances of the victory that Dandolo could wish for. Yet we cannot fix on these horses with absolute certainty either, for they were described by the *Parastaseis Syntomoi Chronikai* as being 'driven headlong', again hardly an accurate representation of the St Mark's horses; and so one might equally choose the third of the sets of horses, that seen in the hippodrome itself in the eighth century. These were also associated with the foundation ceremonies of the city. However, the original Greek word used in the *Parastaseis* to describe them as a group is 'yoked', and there is no evidence from the St Mark's horses of any fittings for yokes on their bodies.

So the identification of the St Mark's horses is not straight-forward. And yet, how better to humiliate Constantinople and its empire than to take a treasure which represented not only its august founder but the moment of the city's foundation itself, and to add it as the crowning piece of the plundered imperial statuary? My own guess would be that Dandolo chose the horses from the Milion. This would explain why the scholarly Bernardo Giustiniani wrote in 1493 of the horses as being 'all made for the chariot of the sun'. If they had been detached from the chariot of Zeus Helios and brought to Venice, then the memory of their original setting may well have travelled with them.

THE HORSES ARRIVE AT ST MARK'S

DESPITE THE ENORMITY OF THE SACK OF CONSTANTINOPLE, the Venetians seem to have been untroubled by guilt. In Martino da Canal's *Estoires de Venise*, written between 1267 and 1275, the sack is presented as a justified conquest and Dandolo praised for it. 'It was through the wisdom of this great man that a city as grand as Constantinople was taken; and this', Canal adds somewhat unscrupulously, 'he did in the service of the Holy Church.' Great canvases by Jacopo Palma il Giovane, hung when the Doge's Palace was redecorated in 1587 after a fire, show Dandolo before the walls of Constantinople, urging on the Venetians from his barge. By that time, of course, the Venetians knew what they were really celebrating: the acquisition of a trading empire which had brought them dominance in the eastern Mediterranean. Even though they were to lose their foothold in Constantinople itself in 1261, when the city was regained by Greek emperors, the thirteenth century was to be one of great prosperity for Venice.

That prosperity was to be reflected in the transformation of St Mark's. The eleventh-century basilica had been fronted in brick, but by the middle of the thirteenth century the western façade had been remodelled to provide an opulent backdrop to the Piazza, and the domes above it raised to the form visible today. The remodelling

goes hand in hand with a rise in status of the procurators of St Mark's, those responsible to the doge for the care and embellishment of the fabric of the basilica. By the 1260s they are housed in the Piazza itself and are increasingly responsible for the Piazza's own buildings and other estates in the city. The office of chief procurator was so prestigious that it could even serve as a stepping stone to that of doge itself.

The work on St Mark's set in hand by the procurators was extensive. A narthex, fronted by five arches reminiscent of the triumphal arches of Rome, was built round the western façade and this was faced with reused marbles, mosaics and columns, many of them from among the loot brought from Constantinople. Unfortunately only one of the original mosaics, that over the Porta San Alipio on the far left, showing the arrival of the body of St Mark in front of the basilica itself, survives, and this is not from Constantinople but Venetian work dating from about 1267; the others are much later restorations or replacements. This façade was dedicated to religious themes – on either side of the central 'triumphal' arch a relief of a saint was added, St Demetrius on one side and St George on the other. Both are warrior saints, as if to proclaim spiritual support for Venice's new status as a city of conquerors. Moving outwards from the centre, between the first and second doors there is a relief of the Angel Gabriel appearing to – in a similar position on the other side – the Virgin Mary *orans*, her arms uplifted in prayer, the standard Byzantine representation. They were no doubt placed on the façade as a reminder of the legend that Venice was founded on the day of the Annunciation. More perplexing are two reliefs of the pagan god Hercules, represented in his labours, attached at the far ends of the façade. They will reappear in the story.

On the south side of the basilica the mood is somewhat different. The porphyry statues of the tetrarchs were placed on the corner wall of the basilica's Treasury (close to what was originally one of the main entrances to the basilica) while the head of another Byzantine emperor, probably Justinian, was, as we have seen, set up

on the end of the *loggia*, the platform which ran along the top of the narthex. Some of the finest marble reliefs and slabs from Constantinople were embedded in the wall of the Treasury. When visitors landed on the Molo this was the first they would see of the basilica, and the façade seems deliberately to have been designed as a showcase of imperial Venetian pride. It was here in the Piazzetta that extra monuments were placed as they arrived in the city. The two pillars from the Church of St Polyeuktos were put in their present place in front of the southern façade in 1258. This somewhat isolated position may seem strange, but the Old Testament description of Solomon's Temple in Jerusalem (I Kings 7: 15) mentions two bronze pillars 'in the vestibule of the sanctuary'. Both are described (v. 20) as having pomegranates on the moulding, and pomegranates are also carved on the St Polyeuktos pillars. It is possible that the Venetians, who had trading links with Jerusalem, were attempting to recreate Solomon's Temple, with all its ancient spiritual resonances; indeed, the suggestion is reinforced when we find that there is a relief of the Judgement of Solomon nearby on the wall of the Doge's Palace.

The stump of a porphyry column, the so-called Colonna del Bando, captured from the Genoese in the city of Acre in 1257, was set up at the corner of the basilica in 1265. It served as a base from which to display the severed heads of criminals, 'though the smell of them doth breede a very offensive and contagious annoyance', remarked the Englishman Thomas Coryat when he visited Venice in 1608. The Colonna had its day of glory, however: on 14 July 1902, when the Campanile collapsed and the Colonna helped prevent the rush of brick and stone reaching St Mark's. Meanwhile the Treasury of St Mark's was crammed with an assortment of loot from Constantinople, including the most sacred relics possible, those directly associated with the passion of Christ. Alongside them were placed the Egyptian vases and Greek vessels showing Dionysiac revels, which the Venetians had carried off with the relics. Sacred and profane still exist happily together in the Treasury today.

Some time in the middle of the thirteenth century the four

horses selected by Enrico Dandolo were hauled up on to the *loggia* above the central door of the basilica. They had been brought back to Venice, on Dandolo's orders, in the personal care of one Domenico Morosini. The story goes that during the voyage a foot was knocked off one of the horses and the Morosini family was allowed to keep it. It passed down the family and was mounted on a bracket on the façade of one or another of their various palaces as a symbol of the family's distinguished history and connection with the sack of Constantinople. When the horses arrived in Venice they were placed at first in the Arsenale, the naval dockyard. It seems no one knew what to do with them: with Dandolo's death in Constantinople, the reasons why he had selected the horses and any plans he might have had for them must have been lost. There is even a story that they came close to being melted down but that

This nineteenth-century terracotta is believed to be the copy of a much earlier silver plate commemorating the presentation of the horses to a personi-fication of Venice by Enrico Dandolo. (Comune di Treviso, Eredità Lattes/ NV. n. 945)

The mosaic from the Porta San Alipio on the façade of St Mark's dates from c.1267 and is the earliest representation of the horses in place on the *loggia*. The scene is anachronistic: it shows the arrival of the body of St Mark at the basilica in the ninth century. (S. Marco, Venezia/Scala).

some visiting Florentines, more sophisticated than the Venetians in such things, were horrified at what was about to be destroyed and urged that they be saved.

A range of dates between the 1220s and the 1260s has been suggested for the moment when the horses were actually raised up on to the *loggia*, but they were certainly in place by 1267, when they were depicted in the mosaic over the Porta San Alipio. There the horses are in the same position over the central door as they are today, divided into two pairs, each horse looking towards its immediate neighbour, with an open space left between them. (However, the mosaicist has transferred the raised leg of the inner horses from the outside to the inside, presumably to create a more symmetrical pattern.)

One's first response to the horses' elevated position overlooking the Piazza is that they are being shown off as plunder, and this is reinforced by the 'triumphal' entrance arch above which they stand. While it is hard to believe that this was not one of the impulses behind their display, the west front of St Mark's was, as we have seen, a 'religious' rather than 'political' façade, and it may be that the horses also represented some kind of religious statement. The problem lies in identifying what it might have been. In the Old Testament there are certainly chariots but it is not always clear by what they are drawn. In the vision of the prophet Ezekiel, for instance, there is a chariot drawn by four animals, but these are strange composite creatures, of human form but with the hooves of oxen and four wings. Then there is the fiery chariot which takes Elijah up to heaven (2 Kings 2). The Hebrew word used to describe it is not associated with any specific number of horses, and when the Hebrew was translated into Greek in the third century BC the Greek word used was *harma*, a general term for chariot, again with no association with a specific number of horses. Yet when the fourth-century scholar Jerome went back to the Hebrew as the basis for his Latin version of the Old Testament (known as the Vulgate, this remained the Roman Catholic Church's 'official' version for centuries), he decided to emphasize Elijah's status by translating

'chariot' as *quadriga*. For Jerome, nothing less was suitable for the prophet. Whether Jerome knew it or not, the same approach had been taken in art: at least two early Christian sarcophagi have reliefs which show Elijah being taken up to heaven in a classical *quadriga* with its four horses.

Centuries after Jerome, in the twelfth century in fact, just a few years before the sack of Constantinople by the Venetians, we find *quadrigae*, this time actual chariots drawn by four horses, used in Constantinople in recreations of that most ancient ceremonial ritual of the Roman world, the triumph. Niketas Choniates, in his history of the events of this century, tells how the Byzantine emperor John inflicted a massive defeat on the Turks and then, in 1133, mounted a triumphal procession, but this time one set in a Christian context, in Constantinople. A silver-plated chariot was constructed and decorated with semi-precious jewels.

> The splendid *quadriga* was pulled by four horses whiter than snow, with magnificent manes. The emperor himself did not mount the chariot [as would have happened, of course, in ancient Rome] but instead mounted upon it the icon of the Mother of God . . . To her as the unconquerable fellow general, he attributed his victories and ordering his chief ministers to take hold of the reins and his closest relations to attend to the chariot, he led the way on foot with the cross held in his hand.

This was not an isolated incident. When the emperor Manuel won his great victory over the Hungarians in 1167, he too decided to hold a Roman-style triumph complete with captives and plunder. The population of Constantinople was assembled to watch from specially constructed platforms as the procession wound its way through the streets. 'When the time came for the emperor to join the triumphal procession, he was preceded by a gilded silver chariot drawn by four horses as white as snowflakes, and ensconced on it was the icon of the Mother of God, the invincible ally and unconquerable fellow general of the emperor.' The procession

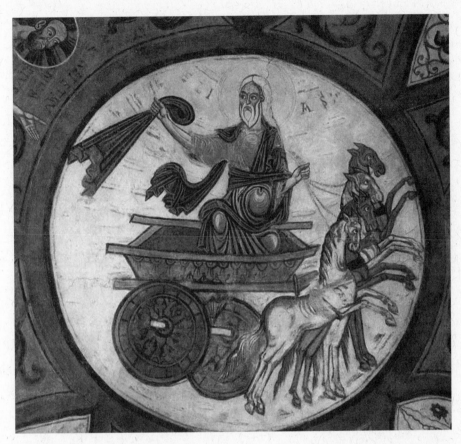

Reliefs of the prophet Elijah ascending to heaven in a *quadriga* are known from as early as the fourth century AD. This portrayal, from the cathedral in Anagni, central Italy, is shown in a fresco dating from the thirteenth century and thus roughly contemporary with the placing of the horses on St Mark's. It reveals how *quadrigae* could be incorporated into Christian art. (The Art Archive)

eventually reached Santa Sophia, where a service of thanksgiving was held before the emperor retired to his palace and then, 'unstringing himself like a bow from the excessive tension, he relaxed at the horse races'.

So the *quadriga* could be transferred into Christian contexts; and the art historian Michael Jacoff has suggested yet another which seems to be of particular relevance to the horses of St Mark's. He

has found references which compare the four evangelists with four horses which pull 'the *quadriga* of the Lord'. As Jerome wrote in a letter of 394, 'Matthew, Mark, Luke and John are the Lord's team of four, the true cherubim or store of knowledge.' In the ninth century another source (Haimo of Auxerre) proclaims that 'the preaching of the Gospel rests upon the authority of the four Evangelists and the four Gospels are like the four of the *quadriga* of the New Testament, which Christ himself as charioteer controls, himself guiding and drawing up the chariot of the Gospels'. There even exists a link to Venice in an eleventh-century sermon by St Peter Damian, on the theme of Mark, and possibly even preached in St Mark's, which describes the chariot of Aminadab, from the Old Testament Song of Songs, as 'a forerunner of the *quadriga* of the gospel of Christ', again with Christ as the charioteer. While there is no surviving direct reference to the St Mark's horses themselves as the '*quadriga* of the Lord', the image was certainly current in Venice.

Seeking support for this view, Jacoff embarked on some architectural detective work. The placing of the horses on the *loggia* with a wide gap between the two pairs is unusual and would have made any relationship with a real chariot impossible. Was there a specific reason for leaving a space? In the present setting there does not seem to be, but the window behind the horses was placed there only in the fifteenth century. Before this, according to the Porta San Alipio mosaic, there were columns flanking the horses but what else was in the vicinity is not clear. However, at the Porta dei Fiori on the northern side of St Mark's there are five reliefs, one each of Christ and the four evangelists, which date from the thirteenth century. It has long been acknowledged that they are out of place there and were probably transferred from somewhere else in the church. They could actually fit in the space above the horses, with the relief of Christ in the centre just under the arch and the evangelists set out below him above the columns which flank the horses themselves. It may be significant that the evangelists are set in two pairs, Luke and Mark, Matthew and John, with the members

of each pair facing one another. Mark is given the most prominent position, on the immediate right hand of Christ, as, understandably, he is in other representations in 'his' basilica. He is designed to face outwards from Christ and towards his partner, Luke, who faces back at him. Conventionally – in ancient art, for instance – the inner horses in a *quadriga* face towards each other and the outer two away from each other. Here on St Mark's, the heads of each pair of horses face each other, just as the evangelists behind them would have done. As we have seen, the heads of the horses could have been detached and changed around to make this possible.

In short, Jacoff suggests that the whole façade was designed as a unity in the thirteenth century, with the positioning of the horses designed to echo the reliefs behind them. The mosaics of the façade recorded the legends, such as the dream, which link Mark to Venice, while the horses and the reliefs placed behind and above them set Mark within the context of universal Christianity. The whole is a triumphant assertion of Venice's status, as a conqueror whose temporal victories can be integrated with the patronage of its saint. The horses stand not only as symbols of victory but also as symbols of Mark. They are transformed within a new Christian context, just as in the Piazzetta other ancient bronzes were transformed into the statues of Theodore and Mark. (These reliefs, some the originals, some resin copies, have now been placed alongside the horses in St Mark's.)

This carefully composed design was shattered when the decision was made in the 1420s to replace the reliefs with the large expanse of glass which fills the space today. Presumably the driving force was the demand for more light within the basilica. Three other windows, one in the north side and two in the south, were inserted into the walls of St Mark's in the late fourteenth and early fifteenth centuries and the western façade, open to the daylight from the Piazza, was the obvious one to exploit if yet more light were needed. This may appear to have been a ruthless destruction of both the aesthetic whole of the original and its spiritual significance, but the continual replanning of St Mark's over the centuries shows that the

Venetians were certainly not sentimental about such things. (A major 'restoration' of St Mark's in the 1860s was so destructive of earlier mosaics and sculpture that an international campaign led by John Ruskin was launched in protest, and luckily succeeded in halting the project before it had reached the western façade.) Even so, there may have been some unease over removing the images of the evangelists. Two smaller representations of the four saints, one in the curve of the arch over the window, appear to have been entered on the façade at the time the window was put in, perhaps as a compensation for what had been lost.

Jacoff's argument is compelling; but would the bold display of the horses from Constantinople, even in so explicit a Christian context, ever have appeared to observers as other than primarily a triumphant display of plunder? Certainly the religious justification for the placing of the horses does not seem to have convinced everyone. We have fascinating evidence of how one of Venice's rivals, the city of Padua on the mainland, perceived the setting of the horses in the early fourteenth century. Here the Florentine artist Giotto was fulfilling a commission to decorate the Arena Chapel (so called because it was built within the walls of the original Roman arena) for a wealthy Paduan merchant, Enrico Scrovegni. His theme was episodes from the life of the Virgin and of Christ. The Arena frescos are seen as the moment when Italian painting turned from Greek to Latin, in particular to a more realistic way of recording emotion and the natural world, and rank among the masterpieces of the early Renaissance. It has long been recognized that Giotto preferred to copy real buildings rather than to reproduce the traditional stylized images used in Byzantine art, and this is what he did when he came to depicting the Temple in Jerusalem for the fresco of *The Expulsion from the Temple*. One of his fellow craftsmen was the sculptor Giovanni Pisano, who had recently worked on Siena Cathedral, and it was this façade, with its pointed arches, that Giotto copied for the Temple. The original, still standing in Siena, has six sculptured animals on the pillars between the arches: two horses, one at either end; two lions in the

centre; and, between the lions and the horses, an ox and a griffin. However, Giotto omits the ox and the griffin and changes over the lions with the horses so that the lions are on the outside. Then he executes a further transformation. The inner horses are none other than copies of those of St Mark's!

Of course, Giotto may simply have been copying the horses because they were works of art which he had seen and admired. Yet if *The Expulsion* is explored alongside the New Testament texts that describe it, something very interesting emerges about the way Giotto portrays it. The gospels of Matthew and Mark both describe the expulsion of the money-changers and the sellers of pigeons (which were bought for sacrifice). John (2: 13–16) adds to this sellers of cattle and sheep, who are expelled by Jesus along with their animals. In Giotto's version the only sign of the money-changers is an upturned table, but he does include an ox and a sheep.

Clearly Giotto has used John's version as his text. It seems that he was being tactful. The fortune of the Scrovegni family came from usury – Enrico's father Reginald was so notorious for the practice that he is to be found in hell in Dante's *Inferno* – and it has been suggested that the Arena Chapel was commissioned by Enrico in the hope of distancing himself from this unhealthy ancestry. Thus there was every good reason for Giotto to concentrate on the sheep and cattle and avoid any emphatic reference to the money-changers. But how would this affect the animals shown on the façade of the Temple? To answer this question one has to go back to an Old Testament text, 2 Kings 23: 11. Here King Josiah is described as destroying the idols which have crept into the Temple of Jerusalem. 'He did away with the horses that the kings of Judah had dedicated to the sun at the entrance of the Temple . . . and he burned the chariot of the sun.' Christ was carrying out a similar cleansing of the same Temple, and Giotto has strengthened his point by portraying two horses to remind onlookers that they had been symbols of idolatry just as the sheep and cattle were in Jesus' time. By portraying the horses of St Mark's, was Giotto making

In his *The Expulsion from the Temple* in the Arena Chapel in Padua (1305), Giotto displays two horses of St Mark's, one either side of the central arch of the Temple. Was he making the point that the independent Paduans saw them as symbols of idolatry? (1990, Foto Scala, Firenze)

the subtle point that they were emblems of pagan idolatry, and that their display had more to do with irreligious pride than with piety? This is certainly how the grand refashioning of the façade of St Mark's with looted treasure might have seemed to Venice's enemies.

DOGE OR EMPEROR? THE HORSES, HIPPODROMES AND IMPERIAL DISPLAY

THE IMMEDIATE CHALLENGE FOR THE DOGES AFTER 1204 was to establish control over their new empire. In Constantinople itself the authority exercised in the city by Enrico Dandolo in the months before his death was passed through election to one Marino Zeno, who arrogantly announced that he was 'lord of a quarter plus half a quarter of the Roman empire' and took on the title of *podestà* (the word means 'one who holds power'; often, in Italian cities, an elected chief magistrate). There was even talk of moving the capital of the Venetian empire to Constantinople. These ambitions were quashed by the emergence of a tough doge, Pietro Ziani (r. 1205–29), who moved quickly to reassert his own authority in Venice. He made it clear that the lands acquired by Enrico Dandolo from the Byzantine empire, certainly those close to Venice, were under his direct control, not that of the *podestà*, and that Venetians could take over the newly acquired territories without reference to the *podestà*. Ziani then further announced that it was he, not Zeno, who was the lord of the Roman empire. In 1207 Zeno was replaced by a *podestà* sent out from Venice and this became the usual procedure. Not that the *podestàe* were without power. One of them, Giacomo Tiepolo, even exploited the weakness of the Latin emperor of his time in order to make his own treaties with surrounding

states and then used a second term as *podestà* (1224–9) as a stepping stone to the office of doge.

Once the doges had asserted their status as 'lord of a quarter plus half a quarter of the Roman empire' we find them linking themselves back to the Byzantine imperial past, even to the heyday of Rome. Pietro Ziani, the doge who had stamped his authority on the *podestà*, was praised on his tomb as 'rich, honest, patient and in all things straightforward. None could be his equal amongst the high-born and wise. Not even Caesar and Vespasian when they were alive.' Julius Caesar, the conqueror of Gaul in the first century BC and later dictator of Rome, needs no introduction. The emperor Vespasian (r. AD 69–79) had restored order to the empire after the reign of Nero and commissioned the building of the Colosseum. Conquest, stability, building: these were the 'Roman' attributes of Ziani. It was in his reign that work to finalize the form of the Piazza San Marco and complete the transformation of the façade of St Mark's, described earlier, was begun.

Ziani's claim that the doges had supplanted the emperors may be seen reflected in his embellishment of the Palo d'Oro, one of the great treasures of St Mark's. The Palo d'Oro is an altar screen which had been commissioned by an earlier doge, Ordelafo Falier (r. 1101–18), from workshops in Constantinople. As originally made, it had three central panels on which portraits of Alexius I, the emperor of the time, and his wife Eirene, flanked the Virgin Mary at prayer, a standard Byzantine image. In this form it was installed by the altar in St Mark's. In other words, the supremacy of the Byzantine emperor was, in the early twelfth century, still being respected in the doge's own chapel in Venice. When a mass of jewels and enamels arrived back in Venice among the treasures of the sack of 1204, it was decided to fit them into the Palo d'Oro. Ziani asked the procurator of St Mark's, one Angelo Falier, who was a descendant of Doge Ordelafo, to oversee the task, and Falier was arrogant enough to discard the portrait of Alexius I and replace it with one of his ancestor – while retaining all the imperial regalia that had been shown on the original! In effect, a doge, albeit

in this case one long dead, was transformed into a Byzantine emperor.

It was only a matter of time before the same transformation was effected of a living doge, and sure enough this occurred in 1284, when Venice decided to mint its own gold ducats. On these the doge — another Dandolo, Giovanni — was shown on the coin receiving an imperial banner just as the emperor was on Byzantine coins. By this period the doge also dressed himself in a costume which drew on Byzantine precedents, notably red stockings, black shoes encrusted in diamonds and a fur-lined mantle.

As we have seen, the coronation rites of the Byzantine emperors stressed that they were the favoured of God, who, the fiction went, had chosen the emperor as his representative on earth. We find Enrico Dandolo making the same claim for himself. One chronicle records his words: 'And God through his mercy and divine grace illuminates the mind of each doge, chief and rector of Venice, so that his state may always grow and expand [God had done Dandolo proud in this respect!], and so that each may accordingly support and govern and preserve his state.' Martino da Canal reproduces the acclamation with which the doge, in this case Reniero Zeno (r. 1253–68), was met in St Mark's when he entered on a feast day: 'Let Christ be victorious, let Christ rule, let Christ reign; to our Lord Reniero Zeno, by the grace of God illustrious Doge of Venice, Dalmatia and Croatia, conqueror of a fourth part and half a fourth part of all the Roman empire, salvation, honour, life and victory, let Christ be victorious, let Christ rule, let Christ reign.' This can be compared to the acclamation with which the Byzantine emperor Leo I was greeted on his succession in 457: 'Give ear, oh God, we call on you. Hear us, oh God. To Leo, life. Give ear, oh God. Leo shall rule. Oh God who loves mankind, the common people ask for Leo as emperor, the army asks for Leo as emperor . . . Let Leo come, he, the ornament of all, Leo shall rule, he, the good of all. Give ear, oh Lord, we call on you.' In both cases the acclamation begins and ends with acknowledgement of God or Christ, with specific epithets applied to the emperor in between. In Constantinople the

emperors had signified their place as representative of Christ by carrying a white paschal candle in the Easter procession. According to Martino da Canal, the doges adopted the same practice for the Easter procession in Piazza San Marco.

If one looks at the burial places of Dandolo's successors one can see how they developed their 'divine' status. As Debra Pincus has shown in her study of the tombs of the doges, the creation of an opulent tomb became a prominent feature of the thirteenth and fourteenth centuries, and their decoration includes echoes of the Byzantine emperors' burial monuments. The tomb of Doge Giacomo Tiepolo, the former *podestà*, survives on the outside wall of the grand Dominican Church of Santi Giovanni e Paolo in Venice. The lid, apparently from an original sarcophagus of the fifth century, is crafted in a style associated with Ravenna, to where the last of the western Roman emperors withdrew their court in the fifth century. Prominent on it is a jewelled cross which stands on steps. The emperor Theodosius (AD 379–95) had placed a similar cross on the site of the crucifixion in Jerusalem, and it is a type found on Byzantine coins. So the cross here is a symbol not just of Christianity but of the Christian emperor. Tiepolo's successors, Doge Marino Morosini (d. 1253) and doge Reniero Zeno (d. 1268), were also buried in antique tombs, 'which encase the body of the doge in images of Christ as ruler', as Debra Pincus puts it. Pincus has also shown how the frontal reliefs of Morosini's tomb, believed to be contemporary with his death, appear to have been influenced by those on one of the most prestigious of all Roman monuments, the triumphal Arch of Constantine in Rome. Another feature of these doges' reigns which enhanced their 'imperial' status was the formation of marriage alliances between their families and neighbouring royal families: the family of Pietro Ziani with the king of Sicily, that of Giacomo Tiepolo with the king of Rascia in the Balkans, and that of Marino Morosini with the kings of Hungary.

Of course, the most prestigious burial place had to be St Mark's. Marino Morosini was the first doge to be buried there, but his

Petrarch describes the doge standing on the *loggia* alongside the horses. A comparison can be made with a relief of the Byzantine emperor Theodosius (AD 379–95), which shows him presiding over the hippodrome in Constantinople. In each case the emperor/doge stood over an arch. (The Art Archive)

> Down below [in the Piazza] there was not a vacant inch; as the saying goes, a grain of millet could not have fallen to earth. The great square, the church itself, the towers, roofs, porches, windows were not so much filled as jammed with spectators . . . On the right a great wooden grandstand had been hastily erected for this purpose only. There sat four hundred young women of the flower of the nobility, very beautiful and splendidly dressed.

It appears, then, that the doges used the Piazza San Marco as a ceremonial arena much as the emperors had come to use the hippodrome in Constantinople. There is even intriguing evidence,

although from a much later date, that the processions which came to take up such a large part of Venetian life could be linked back to Byzantine ceremonial ritual. One of the most celebrated of Venetian paintings, now in the Accademia in the city, is Gentile Bellini's *Procession in the Piazza San Marco*, which shows the festivities of 25 April, the feast day of St Mark himself, in 1496. In the foreground one of the city's *scuole* (confraternities of citizens set up to dispense charity), that of San Giovanni Evangelista, carries its relic of the True Cross. The painting was commissioned, in fact, by the *scuola* itself as part of a cycle which celebrated their important relic and the miracles it had effected. Before and behind the relic walk white-robed officials carrying white candles. A man whose son has been healed by the cross kneels behind it. On the right the doge and city dignitaries are assembled while a mass of white-mantled citizens stand in ranks on the left. Behind the crowds St Mark's is shown in all its radiant glory, and the horses stand out in this earliest painting to show them on the *loggia*.

Looking at the painting, one is reminded of a description of the founding of Constantinople given in a Byzantine document, the *Chronicon Paschale*:

> He [Constantine] made for himself another gilded monument of wood, one bearing in his right hand a Tyche of the same city also gilded, and commanded that on the same day of the anniversary chariot races, the same monument of wood should enter [the hippodrome], escorted by the troops in [white] mantles and slippers, all holding white candles; the carriage should proceed around the further turning post and come to the arena opposite the imperial box; and the emperor of the day should rise and do obeisance to the monuments of the same emperor Constantine and this Tyche of the city.

Is what we see in Bellini's picture a Byzantine ritual adapted to serve the needs of Constantinople, with the wood of the True Cross in its gilded reliquary replacing 'the gilded monument of wood'?

Procession in the Piazza San Marco, 1496, by Gentile Bellini. The first surviving painting to show the horses *in situ*. The procession itself echoes those described in the early Byzantine empire. (Academia Venezia/Scala)

Certainly the candles and the white mantles appear to link the two – one even has a peep of the white slippers of one or two of Bellini's participants! (White was always the colour in which groups clothed themselves in both Greek and Roman processions. In Venice in this period white was a mark of status because it signified detachment from the workaday world where clothes were easily soiled.) It is possible that the Venetians had deliberately incorporated the foundation ceremony of Constantinople – which, as we have seen, took place in the hippodrome – into the feast-day celebrations of the patron saint of Venice.

So we come to the possibility that one of the reasons why the horses were placed where they were was because they reinforced the idea of the Piazza as a ceremonial hippodrome. Of course, there is no suggestion that chariot races were held in the Piazza (although there is an account of a festival there in 1413 in which over four hundred horsemen took part). In any case, by this time the hippodrome in Constantinople, which many Venetians would have seen, had almost lost its function as an arena for races and was predominantly a ceremonial venue.

For further evidence in favour of this idea we need to return to the two reliefs of Hercules which, as noted in chapter 7, were placed on the western façade of St Mark's, one at either end. As with the two other pairs of reliefs between them, one is from Constantinople (dated as early as the fifth century) and the other carved in Venice in the thirteenth century. The older relief shows Hercules in one of his most famous labours, the killing of the Erymanthean Boar. The other portrays the hero having completed two labours, the killings

Two reliefs of Hercules known to have been placed on the façade of St Mark's by the 1260s. The one showing Hercules carrying the Erymanthean Boar is antique, the other, showing the killing of the Cerynean Hind and the Lernean Hydra, is from the thirteenth century. Hercules was the patron of the hippodrome and it is arguable that the placing of the reliefs was intended to reinforce the idea that here, symbolically, was a ceremonial hippodrome. (S. Marco, Venezia/Scala)

of the Cerynean Hind and the Lernean Hydra. The San Alipio mosaic shows them in place so they must have been erected before 1267.

The relief with the Erymanthean Boar closely follows earlier classical models – a third-century sarcophagus found in Rome has a relief almost identical to it – and when it was put in place on the façade it was given an antique framing with dentils. It was as if the antiquity of the relief were being deliberately highlighted. The sculptor of the 'new' Hercules copied the pose of the other relief and carved the dead hind and the hydra around it in a way not known from earlier reliefs. He obviously had no classical example to work from. The setting of Hercules here, alongside four religious reliefs on the façade of a Christian church, seems bizarre. However, the commentators on these reliefs, notably Otto Demus, the great authority on the fabric of St Mark's, explain that Hercules could be used in Christian contexts. As a symbol of strength he could be linked to Samson, even to the Saviour himself 'conquering evil and saving the souls of the faithful'. Moreover, the earliest political centre in the lagoon, Eraclea, was named after him – perhaps echoing legends that Hercules had been the tribal hero of the Veneti, the original tribe in the area – and other churches in the region have Hercules represented on them.

There is, however, another possibility. As we have seen in previous chapters, in both the Greek and the Roman world Hercules was associated, among other things, with chariot racing and the hippodrome. Could it be that these two reliefs were placed on the façade roughly at the same time as the horses in order to emphasize that the Piazza was a symbolic hippodrome? The evidence cannot be conclusive, but it reinforces rather than excludes the possibility.

If the horses were associated with the assertion of imperial prestige, is there a particular doge or event before 1267 to which their elevation on to the *loggia* can be related? There is no mention of the horses on the *loggia* at the coronation of Zeno in 1253, although this is no evidence in itself that they were not in place. We have only the terminal date of the San Alipio mosaic in 1267, when

Zeno was still doge. Zeno's reign marked the zenith of imperial glamour. He was an immensely rich man and fond of displaying himself before his people in gold and jewels in a manner reminiscent of Constantine. During the Easter season he processed through the Piazza each Sunday dressed in all his regalia; the season ended, on Ascension Day, with the grand ceremony of La Sensa, in which the doge and his retinue took to their barges and at the entrance to the lagoon from the open sea cast a gold ring into the water to symbolize Venice's 'marriage' to the sea. This ceremony, perhaps the most hallowed in the Venetian calendar, reached its most elaborate and opulent form in his reign.

The horses could have been put in place simply as part of Zeno's programme of imperial display; but if one is looking for another, more immediate catalyst for the elevation one could also see it as a response to a political crisis. There was good reason why, in the mid-1260s, Venice should have felt the need to reassert its imperial pride through a dramatic reminder of its earlier humiliation of Constantinople. These were years when, despite the glamour of Zeno's dogeship, things were turning sour for Venice. In 1259 the city's confidence had been undermined when a new French king of Sicily had annexed Corfu and parts of the Dalmatian coast, infringing Venice's control of the Adriatic. Such intrusions always made the city edgy. Worse was to come. In 1261 a Greek emperor, Michael Palaiologos, regained control of Constantinople with the help of Genoa, Venice's ancient rival. The Venetian quarter was put to the flames, and there are harrowing stories of its inhabitants, many of whom had known no other home, crowding down to the shore where they were evacuated by the thirty Venetian ships in port. The last *podestà*, Marco Gradenigo, left with them. Zeno continued to use his title of 'lord of quarter and half a quarter of the Roman empire' (he pointedly wrote to the new emperor Michael as 'emperor of the Greeks' not 'of the Romans', the ancient title which Michael might have hoped for) but it was a hollow one. In return for their help, the Genoans had been granted rights to have a colony at Galata, just across the

Golden Horn from Constantinople, and they retained these rights even after Venice and the empire eventually made peace in 1268. The Venetians, although they saved many of their trading posts in the eastern Mediterranean, never recovered their favoured position within the Byzantine capital. At home, meanwhile, the strain of defending what remained of the empire is known to have led to unrest and food riots.

It may well have been during this period of crisis that Zeno decided to use the horses specifically as propaganda to revive the confidence of his city. He was a proud and determined man, sensitive to the prestige of Venice. When in 1265 the new emperor offered him a peace treaty that would have once more granted the Venetians a quarter in Constantinople and freedom to settle in the Black Sea, he declared himself offended by its tone which, he said, was too reminiscent of earlier treaties in which Venice had acquiesced in the supremacy of the Byzantines. So he turned it down. If a flamboyant gesture of Venice's pride were now needed, what better than to haul the horses up on to the *loggia* where they could be seen by all and act as a reminder that the doges were still emperors in spirit? With the doges identifying themselves so closely with Christ they could be presented as 'the *quadriga* of the lord' and yet still function as the presiding symbol of an imperial hippodrome. The Venetians were adept at creating different layers of meaning in their monuments. With the horses in place, the final embellishment of the Piazza, its herringbone paving, which we know was laid down in 1266, was now put in hand.

The association with the Byzantine emperors, so carefully cultivated by the doges, did not last; indeed, their claim to any kind of imperial grandeur was soon under threat. By the end of the thirteenth century Venice had lost its position in Constantinople and the Byzantine empire had revived itself for a final period of independence before its extinction at the hands of the Ottoman Turks in 1453. Old rivals such as Genoa and Pisa, as well as newly emerging Italian cities such as Bologna and Ancona, were threatening Venetian trade. Even Venice's control over the Adriatic, the

sea it claimed as its own, was threatened. In 1273 the Bolognans forced Venice to allow them to import corn directly through the Adriatic ports, so depriving the city of the trade. Conflict with Genoa simmered on through the 1290s. In 1311 Zara, encouraged by the Hungarians, revolted. In Venice itself there were renewed food shortages and currency problems.

As unrest grew, in 1297 the Great Council was reorganized through the law of the Serrata, with the aim of creating a more stable form of government. While the Serrata, the 'cutting-off', would eventually confine government to a finite circle of nobility, in the short term the act allowed more commoners to be included in the nobility, and others were incorporated in the decades that followed. Any immediate hope that this measure would bring calm was dashed by continuing popular disaffection and disorder, in which even the position of doge was challenged. In 1310 Doge Pietro Gradenigo (r. 1289–1311) was the focus of an assassination attempt which, although led by nobles, enjoyed wider support; and when he died (of natural causes, in the end) he could not even have a public burial because it was feared that his corpse would be set upon and desecrated. The secretive Council of Ten, which had the power to order the killing of those suspected of crimes, was set up in 1310 and became a fixed feature of the political system.

This was a different world from that of 1204; even if St Mark's had carried with it connotations of the hippodrome in the thirteenth century, these would have disappeared as popular involvement in government waned and the role of the doge diminished. At the death of each doge a committee met to draw up the coronation oath of his successor, and a study of these shows that with each reign the powers of the doge became more limited. Marriage alliances with European royal families, for instance, were forbidden. No doge was buried in St Mark's after 1354. Up to the 1380s one finds that several ancient families – the Dandolos, the Morosinis, the Zenos and the Faliers – provided among them a succession of doges; after this date these families fade from prominence and a number of new

ones, some of them having gained their high status through recent military successes, achieve prominence.

The rituals surrounding the election and coronation of the doge evolved new forms as he became increasingly subject to the Grand Council. By the fifteenth century the doge was elected by an intricate system in which only the nobility played a part, and even the presentation of the doge before his people for formal approval had vanished. His election was now confirmed *inside* St Mark's by the leader of the forty-one electing nobles. The doge then processed outside the basilica and even though he was elevated above the people in the Piazza on a wooden platform, no part of the ceremony involved his asking them for their support. It was simply assumed. The procession now moved to the Doge's Palace and by the end of the fifteenth century it was here that the formal coronation took place. What had originally been a rather secret, private building had been transformed by an opulent entrance near San Marco, the Porta della Carta (built 1438–42), and the Scala dei Giganti (completed about 1490), a grand ceremonial staircase which led from the inner court to the first floor. The new doge would ascend this and then present himself to the crowds from a balcony inside the palace courtyard. So by this time one has to accept that the Piazza San Marco was no longer seen as fulfilling the 'coronation' functions of a hippodrome. Gone were the days when the doges were 'emperors' acclaimed by the people. They were now servants of the nobility.

9

VENICE: THE REPUBLICAN COMMUNITY

THE WITHDRAWAL OF ITS IMPERIAL ROLE DID NOT MEAN that the Piazza San Marco was left without purpose. If there was a single theme which ran through Venice's history, it was its success as a republican community. Despite episodes of unrest at times of crisis such as that described in the previous chapter, Venetians had a strong and enduring sense of common identity and purpose. Indeed, the very earliest chronicle of Venetian history, that written by John the Deacon in the early eleventh century, praised the harmony in which Venice's population lived on its cluster of islands. The Piazza became the arena in which the city's communal pride was celebrated, the setting for the many ritual processions which celebrated the links between Venice and its patron, St Mark. The year was punctuated by key dates: 25 April was Mark's feast day; 31 January the anniversary of the arrival of his body in Venice; 25 June that of the miraculous rediscovery of his body after the basilica had been destroyed by fire in the eleventh century; and 8 October the anniversary of the dedication of the church itself. These processions served many uses, both religious and political, but they represented above all the regular reaffirmation of the city both as a community and as a republic, rather than merely the domain of an emperor. In this the very size of the Piazza was crucial: it was so large that there

were no practical obstacles to mounting major processions in which the citizenry could display itself as a single entity.

We can see this process in action if we return to Gentile Bellini's *Procession in the Piazza San Marco* (p. 113). Bellini went out of his way to stress the communal harmony of the city, and he shows how there is space for everyone to display themselves in their uniforms of office and to be observed by others. Bellini elaborates the point by displaying the coats of arms of all the major *scuole* of the city on the canopy held over the relic, even though this is the procession of only one of them. During the ritual within St Mark's that followed the procession, the representatives of each *scuola* presented their candles to the doge, his wife, the papal nuncio and the entire religious and political hierarchy of the city, thus consolidating their own place within the community. This was a symbolically significant moment, because the officials of the *scuole* tended to be drawn from the *cittadini*, the citizen class, the class below the nobility who were otherwise excluded from public affairs.

Several forces combined to make Venice such a harmonious community. Its very survival as a city depended on cooperative activity. There had to be continuous activity of draining land, shoring up what was exposed above water, driving in piles to support the buildings. In the thirteenth century the new prosperity brought about by the success of the crusade saw an explosion of building (of which the transformation of San Marco was part) and we find the government taking increasing responsibility for overall control. New agencies oversaw the public thoroughfares, streets were paved, bridges were built, first in wood, then in stone. Islands were created from reclaimed land, laws passed preventing the pollution of canals, especially by the dyers and the butchers who had been throwing in their discarded carcasses. It came to be acknowledged that citizens must accept control of their activities if the community as a whole was to live in good health and order. A supply of clean water was vital and the officials of one agency, the Piovego, sponsored new wells, fifty in the 1320s alone. As the only buildings that could stand on the shifting mud base were those with

timber frames, Venice was particularly vulnerable to fire. So in 1291 the glassmakers, with their hazardous furnaces, were moved off to the island of Murano, where they can still be found at work today. (This did not, however, prevent the devastation of the Rialto area by fire in 1514.)

The sense of cooperation in a shared enterprise could also be seen in the trading activities which were fundamental to the city's prosperity and survival. Over long years of commercial activity Venetian traders acquired an intimate knowledge of the Mediterranean and its ports, and of the inland trading routes. The government saw its primary purpose as the preservation of Venetian supremacy – a priority we saw exercised with ruthless efficiency in the carving up of the Byzantine empire in 1204. Dandolo and his advisers knew exactly what outposts to take to secure the trade routes. Domination was particularly effective in the Adriatic, where Venice enforced its own maritime law. Foreign traders were forbidden to deal independently and were forced to come into the city to buy and sell their goods. (For example, traders from Germany were required to carry out their business in the Fondacio dei Tedeschi, a building near the Rialto.) Lucrative commodities, such as spices and silk, were carried in well-armed government ships. The Venetian ducat became one of the Mediterranean's major currencies. In their day-to-day activities private merchants drew on shared resources, with risks being spread among groups of investors, known as *colleganza*.

In short, Venice's unique needs as a community precariously balanced on expanses of mud and dependent on fragile lines of trade imbued its citizens with an especial appreciation of the value of cooperation and an acquiescence in government interference and support. Individualism was not encouraged. The nobility could certainly construct their fine palaces but, as one writer of the 1580s noted, after describing the haughty aristocrats of the mainland Italian cities, 'the noble Venetians are completely contrary in mood to these; because they go alone [in this case without 'a flock of pages'] with simple clothing; however finely dressed, they keep a

single gondola in the *cavan* that is their stall, and they exercise trade, which was not esteemed by the ancient Roman senators.' Some two hundred and fifty years later, the French writer George Sand attributed the egalitarianism she noted to the nature of the city. 'The lack of carriages and scarceness of land have made for the homogeneous population, who, through jostling one another on the sidewalk or crowding one another in the canals, show concern for the safety of each. All the walking and boating makes for heads on one level, where all eyes meet, where all mouths converse . . .' There were mutterings if any noble family tried to build too ostentatious a family seat. (In fact the Venetian aristocracy modestly used the word *ca*, short for *casa*, 'house', to describe their palaces.) The survival of the Piazza San Marco and its neighbouring Piazzetta as open spaces depended on the restraint of powerful aristocrats who would otherwise have vied for control of the spaces or at least the buildings around them. In Venice, these remained under the supervision of the procurators.

The government as a whole remained relatively broadly based. The Serrata, the law of 1297, turned out to be a turning point in the city's political history. Later historians saw the law with its limiting of government to descendants of the existing nobility, perhaps 4–5 per cent of the population, as the moment when Venice lost its liberty. However, one has only to compare Venice's government in the fourteenth and fifteenth centuries with those of neighbouring cities to get a different perspective. Where one family tended to dominate – the Viscontis in Milan, the Carrara in Padua, the Scaligers in Verona – when a ruler died there was no defined constitution to see the city through the ensuing political vacuum and power struggles. In Venice, by contrast, membership of the Great Council was for life: no one could remove a member under

Opposite: A late sixteenth-century view of St Mark's Square with the Rialto Bridge beyond. In the foreground, right, is Palladio's Church of San Giorgio. The western end of the square was demolished by Napoleon to make way for a palace containing a ballroom. (The Art Archive)

normal circumstances or, from the early fifteenth century onwards, add members from outside the existing noble families, so the Council was impossible to manipulate.

Of course, the size of the Great Council – perhaps 1,100 members in 1300, eventually nearly 2,500 as the original families spawned new branches – made it unwieldy, but a number of smaller councils appointed by it ensured effective decision-making. It elected, for instance, a Senate of about three hundred members which exercised day-to-day supervision over the city's affairs; among other functions, it controlled foreign policy, appointed military commanders and fixed taxation rates. The Senate in its turn appointed a smaller committee, the Collegio, a group of counsellors presided over by the doge, which met almost every day to deal with detailed administrative matters. And there was an even smaller council, the Signoria, composed of the doge and leading councillors, which implemented executive decisions. Its informal power, particularly in shaping foreign policy, was often considerable. All these councils met in the Doge's Palace, the Grand Council in a massive room constructed in the 1340s and still intact (albeit with later decoration, the original having been destroyed by fire). Although many doges were men of impressive ability who had made their way to the top through success in war or trade, in practice the office was a ceremonial one, and increasingly so with time. By the sixteenth century an English traveller was able to note, 'though in appearance he seemeth of great estate, yet indeed his power is but small. He keepeth no house, liveth privately, and is in so much servitude that I have heard some of the Venetians themselves call him an honourable slave.' The doges were not even allowed to have portraits of themselves in public places. The result was that the Serenissima, the most serene republic, maintained its own identity which was sustained from generation to generation.

Yet, however impressive the city in the magnificence of its places and public squares and its apparent harmony and commercial success, Venice as a trading centre was always vulnerable to rivals and the rise of new states. Its commercial single-mindedness ensured

that it aroused enmity. 'If you knew how everyone hates you, your hair would stand on end,' a duke of Milan told the city in the fifteenth century. It was at times of crisis that the horses found themselves transformed into symbols of Venetian independence. There is a story (recorded for the first time in 1497 by a German knight passing through Venice on his way to a pilgrimage) that in the second half of the twelfth century Frederick Barbarossa (Holy Roman Emperor from 1152 to 1190) had threatened to destroy Venice and after his victory plough up the Piazza and use St Mark's as a stable for his horses. The Venetians had seen him off, and it was said that to celebrate their success they had placed the horses on the portico of the basilica and had the Piazza paved with a herringbone pattern to represent ploughing as a riposte to his taunt. The story is found repeated in accounts from the early sixteenth century, some of which replace the emperor with a sultan. Barbarossa had, of course, lived in the period before the horses had even been captured by the Venetians; but the myth shows how strongly they had become identified with the survival of the city.

Another story, this one with a real historical setting, dates from 1379. A war between Venice and its rivals Padua and Genoa had reached a critical stage after Venice's territories had been invaded and the Genoese, with help on the mainland from Paduan troops, had occupied the neighbouring port of Chioggia and so threatened to close off the lagoon. The Venetian Senate was reduced to sending ambassadors to treat for peace. Their approaches were rebuffed by the Genoese commander. 'By faith. You will never have peace from the lord of Padua nor from Genoa until we first put bridles on those unreined horses of yours which stand on the royal house of your Evangelist St Mark.' So by the late fourteenth century the horses were known as emblems of Venetian liberty, to be 'reined in' as a symbol of victory over the city. The Venetians survived the crisis – and there is an appealing story, recorded in a Venetian letter of 1815, that the bits were broken off the horses at this time so that they would be seen by observers to have no restrictions on them.

Yet the political setting within which the horses enjoyed their new status as defenders of Venetian liberty was changing. So long as there was free access to the mainland for supplies and one or two of the many routes into Europe were open, Venice was reasonably secure. During the fourteenth century, however, the states of the mainland were becoming more effective and stable, and persistent warfare between England and France, the Hundred Years War (actually lasting from 1337 to 1453), blocked many routes. Gradually a radical new strategy began to be formulated: Venice should aim to gain permanent control of parts of the mainland — the areas that came to be known as the *terraferma*. A toehold had already been established when Treviso, only a few miles inland, was secured in 1339; but in 1404–5, after Milan had lost its aggressive leader Gian Galeazzo to the plague, Venice took advantage of the power vacuum to seize Vicenza, Verona and Padua. In 1420 the acquisition of the Friuli and Udine brought its territory up to the Alps.

This shift in policy brought new dimensions into Venetian life. On the one hand, the city could now hardly avoid becoming entangled in the complexities of Italian politics; yet on the other new opportunities opened up for its citizens to replace trade with income from land. In the 1420s and 1430s, while dominant both on the land and across the Mediterranean, Venice enjoyed an economic boom — but almost immediately it came under pressure again when, in one of the great turning points in European history, Constantinople fell to the Ottoman Turks in 1453. From now on Venice was on the defensive in the east. There was an important advance in 1489 with the acquisition of Cyprus, but elsewhere the Turks began nibbling away at Venice's colonies. Negroponte on the inner coast of Euboea, the main Venetian base in the northern Aegean, was lost in 1470; Modon and Corone, in the Greek Peloponnese, 'the two eyes of the Republic' as they were known from their important position on the routes to the Levant, in a disastrous war at the end of the century. From the top of the Campanile, the Venetians could see the smoke rising from Turkish

raids on the Dalmatian coast. Equally ominous for Venice's long-term prosperity was the news in 1498 that Portuguese ships under Vasco da Gama had rounded the Cape of Good Hope. There was now a passage by sea, which by-passed the difficult and expensive land routes across Asia, through which the riches of the east travelled to the ports of the Black Sea and the Levant, where the Venetian galleys met them. The sailors of the Atlantic states – Portugal, Holland and England – were now able to siphon off Venetian trade, although the process was a gradual one and Venetian ingenuity and resilience kept the city's economy bouyant for some time to come.

A few years later, Venice's increasingly ambitious forays on the mainland led to serious trouble. A French invasion of Italy in 1494 had unsettled the city-states and Venice took the opportunity to expand even further into northern Italy. Reactions, unsurprisingly, were hostile. The Austrian Habsburgs were outraged when Venetian forces moved along the coast to the east to grab Trieste, the French staked their own claims to cities now free of the control of Milan, while the small neighbouring city-states of Mantua and Ferrara disputed their own borders with Venice. The final straw came when Venice attempted to move into papal territory in Romagna. In retaliation, in 1508 the pope organized an alliance, the League of Cambrai, against the interloper. Venice blustered that it was fighting on behalf of 'Italy and Liberty' but it was a hollow claim and impressed no one. The Venetian forces were routed at the battle of Agnadello near Milan in May 1509, and the humiliation became complete when even the cities of the *terraferma* closed their gates against the fleeing troops. They ended up in disorder on the shores of the lagoon. 'In one battle,' wrote the Florentine statesman and political theorist Niccolò Machiavelli, 'the Venetians lost what in eight hundred years they had won with so much effort.' Venice recovered much of the *terraferma* in the years that followed, but its triumphalism, expansion and even its status as a European power had been dealt a severe blow.

So by the early sixteenth century we are talking of a city which

was still wealthy, which was still untouched by actual invasion (there was talk of Venice's ever-intact virginity, a fitting accolade for a city that claimed the protection of the Virgin Mary), but whose activities had been, and would continue to be, limited and even undermined by new political and economic realities. In Italy itself the most significant of those new realities was the rise of the Habsburg empire under Charles V, who dared to sack Rome in 1527. It was a nasty shock for Venice when Charles, Pope Clement VII and the king of France, whom Venice considered at this point an ally, came to an agreement at Bologna in 1530 which sorted out the affairs of Italy to their mutual advantage with virtually no reference to Venice.

This could have been some kind of final blow to the republic, a humiliation so profound that it broke the city's resolute spirit. On the contrary: remarkably, Venice now entered upon what one might call a contented middle age, which turned into nearly three hundred more years of continued independence. The secret of its survival lay in its enduring political and social stability and a realism honed by centuries of hard commercial bargaining. The 'new look' was summed up by Gasparo Contarini in his *De magistratibus et republica Venetorum*, a book written during the hazardous years of the 1520s but published only in 1543. Contarini's approach was an optimistic one. He did not dwell on the terrible blows Venice had suffered; rather, he marvelled that the city had endured at all. Contarini evolved his own rationale for Venice's survival, which he attributed to its unique constitution, with its mixture of unity and diversity, its maintenance of an ordered hierarchy that was yet open to change from below. 'Such moderation and proportion characterise this Republic and such a mixture of all suitable estates that this city by itself incorporates at once a princely sovereignty, a governance of the nobility, and a rule of citizens so that all appears as balanced as equal weights.' Drawing on the Greek philosopher Aristotle, Contarini assumed that there was a perfect state of government, a natural order of things under which a city grew organically to a final and irreversible state of well-being – and in his view, joy of joys,

Venice had achieved it. If one looked at past examples, Contarini went on, Venice could be compared with Greece under the Roman empire. The Greeks may have been subservient to the power of the Roman legions, but everyone knew that they remained the arbiters of culture and civilization.

By now the horses of St Mark's, which may originally have been associated with the imperial ambitions of the doges, had become part of the city's heritage. The point is made in a silver plate, probably crafted in the sixteenth century, which survives only in a nineteenth-century terracotta copy, on which they are shown arriving in Venice on a sea shell. The setting draws on classical motifs. The doge, dressed as an ancient warrior, is placed beside the horses. Above him floats a personification of Victory holding a victory wreath, which she offers him while her other hand unfurls a banner of St Mark. The doge himself offers the horses to another personification, this time of Venice herself, shown with a lion peacefully settled beside her. Nereids and tritons cavort in the water. So the horses are integrated into the history of Venice, almost as if they were a divine offering to the city.

10

THE SEARCH FOR THE HORSES' ORIGINS

WE LAST MET PETRARCH STANDING ALONGSIDE THE DOGE on the *loggia* of St Mark's in 1364. We now go back to a letter he wrote over twenty years earlier, in 1341, to a friend of his, Giovanni Colonna. Petrarch reminisces of the time he and Giovanni had spent scrambling over the ruins of ancient Rome. They had ended up on the roof of the Baths of Diocletian, where they had perched while discussing the history of the city. Petrarch, as he remembered, had divided the Roman past into two: the years before the coming of Christianity, when Rome ruled its great empire, and the Christian centuries that followed. In this Petrarch was expressing a new, distinctively Renaissance, attitude towards the past — one in which it was broken down into historical periods that were then distanced and explored as discrete entities, rather than being seen as an undifferentiated mass of ruins and texts.

Petrarch was careful not to denigrate Christianity (he claimed that the Pantheon, the finest classical building still standing in Rome, would never have survived had it not been protected by the Virgin Mary, whose church it had become), but he could never hide his enthusiasm for the grandeur of ancient Rome. He was one of those who lived through texts rather than through objects, and he approached the city through its great classical writers, above all the

historian Livy and the epic poet Virgil, whose works he linked to what he found scattered in the ruins. Actually, he hated to use the word 'ruin' for what he found – he preferred *vestigia*, 'traces' of the past into which he could breathe life. Recall how he described the horses on St Mark's; they 'stand as if alive, seeming to neigh from on high and paw with their feet'. In his enthusiasm he tended to overlook any detail which might undermine his romanticized attributions. The pyramid on the edge of the walled city of Rome, built by the senator Cestius as a mausoleum in the first century AD and clearly marked with the occupant's name, was claimed by Petrarch to be that of no less a figure than Remus, the joint founder (with Romulus) of Rome! For Petrarch the past was there to nourish the present. When he had an audience with the Emperor Charles IV, Petrarch

gave him as a gift some gold and silver coins bearing the portraits of our ancient rulers and inscriptions in tiny and ancient lettering, coins that I treasured, and among them was the head of Caesar Augustus who almost seemed to be breathing. 'Here, O Caesar,' I said, 'are the men whom you have succeeded, here are those whom you must try to imitate and admire, whose ways and character you should emulate: I would give those coins to no other save yourself.'

Petrarch's family background was Florentine, although he was actually born in Arezzo (in 1304), and he travelled widely all his life, both in Italy and in southern France. He had first visited Venice in 1321, when he was still a student, but did not return until 1349. It was only in his later years, when renowned as a scholar and poet and living in the university city of Padua, which was not yet under Venetian control, that he grew to love the city. In 1361 he decided to move there, and made a bargain by which he was given a respectable house by the state in return for leaving his books to Venice. He was an honoured guest, enjoying the admiration and patronage of the cultural elite of the city – and, as we have seen,

receiving an invitation to stand alongside the doge and the horses on the *loggia* of St Mark's during the victory celebrations in 1364. (Sadly, Petrarch's promise to leave his library to the city was never honoured; he left Venice in distress in 1368, when a group of young intellectuals ridiculed his scholarship.)

Petrarch appears to have motivated at least some of his admirers into taking an interest in the classical past even before he had become domiciled in the city. For instance, a manuscript of the *Lives of the Caesars* by the second-century-AD Roman author Suetonius was copied in the city in about 1350. The copiers illustrated their text with portraits of the emperors: most were taken from Roman coins, but there is also an illustration of Julius Caesar on horseback. It is virtually unheard of for a manuscript this early to be illustrated from Roman originals, and it seems reasonable to suggest that the classical scholar Petrarch's visit to Venice in 1349 provided the inspiration. It is interesting to see that Caesar's horse, standing with one foreleg raised, is clearly modelled on those of St Mark's. The horses have been neatly slotted into a Roman past, back perhaps to the centuries in which they originated.

That the Suetonius, a Roman text illustrated with Roman examples, is, for its period, unusual reflects the fact that Venice in the fourteenth century, before the *terraferma* had been acquired, was still unsure of its Roman heritage. More was to be gained – more had been gained – through the city's links to the Byzantine east, where Constantinople provided a glittering model of eastern splendour and where Venice owned an empire scattered with ancient Greek cities and monuments. As we have seen, the doges drew on Byzantine models in constructing rituals through which to display their power. There was, too, a continual influx of Greeks into the city. 'Though nations from all over the earth flock in vast numbers to your city, the Greeks are the most numerous of all; as they sail in from their own regions they make their first landfall in Venice, and they have such a tie with you that when they put into your city they feel they are entering another Byzantium.' So enthused the Greek cardinal Bessarion, who was to leave his own library of Greek

texts to the city. He was speaking with hindsight. The fall of Constantinople to the Turks in 1453, which Bessarion had desperately tried to prevent by urging a new crusade, had brought a mass of refugees, many of them distinguished scholars, flooding into the city. They carried with them priceless Greek manuscripts, and one even finds a revival of Byzantine influence in Venice's architecture at this time. Several Venetian churches of the late fifteenth century are modelled on Byzantine church plans.

It was just in these years, however, that Venice also began appropriating a Roman past. In the fourteenth and fifteenth centuries the predominant architectural style had been the Venetian gothic so beloved of the English scholar and artist John Ruskin. The supreme achievement of the gothic era was the Doge's Palace, rebuilt along its façade with the lagoon when a larger meeting room was needed for the Great Council in the 1330s, and then extended in the fifteenth century in the same style along the Piazzetta. It was common for Italian city-states to create city halls, but Venice's was unique in its openness to the world, an openness made all the more spectacular by its setting on the water's edge: 'through the immense windows of its upper storey the Ducal Palace breathes in the sun and the seas,' as the French scholar Élisabeth Crouzet-Pavan has put it. The design — a *loggia* set on columns with a solid mass of masonry above (with crenellations that are Islamic in inspiration) — echoes that of eastern buildings, in particular those of Mameluke Egypt, and — as so often in Venice — the finished building is like nothing anywhere else. Remarkably, the different styles — the classical columns, the Gothic tracery and the eastern ingredients — fit together in harmony.

However, to the later despair of Ruskin, one can see other influences at work, especially those derived from Rome. While the conquest of Constantinople in 1204 might have given the inspiration for the thirteenth-century rebuilding of the façades of St Mark's as a series of triumphal arches, by the fifteenth century the Roman influence is more pervasive. When a new gateway to the Arsenale, the naval dockyard, was built in 1460 it was modelled on

an original Roman triumphal arch which was still standing in Pola, a Venetian city on the Dalmatian coast. Then there was the Scala dei Giganti, the great ceremonial staircase of the Doge's Palace, completed in the 1490s, under which there is a small prison. The stairs were designed to recreate the final ascent of the victorious Roman general or emperor to the Capitoline Hill, at which moment his captives would be led away for execution. The 'prison' was built into the staircase as a symbol of this segregation of conqueror from conquered – ancient Rome brought into the heart of Venice.

The turn towards a Roman architectural heritage was mirrored by a refashioning of Venice's own past. An *Itinerario*, a journal of travels (in this case on the *terraferma* in 1483) by the young Venetian Marin Sanudo, who was to become one of the great diarists of Venetian daily life, details the Roman past of each city of Venice's new empire. Then, in a history of Venice commissioned by the city government and published in 1487, we find the links between Venice and the mainland accentuated by stressing that the Venetians themselves were descended from Roman stock. Soon the older families of the city began constructing Roman pasts for themselves. The Cornaros managed to get themselves back to Scipio Africanus, who had defeated Hannibal at the end of the third century BC, while the Contarinis linked themselves to the Aurelii, the family of the greatly admired second-century emperor Marcus Aurelius.

The point to be made is that Venice, unlike any other European city, managed to find roots in both the Roman and the Greek past. It had two heritages and could draw on either at will. It is fascinating to find that even St Mark was incorporated into this double heritage. A preacher in Venice in the middle of the eleventh century referred back to the translation of St Mark's body to Venice. 'As the East, until very recently, was lit up by a golden radiance, now it is the West which glows in the rays of his presence.' Again, to take a fourteenth-century example, Debra Pincus has argued that the figures on the tomb of Doge Giovanni Soranzo show the amalgamation of eastern Byzantine styles with 'the architectural solidity' of western gothic.

This quintessentially 'international' Venetian style was to be developed and elaborated in the years to come. How closely intertwined Greek and Roman became can be seen from the works of the great printer Aldus Manutius. By the time of his death in 1515, Aldus had published fifty-five texts in Greek and sixty-seven in Latin, as against only six in Italian. Thirty-one of the Greek texts were the first printed editions and confirmed Venice as the cultural capital of the Greek world now that Constantinople had been lost, but its production of Latin texts was no less important. Surrounded by relics from the past — architectural, artistic, literary — the Venetians recognized that they might be either Greek or Roman, or could even have lines of descent from both Greek and Roman. This was the context in which the horses of St. Mark's would be viewed and appreciated.

The man who first considered the horses as classical art in their own right was not Petrarch but one Cyriacus, a native of Ancona, an Adriatic city to the south of Venice. Cyriacus (c.1391–1453) had first become aware of the remains of the classical world when he studied a Roman arch from the reign of Trajan in Ancona. He realized that it was disintegrating and would soon be lost, so even though he could not speak Latin he copied out the inscription on the arch before it disappeared. (The inscription became his 'trademark' and he often reproduced it as a frontispiece to his works.) Cyriacus mastered Latin and then, during a stay in Constantinople, Greek, through the works of Homer, and embarked on extensive travels through the Mediterranean — sometimes as an envoy for Pope Eugenius IV, a friend of his; sometimes in his own capacity as a merchant of carpets, antiquities and slaves. His knowledge of classical literature was not so great as Petrarch's but he absorbed, through his travels, a much greater awareness of the Greek contribution to the classical world. Like Petrarch, Cyriacus believed passionately in bringing the past alive. It was the responsibility of the scholar 'to restore the dead . . . to revive the glorious things that were alive to those living in antiquity but had become buried and defunct . . . to bring them from the dark tomb

to light, to live once more'. Unlike Petrarch, he valued objects more highly than texts, and during his travels he made detailed drawings of what he found. One of the great wonders of the ancient world was a temple to the cult of the Roman emperors at Cyzicus, a commercial city on the Sea of Marmara, built by Hadrian. Today only a mound remains on the site, but Cyriacus' drawings provide a record of what was still standing in his day. It is thanks to him that the tomb of Philopappus in Athens, described earlier, is known in such detail, and he has also left the earliest surviving drawing of the Parthenon.

Many of the cities Cyriacus visited during his travels in the eastern Mediterranean were, of course, outposts of the Venetian empire, and it was inevitable that he would come to Venice itself. He had actually visited the city for the first time with his father, also a merchant, when he was only nine. He returned as an adult in 1432 or 1433, when he is found selling ancient manuscripts and coins of Alexander the Great and Philip of Macedon to local collectors. It was on a slightly later visit, in 1436 or 1437, that he climbed up to the *loggia* of St Mark's, examined the horses properly and recorded his thoughts about them:

> Then after we had looked at all the major sites of the city for three days we finally made our way to the holy and highly decorated temple of St Mark where first we were allowed to inspect – not once but as long as we liked – those four bronze chariot horses which are so splendid a work of art and most elegant design, the noble work indeed of Pheidias, and once the glory of the temple of warlike Janus in Rome.

While Petrarch had recorded his enthusiasm for the horses, making no attempt at an attribution ('some ancient and famous artists unknown to us') and concentrating instead on their emotional impact, Cyriacus, less romantic and more interested in the accumulation of historical detail, tries to pin down their origin. He is ready to identify them as the work of one of the greatest

sculptors of the ancient world, Phidias, whose work he believed he had seen on the Parthenon in Athens. He does not suggest an original location for the horses, but he must have known from his readings that the Romans looted masterpieces to take to the capital. He also associates them with a specific temple in Rome, but there is no record of why he chose the Temple of Janus (it was, in fact, a double triumphal arch rather than a temple) as their home in Rome.

The practice of attributing admired statues to a great sculptor of the past was a common one not only in Renaissance Italy but in Roman times. Two huge marble horses, each with a naked horseman beside it, the Dioscuri, survived from imperial Rome and remained in their original setting in the city (where they can still be seen today, in what is now the Piazza del Quirinale). We now know them to be Roman copies, of uncertain date, of Greek fifth-century originals, but in the late empire they had been treated as the originals themselves and inscriptions had been added to them: *Opus Fidiae* and *Opus Praxitilis*, 'the work of Phidias' and 'the work of Praxiteles'. Neither Praxiteles nor Phidias was a surprising choice for any sculpture of quality. Phidias' links to the Parthenon and to the famous cult statue of Zeus in Olympia were well known, while Praxiteles' Aphrodite of Cnidus, the first life-size statue of the goddess nude, had been copied and recopied since the fourth century BC.

The names of these great sculptors of the classical past came to the fore in the Renaissance after the recovery of Pliny the Elder's *Natural History*, a work dating from the first century AD and translated into Italian for the first time by the Florentine sculptor Ghiberti in the fifteenth century. It is a long and rambling work that ranges over a bewildering variety of subjects, but it was highly influential in spreading the idea that sculpture and painting had reached a pinnacle of excellence in ancient times. For example Pliny told of the painter Apelles (fourth century BC), who could create a painting of grapes so realistic that birds would fly down to eat them. To show off his talent Apelles then persuaded some fellow artists each to paint a horse.

Some real horses were then shown the assembled paintings. They remained unmoved, Pliny records, until they saw Apelles' version, at which they neighed! Among workers in marble and bronze Pliny praised especially Phidias, Praxiteles and Lysippus, the favourite sculptor of Alexander. He claimed that Lysippus had created no fewer than 1,500 statues, many of them *quadrigae*, the greatest of which was 'a Chariot of the Sun' for the people of Rhodes.

By the end of the sixteenth century Lysippus was also being credited with the four horses of St Mark's. 'They say they are the work of Lysippus,' wrote Pietro Giustinian in 1560, and in 1581 another Venetian chronicler, Francesco Sansovino, was even more confident, pronouncing them 'sculpted indeed by Lysippus'. He is echoed by the Englishman Thomas Coryat, who spent some time in the city in 1608, although Coryat had also heard an alternative story of a Roman origin. There was no evidence for Lysippus' involvement other than Pliny's text, but it was typical of the age to find a text or illustration – on a coin, for instance – and immediately link it to a surviving sculpture. It was in the mid-sixteenth century that the *Parastaseis Syntomoi Chronikai* from Constantinople was first published, in Paris, and so the story of the set of horses from Chios above the hippodrome in Constantinople became current; many writers immediately identified them with the horses of St Mark's, as some still do.

Meanwhile, the life the horses were assumed to have led in Rome was elaborated. The most fruitful text was the *Annals* of the historian Tacitus, composed in the early second century AD, which told of the aftermath of the Emperor Nero's peace treaty with the Parthians. On the basis of Tacitus' writings it was believed that a *quadriga* might have come to Rome either as a gift from King Tiridates of Armenia, who had been confirmed in his kingdom by Nero and who had visited Rome in AD 66, or directly as loot from Parthia. Among the antiquities being amassed by Renaissance collectors were coins from Nero's reign showing the triumphal arch erected on the Capitoline Hill in celebration of the victory over the Parthians, and these were believed to show the St Mark's horses on the top. However, each of

the horses on the coins is shown with its left leg raised, while the St Mark's horses have either the right or left leg raised, and so the attribution is unlikely to be valid (see the illustrations on p. 48). Others claimed that the horses had originally stood on a triumphal arch of Augustus or even on his mausoleum. These different stories left many observers confused. Sansovino wrote that some believed the horses to be from Lysippus' Chariot of the Sun, transported to Rome to be placed on Augustus' mausoleum, then rededicated by Nero in celebration of the peace treaty with the Parthians, before being taken to Constantinople by Constantine! 'Whatever the truth,' he concluded, reasonably enough in the circumstances, 'it is uncertain for everyone.'

These attempts to find origins for the horses were stabs in the dark, as Sansovino suggested. As yet almost nothing was known about ancient sculpture. No one had sorted out a sequence of styles and so it was impossible to distinguish a statue from the classical period (480–323 BC) from one of the Hellenistic period (323–31 BC) and another from the Roman period (after 31 BC). Nor was it appreciated just how many statues from the ancient world had been lost – the vast majority, in fact – or how high a proportion of those that had survived were no more than copies of originals. For an illustration of just how confusing the remains of the past could seem, we can turn to an *Itinerario* by a Venetian subject, Fra Urbino from Belluno, who visited Athens sometime between 1475 and 1485.

His immediate problem was that the Acropolis was covered with a mass of later buildings. The Parthenon itself had been transformed first into a Christian church and then, after the fall of Athens to the Turks in 1456, into a mosque. (It was only in the nineteenth century that the later accretions were cleared away to create the 'pure' fifth-century BC Acropolis in shining white marble that we see today.) Fra Urbino even fails to recognize the site as Greek. This is what he says:

And on the summit of the mountain the fortress is built, and there is a very strong castle and ancient walls with square

stones . . . and in the castle there is a church [i.e. the Parthenon] that was once an ancient temple of the Romans [*sic*], most admirable and all of marble with columns around . . . and on the façade in front are an infinite number of images of marble in relief . . . And there is also in the castle a most noble ancient palace near the church, and it is all of marble, built *alla romana* . . .

When such confusion of Greek with Roman was commonplace, it is no wonder that the attributions of the horses could be little more than guesswork.

It is almost impossible to grasp today how difficult it was four hundred years ago to get accurate drawings or images against which statues could be compared. There was a natural tendency for draughtsmen to view images through the conventions of their time. The earliest known drawing of the Parthenon, by Cyriacus of Ancona (of what was then still a church), was inaccurate in that he represented an Athena clad in a Renaissance gown instead of the original classical *chiton*, and transformed the figures on the west pediment into Renaissance *putti*. Even the angle of the pediment was set much too high. A later artist, Giuliano da Sangallo (*c.*1510), worked from Cyriacus' inaccurate drawing of the pediment but drew the columns of a Roman temple below it so that some came to believe that the Parthenon had been rebuilt by the Romans (an idea already promulgated by Fra Urbino, who had seen the real thing). The seventeenth-century drawings of Jacques Carrey, famous because they show reliefs which were later destroyed when the Parthenon was blown up by a Venetian shell in 1687, made the sculpted figures look much more exuberant than they really were.

None of these drawings were printed (the first printed drawing of the Parthenon was published only in the eighteenth century) and few people were able to visit Athens, now a backwater of the Ottoman empire; so there was, in effect, no reliable representation of Phidias' work available. As far as identification of the sculptures of the Parthenon was concerned, things were made worse by the failure to realize that the original entrance to the temple was from

the east, not the west, the end one first comes to on ascending the Acropolis and which, even today, one can all too easily assume to be the original front of the temple. It was not until 1762 that the correct entrance was identified by James Stuart and Nicholas Revett in their *Antiquities of Athens*. The second-century AD Greek traveller Pausanias had described the scenes on the pediments as they stood in his time, but because of the mix-up over which end was the front his description of the pediment over the entrance was applied to the pediment at the back (western end) of the Parthenon and vice versa! Although Cyriacus associated the sculptures of the Parthenon with Phidias, later visitors failed to grasp that all the reliefs were from the fifth century BC; as we have seen, some, knowing that the emperor Hadrian had carried out a major building programme in Athens, thought they were Roman.

In short, it would have been impossible in the sixteenth century to have made any comparison between the horses of St Mark's and the original works of Phidias, if, indeed, the sculptures of the Parthenon are his.* All these attributions were guesswork. Pliny had, in any case, specifically linked several other sculptors with *quadrigae* – not only Lysippus but a Calamis, a Euphranor and a Pyromachus who had sculpted the Athenian Alcibiades, victor in the Olympic Games of 416. All that could be said was that *quadrigae* were common in the ancient world; without any evidence on the horses themselves of their makers, it was impossible to go further.

*Phidias is normally given credit for the inspiration of the Parthenon marbles, even if the actual sculpting of them was not his. He is known to have sculpted the huge cult statue of Athena that stood inside the Parthenon.

I I

THE IDEAL HORSE?

The artists of the Veneto, within the narrow confines of their drawings, portray the forms of beautiful antique figures in marble and sometimes bronze which are lying around or are preserved and treasured publicly and in private, and the arches, baths, theatres and various other buildings which still stand in certain places there; then when they plan to execute some new work, they examine these models, and, seeking to produce likenesses of them with artifice, they believe their labours will earn them the more praise the more nearly they manage to make their work resemble the ancient ones; so they work, aware that the ancient objects approach the perfection of art more closely than do those of more recent times.

Pietro Bembo (1470–1547), who wrote this passage in 1525, was one of those complex characters who make the study of Renaissance intellectual life so interesting. A native of Venice and son of one of its leading nobles, he wavered between religious and secular life, managing to become a cardinal despite fathering three children with one Moresina, the great love of his life. He travelled widely from one Italian court to the next, and even had a spell as secretary to the pope. He could read Latin and Greek, and was seen as one of the

finest Latin stylists of his time; but he also rejoiced in writing love lyrics in Italian, though his enthusiasm for the vernacular tongue (he championed the Tuscan Italian of the fifteenth century) damaged his status as a scholar among more austere intellectuals. He was an associate of Aldus, the Venetian printer, and was responsible for creating critical editions of the Roman poets Virgil and Horace, as well as Petrarch and the great Dante. Immensely rich by the time he reached fifty, he retired to a villa near Padua which he filled with both antiques and the works of the finest artists of his day, among them Mantegna, Giovanni Bellini and Raphael. He even wrote a history of Venice, some of which was censored by the Senate when it described the characters of prominent Venetians he had known rather too perceptively.

Bembo's comments on antique art echo those of Pliny the Elder. The antique becomes an object of admiration in its own right simply because it is a representative of the age in which art was perfected. Even something so apparently mundane as Roman pottery aroused the same adulation as the finest Greek sculpture. As early as 1282 one Ristoro of Arezzo, newly aware of discoveries of Roman ware from his native city, captured the mood of excitement.

> The *cognoscenti*, when they found ancient Aretine vases, they rejoiced and shouted to one another with the greatest delight, and they got loud and nearly lost their senses and became quite silly; and the ignorant wanted to throw the vases and break them up. When some of these pieces got into the hands of sculptors and painters or other *cognoscenti*, they preserved them like holy relics, marvelling that human nature could reach so high.

This treatment of antique objects as sacred relics reached a bizarre climax in 1413 when some bones were found in a lead sarcophagus in a graveyard in Padua. Somehow they were assumed to be those of none other than the great Roman historian Livy, who was born and died in the city, and immediately intellectuals and

sightseers flocked to the scene as if it were the shrine of a saint. Despite the attempts of an enthusiastic monk to break up the bones of this pagan, they were carried off into the city in procession and placed in a casket over an entrance-way to the city's Palazzo della Raggione, the vast thirteenth-century meeting hall. The spiritual boundary between Christianity and paganism dissolved in this outburst of fervour.

If ancient art has reached perfection, then perhaps the Renaissance artist should attempt to imitate it. In a treatise on painting, the *Dialogo della Pittura* (1557) by the Venetian Ludoviso Dolce, an imaginary dialogue is constructed between Pietro Aretino, connoisseur, collector and champion of the Venetian Titian, who had died in Venice in 1556, and one Fabrini, who argues for the supremacy of the Florentine Michelangelo over Titian. Aretino expounds his view of ancient sculpture.

> One should also imitate the lovely marble or bronze works by the ancient masters. Indeed, the man who savours their incredible perfection and fully makes it his own will confidently be able to correct many defects in nature itself and make his paintings noteworthy and pleasing to everyone, for antique objects embody complete artistic perfection and may serve as exemplars for the whole of beauty.

This approach is that of the Greek philosopher Plato, who became highly influential in the fifteenth century, notably through the works of the Florentine Marsilio Ficino (1433–99). Ficino had been installed by the great patron Cosimo de' Medici in a Medici villa outside Florence with a mass of Greek manuscripts, and from them he compiled the first complete translation of Plato in Latin.

Plato, writing in the fourth century BC, had argued that many qualities, including beauty, existed on an eternal plane in Forms or Ideas which contained the essence of the quality. No object of beauty in the natural world could equal the perfection of the Form of Beauty, although it might provide an imitation of it. Pliny, in his

Natural History, had given his own example from the ancient world. One of his 'great' Greek painters, Zeuxis, was commissioned by the city of Croton (in Italy) to paint a Helen, a woman so beautiful that that Trojan War had been fought over her. Zeuxis selected five local girls and posed them in the nude. Of course, none of them was perfect; but he selected the best parts of each, brought them together and in his painting created the most beautiful woman he could. For Plato such a 'beautiful woman' might give the earthly observer a glimpse of what the Form of Beauty might be like, but, as with any object in the material world, it would always fall short of the ideal. In the Platonic tradition the artist had to labour, as Zeuxis had done, to come as close as it was possible on earth to reach the Form. This approach stood in sharp contrast to another view of the artistic mission that was also popular in the fifteenth century: that the task of the artist was to portray the natural world as it existed before his eyes. In the Platonic view the artist could, on the contrary, liberate himself from slavish copying and use his imagination to create an ideal against which any object in the natural world would seem defective.

Many Platonists believed that underlying 'the ideal' was a geometrical proportion: in a sculpture of a human body, for example, a canon of ideal relationships between different parts of the body. This view derived from Greece, even, in fact, before the time of Plato. A fifth-century BC sculptor from the Greek city of Argos, Polyclitus, had even written a book, the *Canon*, now lost, setting out the correct proportions in mathematical terms. 'Perfection is the step-by-step product of many numbers,' he had stated. With the rediscovery of classical writers in the Renaissance, this idea had been resurrected for architecture by the brilliant Florentine humanist Leon Battista Alberti. In his enormously influential *The Art of Building*, compiled in the 1440s and 1450s, Alberti argued for the existence of ideal proportions, setting out theorems that express the required geometrical ratios. We know that *The Art of Building* made its impact in Venice because the Torre dell'Orologio, the clock tower in the Piazza San Marco that was

constructed in the late fifteenth century, conformed to Alberti's recommended proportions for towers in its 1:4 ratio of width to height and its placing 'at a point where a road meets a square or a forum'. In Venetian art the Platonic approach may be seen in Giorgione's *Sleeping Venus* of 1510, a painting in which Venus' sensuality appears elevated beyond the material world of desire. The dreamy landscapes and Madonnas of Giovanni Bellini convey the same Platonic sense of eternal perfection.

The horses of St Mark's could hardly escape being caught up in the enthusiasm for ideals. They were seen as items of quality simply because of their age and provenance; but also, in so far as it was believed that the ancients were imbued with Platonism, they could also be revered as examples of the ideal horse. Moreover, if the artists in the Veneto area were looking for exemplars, there were simply no other standing horses from antiquity to copy from. If one finds a drawing, by an artist of the period who has worked or lived in Venice, of a horse standing on three legs with one foreleg raised, it is likely that it has been modelled on the St Mark's horses. Take the Florentine artist Paolo Uccello, who had lived and worked in Venice between 1425 and 1430 and who is credited with a mosaic of St Peter, now lost, that was positioned on the top left-hand corner of the façade of the basilica, not far from the horses. We can assume that he must have observed them in detail. When he returned to his native Florence, Uccello was commissioned to paint a fresco in Florence's cathedral in memory of Sir John Hawkwood, an Englishman who had successfully led Florence's troops over a period of eighteen years. By chance Uccello's original drawing survives, and it shows how much he was taken with 'ideal' perspectives. It is one of the earliest drawings to be made on squared paper, and much of the design is geometrical, as Polyclitus would have recommended. The top of the horse's rump is the arc of a circle, for instance. The horse itself is modelled on one of the St Mark's horses in so far as it has the front right foot lifted and the rear right foot well in advance (in fact further in advance than that in the St Mark's model). Uccello is trying to dignify his horse by

drawing on classical models but at the same time trying to create an ideal horse. His patrons seemed not to have approved as the fresco itself is much more natural, the rump of Sir John's horse flat in comparison to the sketch. The link to antiquity was nevertheless preserved by painting the horse in a brownish green which suggests bronze, seen at this time as the most prestigious of ancient materials.

The first Venetian artist to incorporate the principles of the Florentine Renaissance into Venetian art was Jacopo Bellini, father of the painters Gentile and Giovanni. His contemporaries saw him as reviving the standards and proportions of ancient art. 'How you may exult, Bellino, that what your lucid intellect feels your industrious hand shapes into rich and unusual form. So that to all others you teach the true way of the divine Apelles and the noble Polycleitus,' as one sonnet by a contemporary put it. Two albums survive of his drawings, which he seems to have treasured and on which he worked for forty years (c.1430–70). His subject matter reflects a mixture of Christian themes (the trial and crucifixion of Christ; St George and the dragon) and those of Roman antiquity. Some show horses, in all kinds of poses, some ridden, some not, and many of these are reminiscent of those on St Mark's in their stance or the way they hold their head. It seems indubitable that Bellini knew the horses well and used them as an ideal, adapting them as necessary in his drawings.

One subject which required a standing horse was that of St Martin giving his cloak to a beggar. The story goes that the fourth-century Martin, who came from Hungary, then part of the Roman empire, met a beggar and cut his cloak in half to share with him. Martin was not yet a Christian but then had a vision of Christ wearing the complete cloak, and it was this which led to his conversion. It was a popular story in medieval times and a favourite among artists. A Venetian artist looking for a model of a standing horse for a depiction of St Martin and the beggar would find one in the horses of St Mark's. In a polyptych by Paolo Veneziano (fl. 1320–60 and the earliest Venetian painter whose work is

In the notebooks of Jacopo Bellini (compiled 1430–70) there are many representations of horses which are clearly modelled on those of St Mark's. The horses would have been the only full-size examples of ancient horses available for a Venetian artist. (Museés Nationaux, Photo RMN–Gérard Blot)

distinguishable from others') in the Church of San Giacomo Maggiore, Bologna, Martin's horse is indeed standing with a foreleg slightly raised, although his head is lowered, unlike those of the horses on St Mark's. A hundred years later Martin, his horse and

the beggar are found on a panel of a polyptych by the Venetian artist
Vittore Carpaccio (1465–1526) in the Cathedral of St Anastasia in
what was then the Venetian subject city of Zara (now Zadar in
Croatia). This horse, seen from the front with its head turned
towards the beggar, has a real feel of a St Mark's horse. Perhaps, too,
one can see a likeness to the St Mark's horses in Carpaccio's *The
Crucifixion of the Ten Thousand Martyrs on Mount Ararat*, now in the
Accademia in Venice. There are a number of horses in the picture

The horses of St Mark's provided a model for many Venetian artists. Here
Paolo Veneziano (active 1320–60) uses one to portray the famous legend of
St Martin dividing his cloak with a beggar. (The Church of San Giacomo
Maggiore, Bologna.) (S. Giacomo Maggiore, Bologna/Scala)

of which four, each with a rider, stand together in the middle foreground; the one on the left in particular seems inspired by those on St Mark's.

A further possible echo of the St Mark's horses can be found in the work of the German painter and engraver Albrecht Dürer (1471–1528). Dürer, who was already known beyond his homeland for his woodcuts and engravings, spent some time in Venice in the early sixteenth century, and was a favourite in aristocratic circles, though his position was never secure: awarded commissions in the city, he aroused the envy and scorn of the local artists, who several times tried to call him before the magistrates for trespassing on the preserve of the city's guild of artists. The horse in his engraving *The Knight, Death and the Devil* is considered by some to have been fashioned after those of St Mark's – but this must remain a tentative suggestion only, for by 1513, when the engraving was made, Venetians had another impressive bronze horse to use as a model: that sculpted by Andrea del Verrocchio in his equestrian statue of the *condottiere* Bartolomeo Colleoni, erected in the Campo dei Santi Giovanni e Paolo in Venice in 1496. Certainly by the beginning of the sixteenth century, the St Mark's horses seem to disappear from paintings and drawings – except, of course, those, like Gentile Bellini's *Procession in the Piazza San Marco* of 1496, where the horses provided the backdrop to the procession.

In fact, we can see a shift in emphasis around this time: now the horses are no longer viewed just as ideals for artists to copy but as tourist attractions. By the sixteenth century the horses begin to be cited in guides to the city as a 'must-see' for visitors. One Venetian, Anton Francesco Doni, compiled a list of the treasures of the city in 1549. They include works by Giorgione, Titian and Dürer, but heading the list is none other than 'the four divine horses'. Francesco Sansovino, in his exploration of the 'most noble and singular city of Venice' (1581), stresses their perfection, describing them as 'four antique horses of such rarity that even to this day they have no equal in any part of the world'. In his earlier short guide to 'the remarkable things of the city of Venice', produced in 1561, Sansovino had

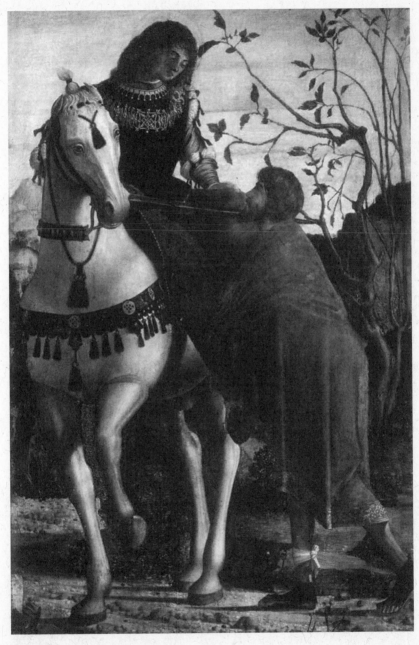

St Martin appears again in this panel by Vittore Carpaccio (1465–1526) to
be found in the cathedral at Zadar. The horses were ideal models for those
who needed to show a horse standing. (Alinari Archives, Florence)

created a dialogue between a Venetian, Veneziano, and a visitor to the
city, Forestiero. They enter the Piazza San Marco and gaze up at the
horses:

> *Veneziano*: . . . It is true that they are difficult to appreciate at
> that height, but up there they do not obstruct the Piazza
> and are out of the way of the people.
>
> *Forestiero*: I confess to you that truly the Cavallo of the
> Campidoglio in Rome is of less beauty than these, though
> it is larger, and that of SS. Giovanni e Paolo is not to be
> compared with them.

Now that travel around Italy was easier, the horses of St Mark's
began to be compared with other bronze horses. The 'Cavallo of the
Campidoglio', the equestrian statue of the emperor Marcus Aurelius
which dated from the reign of the emperor itself (AD 161–80) was
certainly a worthy rival. It seems to have spent all its life in Rome.
When it first emerges in sources from the middle ages it is found
in front of the cathedral of St John Lateran in the south of the city,
and was believed then to be of the Christian emperor Constantine
who had founded the cathedral in the early fourth century. This
almost certainly explains why it was never melted down in the
cataclysmic destruction of pagan art which accompanied the 'triumph'
of Christianity. By the end of the middle ages, this attribution had
been challenged, and a wide variety of Roman heroes and emperors,
including Hadrian, were suggested instead as its subject; but when
Michelangelo transferred the statue to the Capitoline Hill (the
Campidoglio) to serve as the centrepiece of his new Piazza in 1538,
the horseman's identity was still unknown, and so the statue came
to be known simply as Cavallo, 'the horse'. (The attribution to the
emperor Marcus Aurelius was fully accepted about 1600.) None of
this uncertainty affected the admiration of the statue. It is the
model for the earliest known Renaissance reproduction of an
antique statue in bronze, by the Florentine sculptor Antonio
Averlino (normally known as Filarete, from the Greek, 'lover of

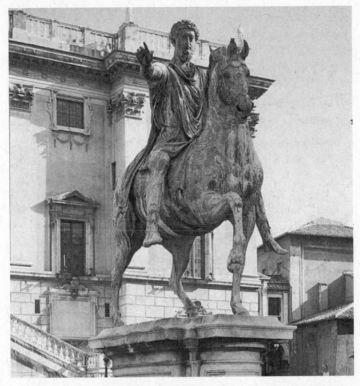

The famous equestrian statue of Marcus Aurelius, one of the most influential statues of antiquity and an inspiration for sculptors from the fifteenth century onwards. (Piazza del Campidoglio, Roma/Scala)

virtue'), possibly made in the 1430s, and more engravings were made in the sixteenth century of the Cavallo than of any other ancient sculpture. A legend records that Michelangelo was so moved by the horse that he asked it to step forward. 'Don't you know that you are alive?' he challenged it. It was even said that the end of the world would be announced through its mouth.

This was an ancient statue, so was revered for its own sake; but now the Venetians had a contemporary bronze equestrian statue in the centre of their own city, Verrocchio's monument to Bartolomeo Colleoni. To honour a military hero by presenting him on horseback was a practice with the most ancient and respectable of precedents, as the bronze of Marcus Aurelius makes abundantly clear. In the

fifteenth century we find equestrian statues appearing on the tombs of Venetians as they begin to construct a Roman past for themselves. The earliest example is the monument commemorating Paolo Savelli in the Church of Santa Maria dei Frari. Here again is a horse which might be said to have been modelled on one of those on St Mark's. The right foreleg is lifted, the head is turned slightly and although there is a full mane, in contrast to the cropped manes of the horses on the basilica, the tail is tied with a knot in the same way. Verrocchio, however, was a Florentine and looked elsewhere for his influences. According to Vasari's sixteenth-century *Lives of the Artists*, Verrocchio was deeply impressed by the Marcus Aurelius, but he would also have been aware of another great bronze equestrian statue from recent times, that created by his fellow Florentine, Donatello, of the Venetian *condottiere* Erasmo da Narni, always known by his *nom de guerre* Gattalamata, 'the calico cat'. The statue, commissioned by the Venetian Senate, was placed in front of the basilica of Sant'Antonio in Padua (where it still stands) in 1453. Donatello seems to have been determined to use the statue to dominate the square – the horse and its rider are monumental.

Bartolomeo Colleoni, the subject of Verrocchio's statue, was a highly successful general, a pioneer, in fact, of the use of field artillery, who despite being from the mainland city of Bergamo had been made leader of Venetian troops fighting in mainland Italy in the 1460s. On his death in 1475 he left a large sum of money for a statue of himself to be erected in Piazza San Marco. The city baulked at the request but the Signoria saved its embarrassment by announcing instead that the statue would be erected in front of the building which housed the Confraternity of St Mark, next to the Church of Santi Giovanni e Paolo.

Verrocchio did Colleoni proud. The *condottiere is* shown riding his great charger into battle, a look of absolute determination and concentrated aggression on his face. Verrocchio died before his clay model was cast and even though the Venetian bronze-worker Alessandro Leopardi, who completed it, toned down some of its exuberance, it still overwhelms the visitor from its high pedestal. It

outclasses the Donatello by its emotional power and was certainly the most famous equestrian statue of the Renaissance – even if the Venetians unscrupulously played down the Florentine Verrocchio's achievement by giving the credit to their own Leopardi, whose name appears on the girth!

So when Forestiero preferred the horses of St Mark's to the Marcus Aurelius and the Colleoni monument, he could hardly have paid them a greater compliment. Nevertheless, in one respect they might be considered inferior: in their display. As Veneziano had said, they were difficult to appreciate where they were – they were much too high up. A direct contrast could be made with the Marcus Aurelius, which Michelangelo deliberately planned to be the focal point of his Capitoline Hill. In 1561 it was set up in the centre of

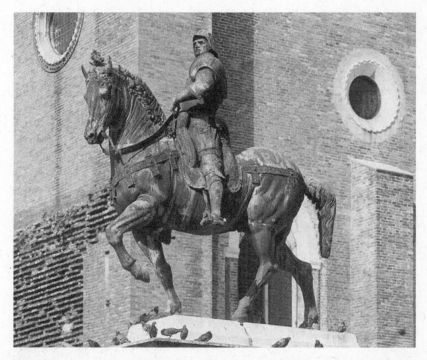

The monument to Bartolomeo Colleoni in the Campo of SS. Giovanni e Paolo in Venice (1486) was an extraordinarily powerful sculpture which echoed the Marcus Aurelius, but many Venetians still preferred the horses of St Mark's. (Campo S. Zanipolo, Venezia/Scala)

the square on a marble base, parts of which were taken from the nearby forum of the Emperor Trajan. As for the Colleoni monument, the tall pedestal on which it stood was the original work of Leopardi and was Roman in style. Its variegated sheets of marble were encased in columns and were embellished with tablets displaying trophies. It allowed Colleoni to be seen from all sides.

Venetians were well aware of the limitations of the horses' position. In 1558 Enea Vico suggested that they should be placed on a high pedestal like the one on which the Colleoni statue stood, but, unlike that statue, they should be placed in the square itself. He writes of 'the noble *quadriga* of four extremely beautiful and undamaged horses, set over the main entrance to the temple of San Marco, a very rare work which both in art and all else is a very stupendous thing, and marvellous and perhaps the most beautiful in all Europe'. However,

being against some large windows of dark glass, they are so greatly deprived of their viewpoint that they are not given that great consideration which such great art and such creations of beauty should merit. From which it seems to me that their dignity requires a very prominent high base of beautiful marble to be set between the flag-poles in the great Piazza [another creation of Leopardi's still in place today], or at the other end of the Piazza opposite to the church [he means the Church of San Geminiano, which was to be demolished by Napoleon]; this might be so majestic and confining that it would be hard to see the feet of the horses, but unimpeded by the height of the pedestal, outlined against the sky, they would appear grander to the sight of onlookers.

Vico's idea was greeted with some sympathy and, although it was never acted on, in the eighteenth century the painter Canaletto actually created a *capriccio* in which the horses are placed down in the square, as Vico had suggested, but in Canaletto's version on separate pedestals.

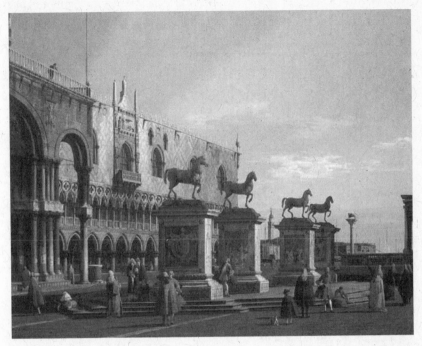

In the sixteenth century, it was suggested that the horses should be placed on pedestals in the square so they could be better seen. It was never done, but in this *capriccio* by Canaletto (1697–1768) he imagines how they might have looked. (The Royal Collection © 2003, Her Majesty Queen Elizabeth II)

It was, of course, possible to 'display' the horses by reproducing them in miniature. In the fifteenth century the ordinary collector was still able to pick up original antique statues. Jacopo Bellini is known to have had several and one, a Venus from Paphos in Cyprus, where Aphrodite was said to have been born in the sea, attributed to Praxiteles, was passed on to his son Gentile. It could be seen, by those interested, on a shelf in his studio in Venice. By the sixteenth century, however, only the wealthiest collector could afford original antiques and had to make do, as second best, with the work of contemporaries. Not that these were without quality. As Sabba di Castiglione (1485–1554) put it in a book of moral reflections published in Venice in 1546, 'the Venetians decorate their houses

with antiques, such as heads, torsos, busts, ancient marble or bronze statues. But since good ancient works, being scarce, cannot be obtained without the greatest difficulty, they decorate them with the works of Donatello or with the works of Michelangelo.' The scarcity of originals led to a new market in small bronzes. Bronze always carried with it an aura of quality and antiquity, and a survey of the most common subjects shows that bronzes representing themes from classical mythology were more popular than those of Christian subjects. Animals or personifications of ideals, in particular, were much sought after. The major 'Venetian' centre for production in the late fifteenth century was Padua, though bronzes were also cast in Venice itself.

One of the attractions of small bronzes was that they could be kept for study or enjoyment in a domestic setting, and just such a setting is to be found in one of the most exquisite works of the

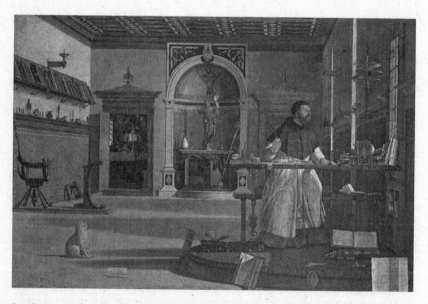

In Carpaccio's *The Vision of St Augustine* (early sixteenth century), a typical Renaissance interior is shown. On the shelf to the left, a model of one of the horses can be seen. Several of these bronze copies from the period survive. (Scuola di S. Giorgio degli Schiavoni, Venezia/Scala)

Venetian artist Vittore Carpaccio, *The Vision of St Augustine*, painted at the very beginning of the sixteenth century as part of a cycle honouring the patron saints of the small confraternity or school of Dalmatian merchants and craftsmen living in Venice (the Schiavoni). St Augustine is shown in his study gazing out of his window towards a light which shines through it. In fact the saint being honoured in the painting was not Augustine, as might be imagined, but the austere and cantankerous Jerome, famous for his translation of the Bible into Latin. Carpaccio has depicted the legend that told of how, at the moment of Jerome's death, just as Augustine was in the act of writing to him, a bright light flooded Augustine's study and he realized that the great man was no longer on earth. The moment is cleverly dramatized not so much through the reaction of Augustine as through the little Maltese dog who sits on the floor transfixed by the light. It is said that Carpaccio modelled his Augustine on Cardinal Bessarion – formerly the archbishop of Nicaea – who had granted special indulgences to the confraternity and who, as noted earlier, had donated a great library of Greek manuscripts to Venice in 1468. The study is that of the quintessential Renaissance scholar. Books, music, astrolabes and an armillary sphere are neatly placed around the well-ordered room. Christian images, including a gilt bronze of Christ on the recess altar, alternate with pieces of Greek pottery and ancient spear-heads. There among them on the shelf is a small bronze of what seems to be one of the St Mark's horses. This is not a fanciful suggestion, as it is known that bronze copies of them were made. One is now to be found in the Fitzwilliam Museum in Cambridge, another in the National Museum in Munich and yet another in the Walters Art Gallery in Baltimore.

By the sixteenth century, then, the horses of St Mark's seem to have worked themselves into the consciousness of many – artists, sculptors, 'tourists' in Venice and, of course, the Venetians themselves, to whom they were a matter of the greatest pride. The square that they overlooked had also been transformed. As already mentioned, in the 1490s a new clock tower, the Torre dell'Orologio,

This late sixteenth-century view of the Piazzetta (by an unknown artist) shows the scene that would have greeted a visitor landing from the Bacino. Note how the southern façade of St Mark's and the clock tower enhance the vista. Sansovino's celebrated Library is in place on the left and his Loggetta, a meeting place for nobles before and after councils, can be seen at the foot of the Campanile. (Musée des Beaux-Arts, Beziers, France/Bridgeman Art Library)

was built for the city. The site was an impressive one, on the northern side of the Piazza but directly facing the Piazzetta so that as the visitor landed he would see the large clock face fitting neatly at the end of his line of vision with the Campanile on one side and the Doge's Palace and St Mark's on the other. The site of the Torre was also an entrance point into the commercial part of the city, and so it acted to reinforce the separation of the Piazza as a distinct ceremonial area.

The whole northern side of the Piazza alongside the Torre was given a facelift after the Procuratie Vecchie was damaged in 1514 in one of Venice's many fires. The new building, completed in

1526, was in full Renaissance style, with three columned storeys, but characteristically is much lighter in tone than one would find in Italian cities on the mainland. On the bottom floor were shops, just as there are today, while the procurators let out the elegant apartments on the two higher floors to raise revenue for their building works. The procurators themselves were housed in a corresponding building on the south side of the Piazza, completed in the seventeenth century.

Further to enhance the grandeur of the area, three new buildings were commissioned by the Senate in the 1530s to fill the area on the west side of the Piazzetta. The first was a new state mint, the Zecca, on the shoreline itself. This was a strictly functional building. It had to keep all the gold and silver for the city's coinage secure and also contain the furnaces which minted it. The architect was Jacopo Sansovino, a Florentine who came to Venice via Rome, where he had served his apprenticeship as sculptor and architect. In 1529 he was appointed the superintendent of all the building works for which the procurators were responsible. Having completed the Zecca he turned to his second commission, the most prestigious of the three: a grand new library to run in the space between the Zecca and the Piazzetta back to the Campanile. This building, in both style and function, marked the high point of the Venetian love affair with antiquity. It was constructed to house, as it still does, the library of Greek texts left to the city by Cardinal Bessarion in 1468. Yet at the same time it was a Roman building replete with allusions to the Roman past. It even had a room set aside for young nobles in which to learn how to read the classics in the original languages. Sansovino's transformation of this area was completed by the Loggetta, a meeting place for nobles, built at the foot of the Campanile. All these buildings are happily intact, despite suffering some damage when the Campanile collapsed in 1902, and they provide a satisfying complement to the classical horses across the way on their *loggia*.

'Our ancestors', proclaimed the Venetian Senate in 1535,

have always striven and been vigilant so as to provide this city

with most beautiful temples, private buildings and spacious squares, so that from a wild and uncultivated refuge . . . it has grown, been ornamented and constructed so as to become the most beautiful and illustrious city which at present exists in the world.

As always with the Venetians there was more than a touch of self-congratulation here, but by the sixteenth century the transformation of swamp and marshes into one of the grandest cities of Europe was complete. The horses were among its greatest treasures.

THE HORSES IN AN AGE
OF *DECADIMENTO*

These horses are advanced on certaine curious and beautiful pillars, to the end that they may be the more conspicuously seene of every person. Of their forefeete, there is but one set on a pillar, and that is of porphyrie marble, the other foote he holdeth up very bravely in his pride, which maketh an excellent shew . . . Two of these horses are set on one side of that beautiful alabaster border full of imagerie and other singular devices, and the other two on the other side. Which yeeldeth a marvellous grace to this frontispiece of the Church, and so greatly are esteemed by the Venetians, that although they have beene offered for them their weight in gold by the King of Spaine, yet they will not sell them.

The man who penned these words, Thomas Coryat (1577–1617), stands high in the annals of English eccentrics. Originally from Somerset, the son of a clergyman, he became a hanger-on at the court of King James I, where he was known for his wit and buffoonery. He seemed to revel, in fact, in being made to look a fool by the more rumbustious courtiers. That there was something more to the man became clear in 1607 when his father died and he determined to use his inheritance to set out on a continental journey. Between May and October 1608 he travelled some 1,975

miles across Europe, most of them, he bragged, on foot. (He later donated his walking shoes to his local church, where they are known to have been preserved for at least a hundred years.) He spent six weeks in Venice and gives us one of the most lively accounts in English of the city, with every detail of daily life from the conduct of courtesans (information gathered, he insists, only through hearsay) to the habits of Venetian wives and the spectacle of public torture in the Piazza, as well as descriptions of the main monuments. Having published this and other accounts of his travels as *Coryat's Crudities* in 1611, he set off again the next year, this time on a trek which took him as far as India, where, overcome with feasting among a colony of English merchants, he died in 1617.

The Venice that Coryat visited in 1608 was at the beginning of a long decline – the years of *decadimento*, as one of Venice's most celebrated historians, Pompeo Molmenti, called it – which was to end in its extinction as a republic in 1797. The sixteenth century was, in fact, the turning point, even though to the outside world Venice remained an impressive city and there were still great moments in its history. One was the major naval victory of 1571 when an alliance of Christian forces, of which the Venetians were the largest contingent, destroyed a Turkish fleet which they trapped in the Bay of Lepanto (Just inside the Gulf of Corinth). Despite their reliance on a foreign commander, Don John of Austria, the half-brother of King Philip II of Spain, and allied forces, the Venetians were quick to appropriate the glory. The first of the galleys to reach home entered the lagoon with its guns blazing and its crews shouting 'Vittoria, Vittoria', captured Turkish flags trailing behind it. However, Lepanto was never exploited and no fully effective campaign was ever launched again against the Turks. Nor was the victory unadulterated: just before the battle one of Venice's most prized possessions, Cyprus, had been lost to the Turks.

In 1574 a visit by the new king of France, Henry III, showed the city at its most sumptuous. The aim of the Venetians' invitation was to warn Henry off an alliance with Spain which risked being turned against Venice. The entry of the young king (aged only

twenty-three) was carefully staged. All laws which restrained aristo-
cratic display were set aside for the visit. He was met on the coast
by a fleet of gilded gondolas and sixty senators. Then he was rowed
out to Murano, where he was joined by forty young Venetian
noblemen who were to be his suite for the visit. The next day the
doge, Alvise Mocenigo, arrived in the *Bucintoro*, the state barge, to
take Henry to a welcoming mass at San Nicolo on the Lido. The
barge then continued across the lagoon and up the Grand Canal to
Palazzo Foscari, which had been set aside as the king's home for the
next week. He was shown all the sights of the city, saw a complete
galley being built in a day, attended a meeting of the Senate, and
even, it is said, took time to enjoy the favours of one of Venice's
most celebrated courtesans, Veronica Franco (who showed off her
accomplishments by writing him a poem). Then the real business
of the visit began. The doge carefully but firmly initiated the king
into the realities of European politics. Spain was too powerful;
France needed to rely on the wisdom of Venice when formulating
its policy. Henry, a devout Catholic and hence reluctant to challenge
that most austerely Catholic of monarchs, Philip, was careful not
to commit himself; but it was said that memories of his glittering
reception in Venice lasted for the rest of his life.

Among the obligatory treats laid on for Henry was a visit to
Titian, now an elderly man but long acknowledged as the leading
painter of Europe. Titian had been born towards the end of the
fifteenth century (his date of birth is unknown) in a small town
in the Dolomites, in Venetian territory but 60 miles north of the
city. Arriving in Venice around 1510, he learned his trade through
the patronage of the Bellini brothers, Gentile and Giovanni, but
his first great commission, the *Assumption* painted for the Church
of Santa Maria dei Frari, is an extraordinary achievement, both for
its size (it remains the largest panel painting in existence) and for
its originality. It still dominates the central altar of the church.
The Virgin soars upwards to where God the Father is waiting to
draw her into to a heaven suffused with light. Below, still on earth,
the apostles are pulled by their adoration towards her but, of

course, remain rooted to the ground. No wonder its unveiling in
1518 was a major event. As Titian extended his range from
altarpieces to portraits, from classical mythology to sensual nudes,
and learned to manipulate oil paints to create a majestic range of
hues and tones, he built up an awesome reputation across Europe
and in fact became the first artist to be treated as an international
celebrity. By 1550 he was able to show himself in a self-portrait in
which he is presented richly dressed in a manner reminiscent of an
opulent Venetian merchant. The gold chain of the Knights of the
Golden Spur, conferred on him by the emperor Charles V, hangs
around his neck. There is, in fact, a good story of Charles V
visiting Titian in his study, and when Titian dropped his brush by
mistake, stooping to pick it up. Titian not only elevated Venetian
painting to new heights but set in motion a revolution in the
status of the artist.

Titian died a very old man in a devastating outbreak of plague
which swept across Venice in 1575–7, killing perhaps a third of the
population. Once the worst was over the Senate commissioned a
church in thanksgiving from the most gifted architect of his day,
Andrea Palladio. Like Titian, Palladio had been born on the
mainland, at Padua in 1508, but it was only after he had completed
a large number of country villas and public buildings in and around
the city of Vicenza that he was able to win any commissions in
Venice itself. While Sansovino had been prepared to compromise
with the procurators by incorporating Venetian motifs into his work,
Palladio was strongly influenced by the Roman architect Vitruvius,
author of the only architectural treatise to have survived from the
classical past (the first scholarly edition of this great work had
actually been printed in Venice, in 1511). He adopted and stuck to
a purer classicism than Sansovino, but this did not appeal to the
procurators and when he applied for the post of chief architect of
the public works in 1554, he was unsuccessful. Interestingly, the
church proved more receptive to his designs and gave him his first
commissions in Venice in the 1560s. Outstanding among them was
the Church of San Giorgio Maggiore. As always with Palladio's

buildings, the setting was central to the design: the church looks majestically across the Bacino towards the Piazzetta. Equally stunning in its position was the Church of the Redentore, the thanksgiving offering to Christ the Redeemer, which stands on the island of the Giudecca, facing directly on the city from the south. These were majestic churches, the grandeur and simplicity of their interiors enhanced by the white Istrian marble (also used for the exteriors) and effective use of light. This was architecture as theatre, and there was no better place in Europe for Palladio's talent to be displayed than Venice. His influence spread throughout the continent and proved as important in architecture as Titian's influence was in painting. So, even though one can spot the first signs of an economic decline which seems in retrospect to be inevitable, in the sixteenth century Venice could claim with some justification to be still at the forefront of European cultural life.

Just as new work from Palladio, Titian and their contemporaries, much of which drew on classical forms or mythology, was spreading across Europe, so too was a more cultured awareness of the classical past itself. Thomas Coryat was one of a growing number of travellers to Italy in the seventeenth century who could see a wide range of antiquities, whether on open display, as the horses were, or in collections open to the public. In Rome in 1471 Pope Sixtus IV had 'restored' four Roman bronzes to the governors of the city, and these were to be the founding donation of the Capitoline Museums. Splendidly housed in Michelangelo's buildings and added to over succeeding centuries (the popes sometimes passed on nude sculptures considered inappropriate for the Vatican galleries), the Museums became and remain one of the greatest collections of antique sculpture in the world. In 1503 another pope, Julius II, extended an ancient villa, known as the Belvedere, which stood on higher ground behind the Vatican Palace, down to the palace itself to create a walled garden for the display of sculpture. The sculptures were placed in niches in the walls among orange and mulberry trees; some were even incorporated into fountains. One of Julius' first acquisitions for the Belvedere was the famous statue

of the Laocoön, dug up in Rome in 1506.* Equally famous was an Apollo, the Apollo Belvedere, considered by some enthusiasts to be the most beautiful Greek statue of all time. The Belvedere, with its cool running water, shade and careful placing of antiquities, became the ideal gallery and was copied by many others – the gallery housing the collections of the Austrian emperors in Vienna even carried the same name.

By the seventeenth century other great collections had been established in Rome: the Ludovisi (still in Rome and now beautifully displayed there in the Palazzo Altemps), the Borghese (also still in Rome) and the Medici on the Pincio Hill. A home for the treasures of the Medici collection was created in Florence by the grand duke of Tuscany and head of the Medici family, Francesco, when he converted the city offices (the *uffizi*) into galleries for art and added a sumptuous room, the Tribuna, for the display of his sculptures. Pride of place in the Tribuna was given to a Venus, the Venus de'Medici, but it became home to other famous statues too such as the bronze Dancing Faun and a crouching figure known as the Arrotino (Knife-grinder). Paintings by Titian, Raphael and Rubens lined the walls. By the late seventeenth century the Tribuna was perhaps the most famous room in the world, as much a cultural icon as the Sistine Chapel is today.

Italy's dominance in this world of antiquity was total. It was not, for instance, until as late as the 1630s that England got its first glimpse of original antiquities. It was to Thomas Howard, earl of Arundel (1585–1646), that 'this corner of the world owed its first sight of Greek and Roman statues'. The 'Collector Earl' bid energetically for sculptures in Rome and even dug up his own in the Forum, in the earliest known overseas archaeological excavation by an Englishman, while his agents scoured the Aegean for original

*Laocoön was a Trojan priest who warned the Trojans against admitting the Wooden Horse into their city. He and his two sons were attacked and strangled by snakes, sent by Athena, supporter of the Greeks. Their frenzied struggle with the snakes is the subject of the sculpture.

Greek works. Arundel was particularly fond of Venice and he bought a mass of Palladio's drawings, which a travelling companion, the young architect Inigo Jones, used to introduce Palladianism to England.

Only the very wealthiest collectors, however, could hope to collect originals (Arundel burdened his family with debt for generations to come) and many had to be content with full-scale casts of the most famous statues. Moulds were created by covering the original statue with a liquid (the composition of which remains unknown) and then placing quick-drying plaster around it. The pieces of plaster were taken off and could then be reassembled into a mould which would be held together by an outer layer of plaster. This would be carefully packed and sent off to the casters, who might be in another part of Europe altogether. Francis I of France (b. 1494; r. 1515–47) was a pioneer collector of copies. He ordered a bronze replica of the Spinario, the boy taking a thorn from his foot, which was one of the founding statues of the Capitoline Museums. The Florentine Benvenuto Cellini arranged the contract, while the caster was none other than Cellini's friend Jacopo Sansovino, the Venetian architect – long before taking up architecture, he had made his name as a sculptor with a cast of the Laocoön. Francis' enthusiasm knew no bounds. A mass of plaster moulds of other statues – one single consignment contained fifty-eight cases – made their way from Rome to Paris and the resulting copies, most of them in bronze, were displayed in the king's chateau at Fontainebleau. The moulds were solid enough for a second collection of copies to be made for Francis' sister-in-law, the widowed queen of Hungary, who wished to decorate the gardens of her Italianate palace near Brussels.

Bronze remained the most prestigious material for copies. As one Florentine sculptor and specialist in bronze casts, Massimiliani Soldani, put it, only in bronze could 'the softness and grace of contours' of the original works be preserved. Others preferred to sculpt in marble, while the cheapest option was to cast in plaster. This method made casts affordable to ordinary artists, who were

encouraged by Bernini, the greatest sculptor of the seventeenth century, to learn to copy from casts 'of all the most beautiful statues, bas-reliefs and busts of antiquity' before drawing from nature itself. This instruction established a model of education for artists which was to last into the twentieth century. The plaster-cast galleries of the Victoria and Albert Museum in London are still intact.

So the courts of northern Europe and – in England in parti-cular – the gardens and halls of aristocrats began to be filled with copies of antique statues. It was Charles I who secured the earliest bronze copy of the Venus de' Medici, which remains today in the Royal Collection at Hampton Court. In the 1660s another French king, Louis XIV, outdid all his fellow sovereigns in the range and number of antiquities he had copied for the gardens of Versailles. Some were in marble, some in bronze; some were exact copies of the originals, others freestyle interpretations, works of art in their own right. (While Francis had delighted in embarrassing the ladies of his court with nude statues, Louis was more circumspect. One cele-brated Venus was reproduced with the naked backside of the original covered in swirling drapery.) 'The best of Italy is now in France,' boasted the king's minister Colbert, 'and Paris is the new Rome.' This was a wild exaggeration, for the king had hardly any originals in his collection; but it proved to have been prescient at the end of the next century when, as we have seen, Napoleon was to ravish Italy for the finest works of art and include the horses of St Mark's among his loot.

For those who could not see the originals or more than a few copies, the first books of engravings began to appear in the early eighteenth century. In France, one Bernard de Montfaucon had a collection of some thirty or forty thousand images of ancient art, and they were assembled into his *L'Antiquité expliquée*, the first volumes of which appeared in Paris in 1724. The work was so comprehensive that it served as the indispensable reference book on ancient art for over a century. The Venetian equivalent came a few years later, in 1740, when two cousins, Anton Maria di Gerolamo

Zanetti and Anton Maria Alessandro Zanetti, published a survey of all the ancient Greek and Roman statues to be found in public places in the city. Pride of place was given to those displayed in the anteroom of Sansovino's Library, but the horses of St Mark's are represented too, in a fine set of engravings. The Zanettis took a cautious view of the horses' origins. They repeated the story that they had been taken from Rome to Constantinople by Constantine and acknowledged that there was some sense in it, even though they

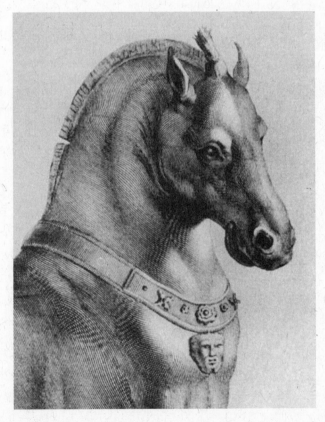

In 1740 the Zanetti cousins produced a series of engravings of Venetian sculptures, the horses of St Mark's among them. They are interesting because they show the horses' collars intact. Sometime between 1740 and 1815, most likely on their travels to and from France, they were vandalized and much of the decoration removed. (Giuseppe Fioretti)

had to accept it was no more than popular tradition. They suggested the reign of Nero as the likely date of their casting and reproduced the Roman coin which showed a *quadriga*, possibly the horses themselves, on Nero's triumphal arch.

Although the Zanettis were unable to give any good reasons for their attributions, their work suggested that they were taking a much more critical approach to sculpture than their Renaissance predecessors. A great step forward had been made when one Jonathan Richardson, an Englishman who visited Italy in 1721, had written up an account of his journey in collaboration with his father, a portrait painter. It was published as *An Account of some of the Statues, Bas-reliefs, Drawings and Pictures in Italy, etc., with Remarks* in 1722. What distinguished the Richardsons' study of their travels from the many others on the market was their appetite for the artistic value of antique statues. Jonathan Richardson told how he spent no less than ten hours in the Tribuna and how he could not last there for three minutes without returning to the Medici Venus. The Richardsons probed the background to the sculptures. They realized, for instance, that many of the names actually carved on the great statues of Rome featured nowhere in Pliny or other accounts. There were many classical sculptors of whom nothing was known; and conversely it was accepted that the great statues of antiquity that were mentioned by Pliny either had not survived or were yet to be rediscovered. The Richardsons had mastered enough classical history to know that there had been major disruptions as the Roman empire had disintegrated and the barbarians had invaded. They realized that in many cases Christians or barbarians would have destroyed statues and that bronzes were melted down for their metal. What had survived had been preserved through chance. It was as if, they said, a great library had been shipwrecked and only a few, randomly picked volumes had been washed ashore. They also recognized that many surviving statues were copies of others, and in most cases these were indistinguishable from each other in quality. As an example they showed through comparison with images on coins that a Standing Venus in the Vatican was a copy of

one of the most famous statues of the ancient world, Praxiteles' Aphrodite of Cnidus.

Jonathan Richardson had hoped to visit Venice but an outbreak of plague in Marseilles in 1720–2 – incidentally, the last great outbreak of bubonic plague in European history – prevented him from taking ship there. Yet even if he never saw the horses of St Mark's, he had provided a context in which they could be reassessed. Just because they were the only *quadriga* to survive did not mean that they were necessarily the work of Phidias or Lysippus or any other sculptor mentioned by Pliny. They could be the creation of a completely unknown sculptor, or they could be a copy of an earlier sculpture. With no direct equivalent by which to measure them, nothing much more could be said about their origin.

It was in the eighteenth century, however, that one important thing about them was discovered. The age of the alchemists and of Aristotelian physics (according to which all matter was made from four basic elements) was over, and with the emergence of scientific chemistry it was now possible to treat metals as coherent and consistent elements which could be separated and purified. Chemical analysis was possible, and when the horses were subjected to proper scrutiny it was found that they were in fact not of bronze but of almost pure copper, never less than 97 per cent in the samples tested. This was a remarkable finding, for copper has such a high melting point in comparison to bronze that a large copper statue was virtually impossible to make. The mystery of why the horses were cast in copper will be explored in the final chapter.

In the seventeenth century Venice became involved in another set of debilitating wars with the Turks. Crete, its last major possession in the Mediterranean, was lost in the 1660s. One Venetian raid on Athens had a disastrous effect when a Venetian shell blew up the Parthenon, which the Turks had been using as an arsenal. Venice's debt soared during the second half of the century and economic decline was hastened by the gradual consolidation of French, Dutch and English inroads into the Levantine trade. The expansion of commerce with ports such as Trieste, just down the coast, which

was part of the Austrian empire, bypassed Venice. A brief success in regaining the territory in the Peloponnese in the 1680s was negated by the cost of holding it, and it was surrendered back to the Turks in 1718.

In the last century of its independence Venice enjoyed a final outburst of artistic glory, not only in painting but equally in music (Antonio Vivaldi) and theatre (Carlo Goldoni). For most people it is the sweeping views of Antonio Canal (better known as Canaletto), in which the serenity of the city is contrasted with the bustling activity of its great festivals or everyday life, or the more impressionistic sketches of Francesco Guardi, which define the art of the century. Equally important, perhaps, are the majestic frescos of Giambattista Tiepolo, the last Venetian painter who can be seen as a direct heir of Titian. Exploding with warmth and colour across the ceilings of Venetian palaces, they glorify the families of their patrons, placing venerable ancestors among the gods or seated between Wisdom and the Virtues. Here is the ancient family shoring up (or perhaps even creating) its heritage. The contrast between the achievements of an earlier generation and the realities of the mannered and directionless lives of the contemporary Venetian aristocracy is glaring. This is a final fling; and however much the art is weighted in illusions ('My eyes are very pleased by Venice, my heart and mind are not,' wrote the French philosopher Montesquieu), it is seldom without panache.

By the eighteenth century, in fact, Venice had lost its purpose. When the Swiss-born writer Jean Jacques Rousseau served as secretary to the French ambassador in Venice between 1743 and 1744, his life seemed to centre on perceived slights to his status – not being able to have his private gondola but having to hire one when he needed one, petty disputes over possession of the keys to one of the theatre boxes allocated to the embassy. He seems to have become thoroughly imbued with the mood of the place; and yet his attitude to the Venetian government was condescending – the decadence of Venetian society, he said, was a consequence of the defects of its constitution, while the Council of Ten was 'a tribunal

of blood'. Increasingly this was the feeling of Europe's intelligentsia and politicians, who derided the impotence of the Venetian government. 'The English use their powder for their cannon, the French for their mortars. In Venice it is usually damp, and if it is dry they use it for fireworks,' one observer remarked. Even the Piazza came in for its fair share of ridicule: 'a large square decorated by the worst architecture I ever saw,' was the dismissive comment of the historian Edward Gibbon. Venice was increasingly a coffee-house city – Florian's was founded in 1720 and Quadri in 1775; both still flourish today – while the courtesans gained in fame. Rousseau was told of their 'gracefulness and elegant manners' and superiority 'to all others of the same description in any other part of the world'. This was, after all, the city of Casanova, whose sexual escapades in Venice and elsewhere were detailed in his auto-biography.

While many of the Venetians were concentrating their skills on voluptuous Venuses, Ariadnes or Dianas, real or imagined – the mid-eighteenth-century artist Giambattista Piazzetta is the master of the sensual female form – in other parts of Europe a more sober tone was beginning to predominate. It involved a return to the ancient world, but this time as a source of virtue and nobility, patriotism and stoic endurance, continence and self-sacrifice. The painting which exemplified this new approach was Jacques Louis David's *The Oath of the Horatii* (1784–5). In this depiction of a myth from early Roman history, the three brothers Horatius swear on their swords that they will risk their lives in personal combat in order to settle a war with a rival city. Only one survives, but the war is won for Rome. David finds his theme in republican Rome, the period before Augustus becomes emperor. Increasingly among the earnest scientists and rationalists of the Enlightenment, we find the Roman republic elevated as a model for disciplined living in the

Overleaf: An eighteenth-century view of a parade of bulls in St Mark's Square by Battista Cimaroli (1687–1753). By this time the square was largely given over to pleasure. (Soprintendenza Gallerie, Valencia/Scala)

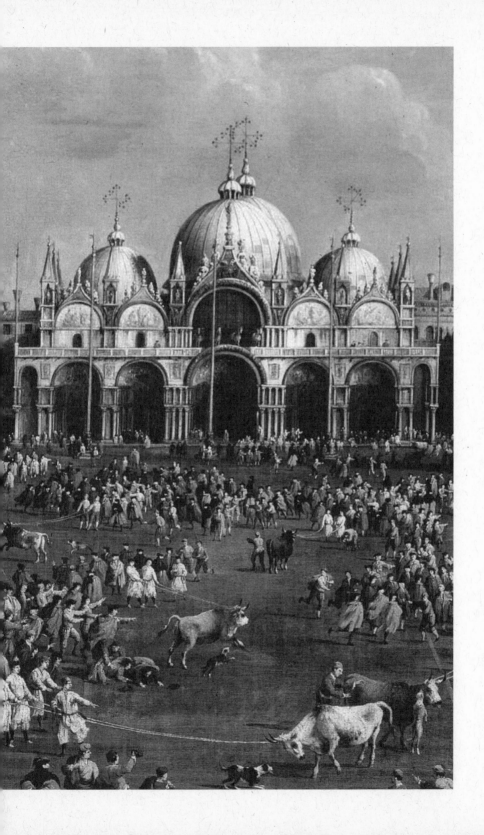

service of the state. As already noted, this was the model which guided so many of the French revolutionaries, whose bourgeois education had been infused with Roman authors.

Yet there were also those within this tradition of idealizing the ancient world who found their models elsewhere. The greatest art historian of the age, Johann Winckelmann (1717–68), was an enthusiast for ancient Greece rather than Rome. Winckelmann was born in Prussia, the son of a cobbler. Drawn to ancient Greece as a young man through reading Homer, he embarked on an academic career and by the age of thirty-one was the librarian of an aristocratic library in Dresden. Here he wrote his first essay on Greek art, *Reflections on the Painting and Sculpture of the Greeks* (1755). Then, having converted to Catholicism, he went to Rome and finally became Librarian at the Vatican. In his most celebrated work, *A History of the Art of Antiquity* (1764), he developed his theory of the relationship between art and history. He took it for granted that Greek art was supreme: 'In the masterpieces of Greek art, connoisseurs and imitators find not only nature at its most beautiful but also something beyond nature, namely certain ideal forms of its beauty.' (Note the influence of Plato.) However – and this is where Winckelmann takes a new direction in his criticism – Greek art was never static; it had its own rise to greatness and its own fall. The rise began with the so-called 'archaic' or 'old' period and reached its height ('sublimity' in Winckelmann's terminology) in the fifth century BC (the period of Phidias and Polyclitus). The essence of 'sublime' art was 'noble simplicity and calm grandeur'. Then followed the 'beautiful' age of Praxiteles and Apelles, the painter extolled by Pliny, of whose works none survived even in copies. However, towards the end of the fourth century came Alexander, and after him the Hellenistic period, when Greece had lost its freedoms and was ruled by monarchs. Finally, with the subjugation of Greece by Rome, Greek liberty was extinguished. From the time of Alexander art had become merely 'imitative' of what had gone before. The same cycle, a rise to a peak of 'sublimity' and 'beauty' followed by a decline into decadence, recurred at

different periods in the history of art. Winckelmann defined
another such cycle for the Renaissance, with the painters Raphael
and Michelangelo defined as 'sublime', Correggio 'beautiful' and all
who came afterwards merely 'imitative' of their great predecessors.

Winckelmann went further in trying to define the conditions in
which 'sublime' art flourished. Politically, he argued, it needed liberty:
'it is to liberty above all that art is indebted for its progress and its
perfection.' This was an idea that he had absorbed from an early
eighteenth-century English philosopher–aristocrat, the third earl of
Shaftesbury, who had applied the theory to his own times in England.
It helped, too, if the climate was right. In Greece, Winckelmann –
who never visited the country – assumed, 'a temperature prevails that
is balanced between winter and summer.' Those encountering the
heat of a Greek summer might disagree, but there were respectable –
and Greek – precedents for the view: the fifth-century BC historian
Herodotus claimed that it was the ideal climate of Greece that bred
men hardy enough to fight off the Persian invaders, who were
themselves enfeebled by the heat of their country.

Relating artistic work to its surrounding culture was an
important development in the history of art, but in Winckelmann's
case it created its own problems. If one comes across a 'sublime'
piece of art, does that mean that the period in which it was created
must have been one of 'liberty'? If a country becomes free, then
does its art by some form of osmosis become great? If a warmer
climate is needed to create the best artists, does this mean that one
can never produce great art in a cold one? How far can one take this
'cultural' approach? Is the art of each culture understandable only
in its own terms or can there be ideals which transcend cultures?

These problems can be helpfully explored if one looks at the
examples Winckelmann himself used to advance his arguments. The
only antiquities he could see at first hand were those in Rome or
Florence, although he also had access to books of engravings such
as Montfaucon's *L'Antiquité expliquée*. His favourite statue was the
Apollo Belvedere, and his descriptions of it bordered on full-blown
romanticism.

This statue surpasses all other representations of the god, just
as Homer's description surpasses those attempted by all other
poets . . . An eternal springtime, like that which reigns in the
happy fields of Elysium, clothes his body with the charms of
youth and softly shines on the proud structure of his limbs . . .
In the presence of this miracle of art I forget the whole universe
and my soul acquires a loftiness appropriate to its dignity . . .
From admiration I pass to ecstasy . . . I am transported to Delos
and the sacred groves of Lycia – places Apollo honoured with his
presence . . .

Such an inspirational statue must, Winckelmann assumed, be a
Greek original and he suggested that it had been brought to Rome
by Nero, who is known to have looted extensively in Greece. Within
a few years of Winckelmann's death, however, it was noted that the
marble was Italian, not Greek, and that the added tree stump by
which the statue stood suggested that the original would have been
bronze. (As bronze is more tensile than marble, a marble copy of
a bronze often needs a support of some kind to enable it to stand
without cracking.) Expert opinion now sees the Apollo as a copy
from the second century AD of an original Greek bronze, modified
to suit Roman taste – thus, far into Winckelmann's decadent and
imitative period.

Winckelmann did not fare much better with his next great statue,
the Laocoön. A Laocoön had been mentioned by Pliny, and the one
dug up in 1506 was assumed to be the same. Winckelmann
enthused over the heroic suffering shown by the priest as he
struggled with the snakes. His gaze upwards was, in Winckelmann's
interpretation, a plea to heaven that his sons at least should be
saved. He felt that the perfection of the statue was so obvious that
it could not possibly be later than the reign of Alexander the Great,
the moment when Greek art began to decline into imitation. In fact,
the date of its making is still debated – one of the sons may well
have been a late addition – but many modern authorities suggest
the early centuries AD, again well into Winckelmann's period of

The Apollo Belvedere became the most famous statue of the classical world in the late eighteenth century after its endorsement by Winckelmann. By the nineteenth century it lost its place as taste came to prefer the less ornate classicism of the fifth century BC. (Museo Pio-Clementino, Vaticano/Scala)

decadence. It has been perhaps justly said of Winckelmann that his mind was better than his eye.

The problem of relating great art to periods of liberty showed itself in a more acute form with another of Winckelmann's favourites: a fine torso in the Vatican, the so-called Belvedere Torso. This could be dated by its inscription to later than Alexander, and so

during the period of imitation. How, then, could it be a great sculpture? Winckelmann fitted it neatly into the brief period after 194 BC when the Greeks had been freed by Roman arms from the rule of Philip of Macedon but had not yet succumbed entirely to Roman imperialism. This was decreed to be an 'age of liberty'. More difficult to fit into Winckelmann's scheme was a head of 'sublime beauty' of Antinous, the youth favoured by the emperor Hadrian, whose death had led the emperor to declare a cult in his memory. There are many statues of Antinous, none of which can be earlier than AD 130, when he died. Again an age of liberty had to be discovered to explain its greatness, and Winckelmann claimed that Hadrian 'planned to restore their original freedom to the Greeks and had begun by declaring Greece to be free'. This was certainly an ingenious solution, but it showed just how much special pleading was needed to sustain his theory.

These difficulties help explain Winckelmann's approach to the horses of St Mark's. He didn't see them. It is possible he intended to do so in 1768, when he was returning to Italy from Germany via Trieste, just along the coast from Venice, and might have decided to break the journey back to Rome. We shall never know. In Trieste, Winckelmann became involved in a homosexual entanglement and was murdered by his 'lover'. We are left with no more than his impressions of engravings of the horses he had seen, and he does not seem to have been inspired by them. In *Reflections on the Painting and Sculpture of the Greeks* he makes the general comment that 'the ancients seem not to have been acquainted with the handsome varieties of different animals in different climes' (I am using the first English translation of 1765) and he gives as examples the Marcus Aurelius, the Dioscuri (neither of which he had yet seen when he was writing) and 'the pretended Lysippian horses above the portal of St Mark's church at Venice'. All seem to have disappointed him.

Winckelmann recognized that the horses were of copper. He seems also to have heard of examinations of the horses which had thrown doubt on the quality of their casting. Any lack of quality

was largely attributable to the metal used: copper not only has a much higher melting point than bronze but also solidifies quickly; this tends to make the cast metal more porous than that of bronze, and also requires the casting to be carried out in smaller pieces, leading to a greater number of internal joins. Any close examination of the St Mark's horses show that they have a mass of imperfections. However, Winckelmann had his own explanation for this. He had read in Pliny's *Natural History* that at the time of Nero the art of casting was in decline. If the horses had imperfections, he now argued, it was because they had been cast in the age of Nero! There was supporting evidence in the gilding. Winckelmann and his neoclassicist supporters preferred marble to be white and metals to be untouched. This was the essence of the 'noble simplicity' of the finest Greek works. Gilding was by definition a sign of decadence and accordingly was assigned, on these grounds alone, to Roman imperial art. Thus in his *History of Ancient Art* Winckelmann writes that 'we can form an idea of Nero's vitiated taste from the fact that he caused a bronze figure of Alexander the Great, executed by Lysippus, to be gilded.' A contemporary of Winckelmann, one Octave Guasco, writing in 1768, picked up the point and related it to the 'four horses of Nero', which were 'among those works which were gilded, reflecting the bad taste of contemporary Roman decadence'. So, the argument ran, if the horses were gilded they must come from a decadent period, and this conclusion was correlated with the imperfections of their casting to mean Nero's reign. Winckelmann's method of dating is, of course, deeply flawed. The horses would be difficult to date in any case – there was little to compare them with and no reliable documentary evidence to place them – and for the time being the issue remained unsettled.

Notwithstanding his contestable assumptions and assertions, the enthusiasm of Winckelmann inspired many of his contemporaries. 'We learn nothing by reading Winckelmann,' wrote Goethe, 'but we become something.' Goethe (1749–1832) was without doubt the most fertile mind of his age, a poet, a dramatist, a painter, even an

architect, skills which he combined with an intense scientific curiosity. By the age of twenty-five Goethe was already a celebrity, not only in his native Germany but throughout Europe, and he remained so until he died aged eighty-three. Part of his importance for later scholars and readers derives from the tumultuous times through which he lived, including the upheavals of the French Revolution and the Napoleonic Wars. He was always ready with his own responses: as his biographer Nicholas Boyle puts it, 'At each new birth pang of modernity, specifically in Germany, but also generally in Europe, he felt the pain, recollected and recovered himself, and attained and expressed understanding.' His dominance of intellectual life and breadth of interests were such that Nietzsche was to describe him as 'not just a good and a great man, but an entire culture'.

During his youth Goethe had been soaked in ancient history and literature, and Italy had always been the country he had most yearned to visit (Italian was the first foreign language he learned), but it was not until 1786, when he was in his mid-thirties, that he first went there. He crossed the Alps by the Brenner Pass, made his way to Verona (where he saw his first original Roman building, the amphitheatre) and then moved on to Venice, where he arrived on 28 September.

Goethe had a romanticized view of Venice which originated with a toy gondola given him by his father who had visited the city when his son was still a child. While other men of his time, such as Rousseau, had derided the Venetian republic as corrupt and decadent, Goethe had a soft spot for it. 'If their lagoons are gradually filling up and stinking and their trade is getting weaker and their power has declined, that doesn't make their republic any less venerable to me in its whole conception and essence,' he wrote; and one of his most powerful experiences arose from employing two boatmen to revive the ancient art, which belonged, in Goethe's words, 'to the half-forgotten legends of the past', of singing to each other across the lagoon: 'a solitary man singing into the far distance, in order that another in like mood may hear and answer

him'. (The Romantic poet Byron was to do the same in 1818, but his singers, though taking to the lagoon, performed no further from each other than the opposite ends of a gondola.) He was enthralled by the range of Venetian theatre and warmed to the variety of human encounters he observed in his travels through the canals and *calli* (passageways) of the city. Nor was it only the city itself which impressed Goethe. Venice provided him, extraordinarily enough, with his first sight of the sea, and he was so enthused by this that he made his way to the Lido, which bordered on the open waters of the Adriatic, and explored the world of mussels, limpets and crabs.

He was soon aware, of course, that the city was not all he had hoped for. He found the streets dirty and, typically for a man of his time, began to devise a more scientific way of cleaning them. Much of the architecture left him unmoved: he never appreciated the mosaics of St Mark's or the gothic style, and even went so far as to describe the façade of St Mark's as like that of a giant crab. As one steeped in the ancient world he turned to the works of Palladio for excitement and inspiration. Palladio, he claimed, had shown it was possible to transform the petty-mindedness of Christian society through the noble spirit of the ancients. 'There is something divine about his talent, something comparable to the power of a great poet who, out of the world of truth and falsehood, creates a third whose borrowed existence enchants us.'

It was inevitable that Goethe would be interested in the horses, among the few genuine antiquities in the city. In his diary entry for 30 September, two days after his arrival in Venice, he records his first impressions of them. Expecting perhaps some overpowering presence, he is disappointed with their display.

These exquisite animals stand here like sheep that have lost their shepherd. When they stood closer together on a more worthy building in front of the triumphal chariot of a world-conqueror, it may have been a noble sight. Still, thank God that Christian enthusiasm hasn't melted them down and made chandeliers and

crucifixes out of them. May they stand here in honour of St Mark since we owe their preservation to St Mark.

A week later he gets closer.

The horses of St Mark's seen near to. Excellent figures! From below I'd just about noticed that they had patches of colour, partly a lovely metal sheen, partly touches of copperish green. Close up you can see they were completely gilded and are covered all over with weals, as the barbarians wouldn't file the gold but tried to hack it off. Never mind, at least that way the shape was left. A magnificent team. I'd love to hear someone who really knows horses talk about them.

He noted too — as we saw earlier — how 'up there they look heavier and from down on the square they look as delicate as deer'. Goethe had spotted that the horses had been crafted so as to appear

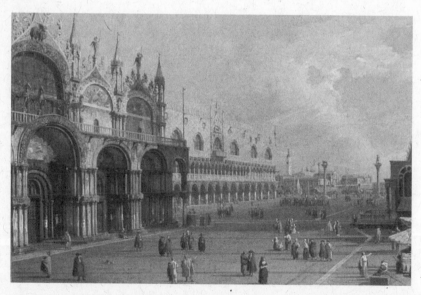

The horses, St Mark's and the Piazzetta as they would have looked at the time of Goethe's visits to Venice in the 1780s. (Artist unknown.) (Christie's Images, London/Bridgeman Art Library)

more natural from below – as had the Delphi charioteer: an important point to note when we consider the setting for which they might have been created. Like others, he assumed that the gilding had been scratched off by 'barbarians'; but, as we shall see, the scoring was probably done deliberately to lessen the reflective glare of the sun.

Goethe's real goal was Rome, and he continued his journey southwards after only two weeks in Venice, but four years later he made a second and what turned out to be a final visit to the city. His mood then was very different. Venice and the sea could hardly have the impact they had had on his first visit – 'the first bloom of affection and curiosity has fallen off.' He has had new experiences. Back in Germany are his mistress Christiana and their six-month-old baby August, whom he misses more than he expects. He becomes deeply melancholic. 'My heart felt no desire: the yearning gaze soon turned backwards to the snow of the mountains [the Alps]. South-ward [of Venice] lie so many treasures! But a treasure in the North, a great magnet, draws me back irresistibly.' In his frustration he writes poems full of erotic yearning interspersed with violently anti-Christian sentiment. Only the arrival in Venice of the Dowager Duchess Anna Amalia of Saxe-Weimar – one of his patrons, to whose 'court' he could now attach himself – brought him some relief, through the entrées into Venetian society the attachment gave him.

There were other matters haunting Goethe. While the retinue of the dowager duchess was enjoying the fading aristocratic splendours of Venice, in France a revolution was unfolding. Goethe felt ambivalent towards the turmoil. 'To me too the French seem mad; but a madman at liberty can utter wise sayings while in the slave, alas, wisdom falls silent.' So, despite the chaos of upheaval, there may be some good emerging – but Goethe was too realistic not to sense the dangers, presaging 'the sad fate of France . . . [when] the masses became tyrant to the masses'. What Goethe could not have predicted was that it was to be a child of the revolution, Napoleon Bonaparte, who was to overthrow the republic whose last years he was enjoying.

13

THE FALL OF THE VENETIAN REPUBLIC

A republic famous, long powerful, remarkable for the singularity of its origin, of its site and institutions, has disappeared in our time, under our eyes, in a moment. Contemporary with the most ancient monarchies of Europe, isolated by its system and its position, it has perished in the great revolution that has overthrown many other states . . . Venice has disappeared with no possibility of returning; her people are effaced from the list of nations; and when, after the long storms, many of her ancient possessions will have regained her rights, the rich inheritance is no longer.

PIERRE DARU, *History of the Venetian Republic,*
1819 (trans. Margaret Plant)

FOR CENTURIES VENICE HAD BEEN PROTECTED BY A combination of its position as an island, its diplomacy and, often, sheer luck. With the city's economic and political power almost gone, it could be tolerated by other Europeans as an aristocratic pleasure park. Yet even this limited role was placed in jeopardy when a new force hit northern Italy: the French Revolution as personified in the military genius of Napoleon Bonaparte.

The outbreak of the Revolution in 1789 had set off tremors across Europe, and in the first heady days of revolutionary fervour

liberals everywhere supported its ideals. In Venice there were many, particularly among the impoverished nobility, the *barnabotti* (so called because they tended to congregate in the district round the Church of St Barnabas), and the bourgeois citizenry, who had always been excluded from power, who clamoured for change. Unsettled by the unrest, the doge and his ministers tightened up censorship and forbade public political meetings; as in France, the weight of centuries of tradition and introspection stifled any chance of effective reform. The Venetian government was unable to do more than react to events and its image was so steeped in aristocratic absolutism that when, in Paris, the royal palace of the Tuileries was stormed by a mob in August 1792 and the king could not at first be found, the crowd surged on to the house of the Venetian ambassador, suspecting he might have sheltered there.

By 1793 a coalition of conservative European powers – Britain, Austria, Prussia, Holland, Spain and Sardinia – was forming against the French, but Venice could not even muster the energy to join it. By now the city had little military strength – a poorly armed militia numbering perhaps no more than five thousand – but at least it might have derived some protection from membership of an alliance. Instead, it plunged deeper into isolation. Having already forfeited the opportunity of support from its neighbour Austria, Venice lost any chance of being regarded favourably by the new French regime when the brother of the guillotined king Louis XVI, the Comte de Lille, actually proclaimed himself the new king of France on Venetian territory in Verona. After protests from Paris the Venetians persuaded him to leave – but then found themselves in more trouble with the French when an Austrian army crossed the *terraferma* on the way to fight the French in central Italy. In a muddle typical of its diminished vitality, Venice claimed that Austria had the right to do so by an ancient treaty – then, when the French demanded to see the treaty document, could not find it.

In 1796 the French army in northern Italy was led by the 26-year-old general Napoleon Bonaparte, whose origins, in Corsica,

were Italian.* In a series of startling victories that summer, Napoleon had seized Savoy and Lombardy and had reached the borders of Venice and Austria. Although he was technically the servant of the French government (at this point the Directory, which had come to power in November 1795), he was already assuming personal control of Italy's destiny. As a child of the Revolution, he had absorbed the stories of Venice's decadence and tyranny, and so was hardly predisposed to do the city any favours. The easiest way into the heartland of the Austrian empire was through the Brenner Pass, and Venetian envoys were bullied into allowing the French to occupy Verona, which stood at the foot of the pass. The retreating Austrian troops then tricked the Venetians into letting them occupy the fortress of Peschiera on the edge of Lake Garda to the north of Verona, which simply gave Napoleon another excuse for vilifying Venice. Belatedly the Venetians began raising a new militia on the *terraferma*, but the recruits were so ill-disciplined they soon became involved in scraps with the French occupying troops. When riots broke out in Verona Napoleon took his chance to send an envoy to Venice to tell the doge and the Collegio that if the Venetians did not bring the militia to order he would declare war on Venice. The Senate offered a cringing apology but it was rendered meaningless when a full-scale revolt broke out in Verona. It was suppressed in April 1797, after which the city was stripped of its art treasures and required to provide horses, boots and cloth for the French armies.

The French occupying forces in northern Italy claimed that they were liberators, but this meant little to the conservative Italian peasantry. Unrest simmered. By early 1797 Napoleon had crossed into Austria and realized that he risked being isolated on the far side of the Alps if he did not impose a political solution that would secure his rear. In a secret treaty with the Austrians made in April

*Corsica became French in 1768, just a year before Napoleon's birth.

1797 he forced them to surrender central Italy, telling them that they could have the Venetian *terraferma* in compensation. Having made the deal and now needing to impose it, he had fresh incentive for humiliating Venice. He rested his case on the 'tyranny' of the Venetian government. 'I will have no more Inquisition, no more Senate. I shall be an Attila to the state of Venice,' he told a grovelling set of Venetian envoys who had caught up with him in Austria. Just as the envoys were setting off back to Venice, messengers from the city arrived with ominous news. On 20 April a French lugger, the *Libérateur*, had entered the lagoon, and even though no actual state of war existed between Venice and France, it had been treated as an enemy ship and fired upon; its commander had been killed. The unfortunate envoys were told to return to Napoleon to present a Venetian version of events. It was hardly convincing and Napoleon exploited his opportunity. The murder of the *Libérateur*'s commander, he blustered, was 'without parallel in the annals of the nations of our time', and he considered himself fully justified in declaring war.

In the last days of April 1797 French troops reached the shores of the lagoon and began training their guns on Venice. An ultimatum arrived asking for a complete capitulation of the city. Three thousand French troops were to be allowed to enter to take over all strategic buildings and the French would assume command over what remained of the Venetian fleet. A democratic government was to be installed and all political prisoners were to be released. (French propagandists had long talked of torture chambers deep in the Doge's Palace.) Twenty paintings and six hundred manuscripts, to be chosen by French commissioners, were to be handed over to the French.

The Venetian government had allowed itself to be outmanoeuvred and was now completely exposed. Even so, it might have faced the challenge with more dignity. A meeting of the Grand Council was called for 12 May, but so many members of the nobility had fled to the mainland or failed to turn up on the day that it did not even have the required quorum of six hundred. There was little will to

resist. The doge moved that the Council should surrender its powers to a democratic government in the hope, he argued, of 'preserving the religion, life and property of all these most beloved inhabitants'. The resolution received the support of 512 of the 537 nobles who had appeared – many of whom, as soon as they had voted, slipped off their robes and left by back entrances of the palace, perhaps hoping to avoid the bands of more resolute citizens who were touring the streets chanting 'Viva San Marco!' Back in the palace, Ludovico Manin, the 118th of the doges, faced an almost empty Council Chamber and declared the resolution carried. Returning to his quarters he handed his *corno* and linen cap to his manservant. 'Take these,' he said, in a final tired gesture of abdication, 'I shall not be needing them again'.

The republic had collapsed with no more than a whimper, the victim of its own moral and political bankruptcy. On 12 May 'there died', wrote Ippolito Nievo in *Confessioni d'un Italiano*, his novel of the downfall of the republic published in 1858, 'a great queen of fourteen centuries, without tears, without dignity, without funeral'. Venice had, of course, surrendered itself to the bullying of Napoleon; but the fiction was promulgated that the city had been 'liberated' from tyranny. Within a few days 'Year One of Italian Liberty' had been proclaimed and a Committee of Public Instruction set up under French supervision to educate the Venetians in their new life. The history of Venice, so carefully manipulated by its rulers in the past, now received a radical makeover. Originally, it was now said, the Venetians had fled to the lagoon in order to live in liberty; then, with the law of the Serrata of 1297, instituting closed rule by the nobility, this had all been lost. It was fitting that exactly five hundred years later the original liberty of its citizens should be restored. To provide a symbolic marker of the occasion the remains of the doge responsible for the Serrata, Pietro Gradenigo, were exhumed from the Church of San Cipriano and thrown to the winds.

The new freedom was to be celebrated on 4 June with a festival in the Piazza San Marco, which, in a moment of anti-clerical fervour, was renamed (somewhat prosaically) Piazza Grande. A Tree

of Liberty was set up in the Piazza and placards with slogans were erected proclaiming 'Established liberty brings about universal peace' and 'Dawning liberty is protected by force of arms' – the latter a reference to the French garrison which now kept order in the city. On the day of the festival itself, bands marched round the Piazza with processions of citizens in tow. The newly appointed president of 'the sovereign people of Venice', one Angelo Talier, extolled the Tree of Liberty as a symbol of regeneration. 'The day destined for the erection of the sacred Tree of Liberty will be a day of joy for all true citizens, who may begin to live the worthy life of man, and it will be a monument of gratitude to our descendants, who will bless the generosity of France.' (Whatever noble ideals the French revolutionaries held, they did not include equality of the sexes. It was argued that the 'feminine' softness of aristocratic vanity and luxury had been transformed into the more 'manly' valour of 'democratic industry'!) So the myth was sustained that the French had simply enabled an organic revolution of the Venetian masses ('Long live the heroes of France, lightnings of war, who without shedding a drop of blood among us, knew how to break our harsh bonds'), and the president's speech led on to a symbolic burning of the Golden Book, in which the names of the noble families were recorded, together with the *corno* and other insignia of the doges. Suitable exhortations on 'the hateful and detestable aristocratic yoke' accompanied their reduction to ashes. The Fenice, the opera house, was ordered to put on relevant shows inspired by glorious moments of the Roman republican past, notably a drama of the assassination of Caesar by Brutus.

Few of those watching the 'celebrations' can have been deceived. The Venetian playwright Carlo Gozzi saw the dance around the Tree of Liberty as a Dance of Death.

> The sweet delusive dream of a democracy . . . made men howl and laugh and dance and weep together. The ululations of the dreamers, yelling out Liberty, Equality, Fraternity, deafened our ears, and those of us who still remained awake were forced to

feign ourselves dreamers, in order to protect their honour, their property, their lives.

The reality of the refound Venetian 'liberty' was soon exposed. The only real liberation was that of the Jews, whose ghetto (the word, which is believed to have been derived from a medieval Venetian word for foundry, is first recorded in Venice) was opened up and its gates burned so that its inhabitants were no longer segregated. There was never a democratic election in the city, and in the Treaty of Campo Formio made between Napoleon and Austria in October 1797, Venice and the Dalmatian coast were simply handed over to Austria.

Before the new owners arrived, Napoleon, who was to visit Venice only once, for ten days in 1807, put in hand the city's final humiliation. The *Bucintoro*, the state barge, was burned and the commissioners arrived to select the paintings and manuscripts according to the ultimatum announced by Napoleon in May. In the spirit of the Revolution, the church and the seat of autocratic government were to bear the brunt of the confiscations. So the ceilings of the Council of Ten's meeting room and the refectory of the monastery of San Giorgio Maggiore were stripped of their Veroneses, and a selection of Titians and Tintorettos, together with a stunning Giovanni Bellini, *The Madonna and Child Enthroned* from the Church of San Zaccaria, were collected. The commissioners confined themselves to their original quota of twenty paintings; such was the mass of riches available they even passed over the two great Titian altarpieces of the Frari, taking instead another Titian from Santi Giovanni e Paolo, *The Death of St Peter Martyr*, which was then considered his masterpiece.*

No sculpture had been mentioned in the ultimatum and it was only after the commissioners left, on 13 December, that the four horses were lowered from their platform on the *loggia* of St Mark's

*It has not survived, having been destroyed in a fire in 1868.

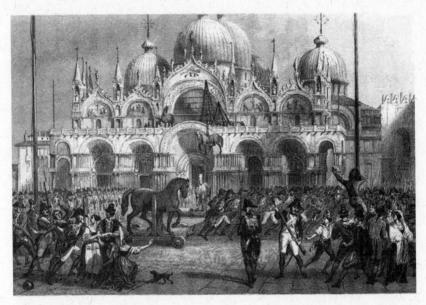

The horses are removed from St Mark's on the orders of Napoleon in December 1797. Protesting Venetians are roughly dealt with by the French troops. (Charles Freeman)

on to carts to be transported to Paris. It has to be assumed that Napoleon himself insisted on their addition to the haul. He had already ordered any lions of Venice to be destroyed as symbols of the old regime, although the winged lion on the column in the Piazzetta was among those saved and taken to France. (It was re-erected on a fountain in front of the Hôpital des Invalides in Paris, having suffered the indignity of having its proudly outstretched tail cut off and replaced between its legs.) As for the horses, a surviving French print shows the massed French troops alongside the Piazza, with one horse already being drawn away as the last still dangles down from a rope over the portico. The watching crowd stands silent. Another, perhaps more accurate in that the horses are being hauled by soldiers towards the water rather than away from it as in the first, shows protesting Venetian citizens being roughly treated by the French troops. It seems to have been a richly remembered

moment, and as late as 1839 a play called *The Horses of the Carrousel: The Last Day of Venice* was performed in Paris. Napoleon himself makes a guest appearance to the sound of the 'Marseillaise' and orders the horses off to 'the Carrousel', their new home in Paris.*

The Venetians' anger at the French was such that the arrival of their new overlords the Austrians – aristocratic, Catholic and ready to respect the Venetian heritage – in early 1798 was greeted with some relief. The great Venetian sculptor Antonio Canova wrote from his home village of Possagno on the mainland: 'I do not have to strain my imagination to believe the joy of all the Venetian population and that of the Terra Firma at the arrival of the Austrian troops; peace, tranquillity, security are real benefits not to be compared with the fantasies of hotheads.' Yet the horses were gone.

It was Canova who was eventually to secure their return.

*As the Arc du Carrousel where the horses were eventually to stand had not even been imagined in 1798, this, together with Napoleon's presence, was a piece of poetic licence.

14

'TO THE CARROUSEL!':
THE HORSES TRIUMPH IN PARIS

AS WE HAVE SEEN, VENICE WAS FAR FROM THE ONLY CITY humiliated by Napoleon during his campaigns. By 1798 he had overrun most of Italy, setting up republics in the place of the pope, kings and grand dukes who had ruled the politically fragmented peninsula. His appropriation of the finest treasures of antiquity followed in the tradition initiated by the French revolutionary armies when they had conquered Belgium in 1794. These forces had used 'the right of conquest' to justify the seizing of whatever works of art came their way, but with the additional if specious claim that they had the right to free the defeated populations from the works of superstition and tyranny which filled churches and palaces. Among their plunder from Belgium was Rubens' majestic *Descent from the Cross*, from Antwerp Cathedral, and a marble Madonna by Michelangelo from Bruges, probably the most important piece of sculpture in the country.

So when the pope, Pius VI, signed a truce with Napoleon in June 1796 after Napoleon had captured the papal city of Bologna, it was stipulated that he should surrender five hundred manuscripts and a hundred 'pictures and busts', the Brutuses among them. This was confirmed at the Treaty of Tolentino made with the pope in 1797. So far as the manuscripts were concerned Napoleon seems to have

taken his cue from the ruthless republican Roman general Sulla, who after his sack of Athens in 86 BC had seized for Rome one of the finest libraries of the city, which included the works of Aristotle. Whatever the inspirations for the French commissioners in Rome and their masters, the city and its extraordinary collections, both public and private, were at their mercy and they showed few inhibitions in what they chose. It was now that they began assembling the finest ancient sculptures, including Winckelmann's favourites, the Laocoön and the Apollo Belvedere, and bronzes from the Capitoline Museums such as the Spinario and the celebrated marble Capitoline Venus. The Dioscuri and the Marcus Aurelius would surely have been included too, had they not been impossibly heavy to transport. The Roman treasures were to be followed by others from major collections in Parma, Modena, Milan and Perugia. By 1799, when French control over Italy was even more extensive, Florence and Turin were also to be despoiled. (The Florentines did everything they could to avoid surrendering their masterpieces and it was not until August 1803 that Napoleon was able to view the Venus de' Medici in Paris.)

Once the triumphal procession of July 1798 was over, the sculptures and paintings were taken on to be unpacked in the Grande Galerie of the Louvre. The Louvre, originally a medieval fortress which had been converted into a Renaissance palace by Francis I, had been chosen by King Charles IX as his principal residence when he came of age in 1563. Charles's formidable mother, Catherine de' Medici, insisted on staying close to him and built her own palace, the Tuileries, on the site of a neighbouring tile factory (*tuile* = tile) so that she could be, in her own words, 'invisible and present' at the same time – he was, after all, still only thirteen. Later, at the end of the sixteenth century, King Henry IV constructed the Grande Galerie to connect the two palaces. By the eighteenth century, however, with the French kings having moved outside Paris to the Palace of Versailles, the whole complex was in a state of abandonment. There had been talk during the century of using the Louvre as a gallery for paintings, and the annual exhibition of the

Academy of Painting and Sculpture was held there in the Salon Carré.* But it took the overthrow of the monarchy and the seizure of the royal art collections by the state for the plan to become a reality. The museum had been opened for the first time in 1793.

With the antiquities settled in Paris, Napoleon installed himself nearby in the Tuileries Palace and gradually consolidated his power. In November 1799 the scope of his political ambitions became clear when he overthrew the Directory. The influence of republican Rome remained strong enough for him to take the title of first consul (the consuls were the leading magistrates of republican Rome) in 1799, but in 1802 he transformed this into consul for life. Ironically this was an echo of the 'dictator' Julius Caesar's decision, shortly before he was assassinated, to give himself a prolonged consulship, in his case for ten years. In a move worthy of George Orwell's *Animal Farm*, the bust of Junius Brutus, hitherto a hero for the French as Caesar's assassin, was taken from its pedestal before the Altar of the Fatherland and placed, almost anonymously it seems, among the other statues in the Louvre, which was renamed the Musée Napoléon. In 1804 Napoleon declared himself emperor of the French. The transformation from revolutionary to conservative ruler was complete. Jacques Louis David, whose most famous painting to date was that of the assassinated extremist Marat lying dead in his bath, completed a similar transition and re-emerged as the official painter of the new imperial regime.

So what happened to the Venetian horses? Their first home was on piers on the gateway to the Tuileries, but Napoleon wanted to use them more flamboyantly than this. He had already adopted many of the trappings of Roman imperialism, proclaiming himself in all but name the new Augustus, who had brought order to France without betraying its revolutionary ideals, just as the Emperor Augustus had claimed to have done in Rome in the first century BC. Whether he was

*This was how the Salon, the exhibition of approved French art which was so impressively boycotted by the Impressionists, originated.

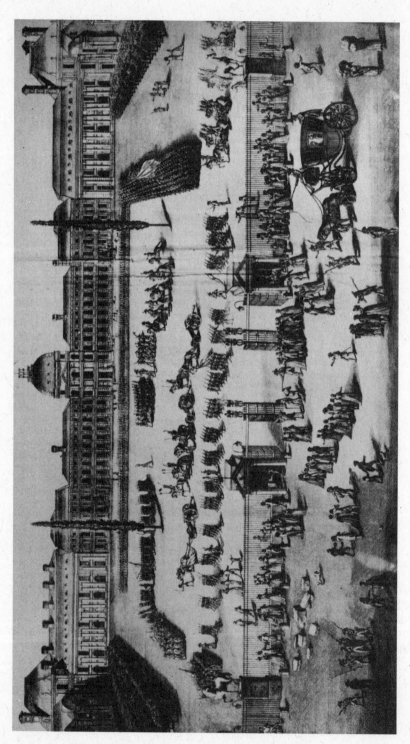

Once arrived in Paris, the horses were first set up on the railings in front of the Tuileries Palace, which Napoleon had appropriated as the seat of imperial government. Two of them can be seen here on the far left and right of the railings. (Museo Correr, Venezia)

creating a new system of laws (the Code Civil), designing a sewerage system for Paris or just decorating a palace, imperial Rome was now his model. He even discussed bringing Trajan's Column, with its panorama of the military victory of the Emperor Trajan, to Paris; but fortunately it was too heavy to move, and Napoleon had to commission, in 1803, his own column of victories for the Place Vendôme.

After his great victories over the Austrians at Ulm and Austerlitz in 1805, Napoleon had told his soldiers that they would 'go home beneath triumphal arches', and he now set in hand the construction of two in Paris. The first arch to be commissioned, in 1806, was that known today as the Arc de Triomphe, but this massive edifice was not completed until well after Napoleon's fall and death (eventually only in 1836). Then, at eleven o'clock one night in February 1807, the emperor ordered his architect Fontaine to have five hundred labourers in place by the very next morning to begin preparing a site for a second arch which was to stand in the Place du Carrousel, an open space in front of the Tuileries, where the cavalry of Louis XIV had carried out its parades. It would serve as a grand entrance to the palace.

Plans were quickly drawn up. The immediate model was the arch of the emperor Constantine, which still stands by the Colosseum in Rome. Constantine's arch had reliefs of his victories incorporated on the façades, and the Arc du Carrousel would be similarly adorned with Napoleon's achievements. On Constantine's arch there were eight free-standing figures of captives; on the Carrousel there would also be figures, but in this case they were to be of representatives of the Grande Armée. There was to be a further embellishment. Fontaine suggested that the 'masterpiece of Greek sculpture, the horses, hitherto nomadic', be placed on its summit. Behind them would be a chariot driven by Mars, the Roman god of war. When Fontaine was diverted to another imperial project it was the Director of Museums, Vivant Denon, who was put in charge of the design of the arch, and it was Denon who hatched the idea of placing a statue of the emperor himself in the chariot. The first stone was in place by 7 July, and on 1 January 1808 there is a report of Napoleon gazing at the

arch, still in its scaffolding, from the windows of the Tuileries. He moaned that it was more of a lodge than a gateway, was too wide, that the marble columns (which were remnants taken from a seventeenth-century monument) were not as beautiful as those fronting the restored abbey of St Denis – but those around him could not help noticing his pride.

By August 1808 the summit was complete but still covered in canvas, and when Napoleon, in Paris for his birthday celebrations, asked what this was concealing, the governor of the Tuileries Palace, a rival of Denon, let slip that a statue of the emperor himself was being placed in the chariot. Napoleon insisted it be taken out – 'It is not for me to make statues of myself' – and ordered the chariot to be left empty. The statue was placed instead in the Orangerie of the Louvre. It is not clear why Napoleon was so coy about being represented in this context – given that less than two years before, in September 1806, he had shown no inhibitions about ordering a statue of himself, dressed as a Roman emperor with a globe surmounted by a personification of Victory in his hand, to be placed on top of the Vendôme column; and two years later, in 1809, when the *Description d'Égypte*, the great study of ancient Egypt commissioned after Napoleon's conquest of the country, was published, he was shown in a *quadriga* on the frontispiece.

By the end of 1808 the arch was finished with the horses on its summit – but it was not universally admired. The most common criticisms were that the horses looked too small for the summit or that the statues personifying Victory who led them were too big. William Rootes, visiting Paris in 1814, after the first defeat of Napoleon by the allies opened the city again to English travellers, felt that much of their beauty was lost because of the height of the arch. Another English visitor, Henry Milton, was even harsher in his criticism.

The four bronze horses were placed on the summit and close to each other, harnessed to a triumphal car and led by two figures representing Victory and Peace. The horses are of natural size,

The horses on the Arc du Carrousel, where many felt that they were eclipsed by the size of the arch. After their removal in 1815, a minor victory by France in Spain in the 1820s was used to justify the installation of replicas. (Mary Evans Picture Library)

these figures are colossal: and with a want of judgement and a depravity of taste, astonishing even in Paris, the car, the figures and all the other ridiculous appendages of the horses are sumptuously gilded . . . To build a puny arch of fine marble is no great offence, but to crowd together on its summit the matchless Venetian horses, to hide them from observation by disproportionate figures, a cumbrous car and gaudy discordant trappings is a transgression not easily to be pardoned.

Milton's thoughts reflect his English prejudices, but they also suggest that Napoleon's ambition had resulted in a tasteless display of extravagance. Although the emperor liked to extol himself as a

patron of the arts and sciences, there is no evidence that he had any aesthetic sense. We have a report that when his minister of the interior, Jean Antoine Chaptal, took him round the treasures of the Musée Napoléon, its main benefactor made virtually no comment except to ask occasionally for the name of an artist or sculptor, greeting the answer with apparent indifference. When he married, as his second wife, the Austrian princess Marie-Louise, he asked that Veronese's *Marriage at Cana* (looted from Venice) be moved to the reception room. When Denon replied that it was too fragile to move, Napoleon retorted that, in that case, it might as well be burned. In his palaces and the homes of his newly created aristocracy heavy, ornate and opulent *objets d'art* came to pre-dominate, and the lightness of tone so typical of much French art of the eighteenth century was lost. The artistic bankruptcy of the regime was epitomized by a factory owned by Napoleon's sister Elisa which churned out five hundred busts of him a year, using a new pointing system and an organized production line. In fact, she initiated the mass production of small copies of sculptures which overwhelm visitors to the tourist areas of Italy today.

Nevertheless the collecting continued, with more masterpieces from Germany, Spain and Italy (after the French administration closed down all monasteries there) being added to the Musée Napoléon. In 1809 Prince Borghese, owner of one of the great Roman collections, was forced to sell it to Napoleon for eight million francs, not all of which ever reached him. (The fact that the prince was married to Napoleon's favourite sister Pauline meant nothing.) Vivant Denon, who had come to Napoleon's notice when he accompanied the emperor on his famous expedition to Egypt, proved an extraordinarily energetic curator. He was now in his sixties, having begun his career in the court of King Louis XV, but he hurried off to each country as it was conquered to see what he could sequester or buy, and acted as a propagandist for what was by 1810 by far the most impressive museum in the world. Always the consummate courtier, he reported to a colleague that in his desire to serve Napoleon's first wife, the Empress Josephine, 'I always took, in

addition to the paintings I was ordered to seize, a number of pretty little things which the Emperor would be delighted to give her.'

He was to enjoy only four more years of glory. By 1811 the British were wearing down Napoleon's armies in Spain. In 1812 came the disastrous winter campaign in Russia. In 1814 Napoleon's overblown and overextended empire finally collapsed at the hands of a coalition of powers, Austria, Prussia, Russia and Great Britain. Napoleon abdicated on 6 April and by May the allies had restored the royal family, in the person of Louis XVIII, brother of the guillotined Louis XVI. In none of the peace treaties, however, was any mention made of the looted antiquities. There were good reasons for this. The concern of the great powers was to settle the French down under a restored royal family, and it was hoped that Louis would negotiate himself with those who wished for the return of their treasures; the allies did not want to weaken the settlement by insisting on such restitution themselves. They accepted, too, that many of the works had been acquired through treaties, notably that made at Tolentino with the pope, and there was a reluctance to break diplomatic convention by declaring these agreements invalid. As Pius VII had no soldiers and only one of the allied powers, Austria, was Catholic, he had little negotiating power. Hopes were raised in May when Louis announced that he would be prepared to return any works of art not already displayed in the Louvre or the Tuileries, but by June his position had shifted and he talked vaguely of 'masterpieces of the arts which belong to us from now on by stronger rights than those of victory'. The Musée Napoléon was renamed the Musée Royal as if everything had simply passed from the deposed emperor to the returning monarch.

This relaxed attitude to Napoleon's plunder on the part of the allies changed when in March 1815 Napoleon escaped from his first place of exile, Elba, landed in France to widespread acclamation, reformed the Grande Armée and came close to defeating the allied troops at Waterloo in June. With his second capitulation in 1815, many of the inhibitions of 1814 were swept away and there was now talk of punishing France. When the French tried to insert a

clause in the peace treaty of 3 July guaranteeing 'the integrity of
museums and libraries', it was struck out. By 10 July Prussian
soldiers had arrived at the Louvre to take Prussia's treasures back.
The British prime minister, Lord Liverpool, supported the return:
'It is most desirable', he announced on 15 July, 'in point of policy
to remove them if possible from France, as whilst in that country
they must necessarily have the effect of keeping up the
remembrance of their former conquests and of cherishing the
military spirit and vanity of the nation.' The British – notably the
Prince Regent – who had themselves had designs on some of the
antiquities, particularly the Apollo Belvedere, realized that this
would be a humiliation too far for France, and shifted to support
the restoration of art works to their original owners. On 5 August
the Austrians put in a formal request to the French government for
their losses. The pope sent his envoy in the shape of Antonio
Canova, who arrived in Paris on 28 August. (His mission is dealt
with in the next chapter.)

On 20 September the allies concluded a formal agreement
stipulating that all art objects be returned to their original homes.
Only the Russians did not sign, it is said because Tsar Alexander
had bought the finest paintings in the collection of Josephine
Bonaparte, who had been divorced by Napoleon in 1809, from
her family when she died in 1814 and, if he acquiesced in the
agreement, they would be among those which would have to be
returned. The duke of Wellington, buoyed with immense prestige
as victor of Waterloo, and commander in chief of the allied forces
in France, weighed in in support of the agreement. No one, he
argued in a letter to the British foreign secretary Lord Castlereagh,
is taken in by the argument that the art is better off in France than
it would be in its original homes. It is only the national vanity of
the French which keeps it in Paris. If they had seized the 'pictures
and statues of other nations' solely through force of arms, they
could hardly complain that these were returned, and indeed it would
serve as 'a moral lesson' to the French if they were. The *London
Courier* made the point that if the allies behaved as the French had

done they would have stripped France of the art it had accumulated before the reign of Napoleon. Wellington was prepared to condone the use of troops to ensure the dismantlement of the museum and, in the face of rising anger among the Parisians, he ordered a formal parade of all his forces to stress his point.

Poor Denon; his dream was dissolving before his eyes. He was openly humiliated by William Hamilton, the diplomat appointed by the British government as secretary of the delegation sent to enforce the agreement. 'This viper Hamilton' was already much hated by the French as he had been sent on a previous mission to Egypt after the French evacuation of the country and had caught the French trying to smuggle out the Rosetta Stone, which had been ceded by treaty to the English.* Now he added insult to injury by tactlessly taunting Denon that all these treasures had not inspired a single French artist of genius to emerge and that, with Paris' main centre of prostitution, the Palais Royal, only a few yards from the Louvre, the city was too dissipated to be the guardian of great work. Denon remarked that London was even worse, every street offering prostitutes. Well, at least the treasures of the British Museum are ours, said Hamilton, glossing over the fact that in 1802 he, as secretary to Lord Elgin, Britain's ambassador to Constantinople, had directly supervised the removal of the Parthenon frieze, which the earl was currently offering to the British government.

Denon, for his part, did everything he could to save his collection, pretending that works had mysteriously disappeared, had been in France for decades, or were in parts of the palace which were the private property of the king. Works which had been transported from Italy without difficulty were now proclaimed so fragile that they could not travel. A more successful plea was lodged over some ancient columns from Aachen Cathedral which had been built into

*The Rosetta Stone, now in the British Museum, was inscribed with a text in hieroglyphics, Greek and demotic Egyptian and provided the key to the decipherment of Egyptian hieroglyphics by Jean-François Champollion.

the Louvre — Denon's argument that the roof would fall in if they were extracted carried the day. But most of the rest had to go. 'Let them take them then,' he eventually conceded, 'but they have no eyes to see them with; France will always prove by her superiority in the arts that the masterpieces were better here than elsewhere.'

The dispersals now got under way in earnest. On 2 October the *London Courier* reported:

> The public mind of Paris still continues in a state of extreme agitation; the public appear every day more and more exasperated against the Allies . . . The stripping of the Louvre is the chief cause of public irritation at present; . . . the Grande Galerie of the Museum presents the strongest possible image of desolation; here and there a few pictures giving greater effect to the disfigured nakedness of the walls. I have seen several French ladies in passing along the galleries suddenly break into extravagant fits of rage and lamentation; they gather round the Apollo [Belvedere] to take their last farewell with the most romantic enthusiasm; there is so much passion in their looks, their language and their sighs, in the presence of this monument of human genius that a person unacquainted with their character or accustomed to study the character of the fair sex in England, where feeling is controlled by perpetual discipline, would be disposed to pronounce them literally mad . . .

The novelist Walter Scott, having noted that English troops were stationed in Paris for the first time since 1436, remarked that the best statues were treated as objects of adoration.

On 12 October another British visitor, Andrew Robertson, wrote: 'The Louvre is truly doleful to look at now, all the best statues are gone, and half the rest, the place is full of dust, ropes, triangles and pulleys with boards, rollers, etc.'

But perhaps the humiliation most deeply felt by the French was the dismantlement of the Venetian horses. We need to return to their saviour, Antonio Canova.

15

ANTONIO CANOVA AND THE RETURN
OF THE HORSES TO VENICE

IN BECOMING GAUDY AND UNINSPIRED, NAPOLEONIC ART
had betrayed the ideals of neoclassicism which had been upheld and
developed by the greatest sculptor of the Napoleonic era, the
Venetian Antonio Canova. Like Titian and Palladio before him,
Canova was a native of the *terraferma* who through his own talent and
personal qualities made himself into a European celebrity. He knew
of the horses from his youth, was confident enough to complain
personally to Napoleon about their removal and was largely
responsible for masterminding their return in 1815 to his native
Venice. It is perhaps fitting that his funeral service in 1822 was held
in St Mark's and so his body was carried out under the *loggia* on
which, thanks to his own efforts, the horses once again stood in
glory.

Canova was born in 1757 in the small village of Possagno, in the
hills near Treviso. His father died when he was only three, his
mother remarried and moved, in effect abandoning him, and it was
his grandfather who took care of him and apprenticed him to a
family of sculptors. Canova resembles Palladio in that his talent was
recognized by a local aristocrat, in his case Giovanni Falier, who
gained him his early commissions. One of his very first, for Falier
himself, of an Orpheus, was exhibited in the Piazza San Marco on

Antonio Canova in his studio. An early nineteenth-century lithograph. (Mary Evans Picture Library)

the feast of the Ascension in 1777; so by the time he was twenty Canova already knew the horses of St Mark's. His initiation into the sculpture of the ancient world was furthered by a famous collection of plaster casts of antique statues in the Palazzo Farsetti, from which he used to copy. Always ambitious, in 1779 he left Venice for Rome, where he came under the protection of the Venetian ambassador to the pope. In the highly competitive atmosphere of the Roman art world, personality and determination were as important as natural talent, and although Canova was a

quiet and often withdrawn man, there was a confidence about him which enabled him to gain the immediate respect of those with whom he worked, even emperors. (Again one is reminded of Titian and Palladio.) He was particularly inspired by the classical past, especially its mythology, and he assembled his own library of classics and read deeply in archaeology and the lives of ancient heroes. He transformed the way he dressed, mastered 'correct' Italian and even learned some English and French. While Rome, and a connection to the papacy, were central to his life, he never forgot that he was first and foremost a Venetian. 'I have St Mark in my heart and nothing in the world will change me,' he said when he heard the news of the fall of the republic to Napoleon in 1797. The word *patria* in his letters refers not to Italy but to Venice.

Canova's breakthrough came in 1783 with the commission to create the tomb of Pope Clement XIV (d. 1774) for the Church of the Holy Apostles in Rome. This monument was so admired on its completion in 1788 that it won Canova renown across Europe and a status he retained for the rest of his life; those who loved the austere classicism of his work acclaimed him as 'the new Phidias'. His success was all the more remarkable because it was the common belief that the genius of Italy and its people had faded. The French writer Stendhal caught the mood when he commented that Canova 'had emerged quite by chance out of the sheer inertia which this warm climate imposed, but he is a freak. Nobody else [in Italy] is the least like him.' Exquisite pieces such the Cupid and Psyche, with Psyche stretching upwards to place her arms around Cupid as he bends over her, or more formal tombs, such as that to Pope Clement XIII (d. 1769) in St Peter's itself, completed in 1792, consolidated his reputation. He could pass from classical myth to commemoration of popes without embarrassment, just as Titian could.

Like most Italians, Canova was caught up in the turmoil of Napoleon's invasions, shut up in Rome when Napoleon besieged the city in 1797 and affected more directly when Napoleon included some of his most prized plaster models among the works of art taken

from the city. Then came the news of the spoliation of Venice itself, which upset Canova profoundly. With the Italians seemingly humiliated in their traditional role as the creators and guardians of some of the world's finest art, Canova was seen to embody the continuing genius of Italy. 'You are a true power in the world,' exclaimed his friend Count Leopoldo Cicognara, later director of the Venetian Academy. 'You have a glory common to extraordinary influence, namely, that of having made a revolution in the arts, like the one the military powers are making in politics.' In 1806 Canova won the commission to design a tomb for the Piedmontese poet Vittorio Alfieri in the Church of Santa Croce in Florence. The church was already being associated with the cause of Italian nationalism and was a fitting resting place for Alfieri, whose poems had championed Italy against the French. Canova introduced the figure of Italia, depicted mourning on the sarcophagus of the poet.

Yet there was no escaping the looming power of France. As early as 1797 Napoleon recognized Canova's talent, promising to keep paying him the annuity which Venice had awarded him in exchange for a sculpture; but, like so many of Napoleon's promises, it was never honoured. As Napoleon consolidated his position and became ever more interested in his own commemoration, it was inevitable that Canova would be approached to serve him. The call to Paris came in 1802 through the French ambassador in Rome, François Cacault, but Canova, still smarting at Napoleon's treatment of Italy and the arrogance with which he had treated Pius VI (d. 1800) and his successor Pius VII, resisted it. He claimed that his health was bad and that the roads to Paris were impassable. It took pressure from the conciliatory Pius VII, who feared the repercussions if Napoleon's anger were aroused, to get him on his way. When Canova did arrive in Paris he refused to stay at Napoleon's court but lodged instead with the papal nuncio as if to stress his independence. As he entered the Tuileries palace he must have passed the Venetian horses, still then on their piers, and he complained at once to Napoleon of the despoiling of Italy and in particular the seizure of the treasures of Venice. He even referred

to the letter in which Quatremère de Quincy had inveighed against the dismemberment of Italy's cultural centres.

Napoleon took the attack in surprisingly good part. Like most bullies, he respected someone who would stand up to him; but he also seems to have been overawed by the achievements of the sculptor. Eventually Canova agreed to produce two works: a portrait bust of Napoleon, which became one of the canonical images of the emperor (it was this one that Napoleon's sister Elisa reproduced), and, more controversially, a gigantic sculpture of Napoleon as the god Mars in his role as peacemaker, the latter for the staggering price of 120,000 francs. The notion of Napoleon as a peacemaker could be justified by reference to the short-lived Treaty of Amiens, which did bring peace to Europe for a time in 1802; but the role became increasingly unsustainable as Napoleon set off on new conquests.

The challenge for Canova was how to merge the figure of Napoleon with the image of a classical god. He proposed that the emperor, who had wished to be sculpted in uniform, be shown in the nude, as Greek heroes and Hellenistic monarchs had been. Napoleon's advisers, including Vivant Denon, supported the proposal. A costume was rooted in time, they argued; nudity, by contrast, was timeless, as befitted such a great conqueror. Napoleon, initially reluctant, eventually gave in to their flattery, but his reservations proved to have been well founded. In 1810, before the Mars had arrived in Paris, the emperor unveiled another nude statue, to the hero Desaix, a general who had fallen in Napoleon's victory over the Austrians at Marengo in 1800. It was greeted with embarrassment and ridicule by the Paris crowds. Whatever the intellectuals felt, the decently togaed figures of the Roman republic were seen as a much more appropriate model from the past. Napoleon himself was gaining weight and he must have realized that the portrayal of his sagging figure as nude muscled hero would be received with disbelief. By now, moreover, it was becoming all too clear to a wearied French public that they were led by a warmonger, not a peacemaker.

When the statue arrived in Paris in 1811, Napoleon received it with coldness and then forbade public access to it. Denon had the unhappy task of telling Canova that the destination of the statue remained undecided. Canova was deeply hurt – it was the only one of his statues that was ever rejected. Eventually it was bought by the British government, which gave it to the duke of Wellington, and it still stands in the duke's London home, Apsley House (where, a later report suggested, the servants used it to prop their bicycles against). A plan to have a copy placed in the Roman Forum between two of the surviving triumphal arches also came to nothing. It would never have survived the derision of the Roman citizenry.

In 1810, before the Mars had arrived in Paris, Canova had paid another visit to the city – this time on the direct orders of Napoleon. Since the latter had by now declared himself king of Italy, Canova had become one of his subjects and could hardly refuse. The fresh commission was to make a statue of Napoleon's new empress, Marie-Louise of Austria, and the piece was duly completed in 1814 – by which time the days of Napoleon's empire were over. Meeting Napoleon at the chateau of Fontainebleau, Canova again amazed the courtiers by the confidence with which he confronted the emperor over his treatment of Italy, forcing the emperor to agree to new patronage of artists and archaeological excavations. But little of what Napoleon promised was ever paid, and on his return to Rome Canova found that his acceptance of yet another Bonaparte commission had made him vulnerable to public disapproval. He had to tread carefully. As principal of the city's Accademia of San Luca, which trained students in art, he was, of course, expected to attend the annual prizegiving; but with Rome directly ruled by the French (as it had been since 1809, when Pius VII had been exiled), this was clearly going to be a French propaganda show. Napoleon's pretensions to be the heir of the Roman emperors were underlined by holding the ceremony on the Capitoline Hill, the most sacred spot of ancient Rome. One speech by a French functionary caught the new mood of bombastic flattery.

Winners, come forward! . . . You may expect all things from your great benefactor! Raise high on the Palatine a new palace to Caesar, raise new arches of triumph where Constantine entered, where another will enter who is greater than he! Paint on your palace walls [presumably the 'palace' in which the students painted] his marvellous deeds with which the whole world is resounding.

It is good to report that Canova failed to attend the ceremony – he had, he said, to be in Florence overseeing some final details of his monument to Vittorio Alfieri. The snub could not have been more pointed; but just how powerless he was was shown the next year when Vivant Denon descended on Italy in search of more loot despite Napoleon's promise to Canova a few months earlier that no more would be taken. The French occupation of Rome, for all its blustering rhetoric of liberation from the superstition and tyranny of the church, was profoundly unpopular, and became even more so when military conscription was introduced to replenish the French armies as Napoleon's empire crumbled. When the French eventually left Rome in 1814, Pius VII was welcomed back with rejoicing.

There were still many in Italy who criticized Canova for having had anything at all to do with Napoleon. Pius had appointed him Director of Museums in Rome before going into exile, and he had kept the post when the French took over, hoping – unrealistically, as it turned out – to prevent further French looting of the city. To those who knew little of his spirited personal attacks on Napoleon he looked like a collaborator, especially as he also fulfilled commissions for many members of Napoleon's family, the most celebrated of them the reclining statue of Napoleon's sister Pauline (who was married to the Roman Prince Borghese) as Venus Victrix, the conquering goddess of love, which is still to be seen in the Borghese collection in Rome.* In fact, he maintained a remarkable degree of

*Prince Borghese was rumoured to be impotent, and Pauline gained her reputation as Venus Victrix by her adventures in other beds than his.

freedom. In these same years he managed to do work for the Austrian Habsburgs and the royal family of Naples, both enemies of Napoleon. He even designed a massive tomb for Lord Nelson, who had died while destroying Napoleon's fleet at Trafalgar, and it is possible that there was a touch of subversion in his work for the Bonapartes. A statue of Napoleon's mother appears to be directly inspired by an original of the Empress Agrippina, the mother of the deranged emperor Nero. The pope certainly remained warmly appreciative of Canova and, when the time came to send an envoy to Paris to reclaim the Vatican treasures, saw him as the ideal candidate.

When Canova arrived in the city in August 1815 his mission was a particularly delicate one. Unlike the allies, he had no troops to back his demands, and Pius VI had signed the treaty of Tolentino, which included a clause stating that it was binding on the papacy for ever. Already a letter from Pius to Louis XVIII asking for the return of the Vatican's art works had been met with a blank refusal. In the circumstances Canova's achievements in the ensuing negotiations, on behalf of both Rome and his native Venice, were remarkable. The secret seems to have lain in his relationship with the 'viper Hamilton'. Canova always got on well with Englishmen, having met many in his early years in Venice, where they were respected as generous and often well-informed patrons. It was rare for Italians to speak English at that time (French was the most prestigious second language), but one report claims that Canova spoke English 'fluently' and there is some evidence that he and Hamilton had already met in Rome. They certainly built a profitable relationship, and Hamilton was soon giving Canova access to those British diplomatic documents which dealt with negotiations over the plunder. Canova knew that the biggest hurdle was the Treaty of Tolentino, but he persuaded Hamilton that the pope had in fact not been entitled to make a treaty giving away what did not strictly belong to him. Hamilton in his turn helped Canova construct an argument which he felt the British foreign secretary, Viscount Castlereagh, to whom Hamilton was responsible, would accept. The

best strategy, Hamilton advised, was to stress the unique position of Rome as a great repository of the arts. Castlereagh's support was won and proved decisive. On 30 September it was formally agreed by the allies that the pope should have his statues back.

Canova was exhausted by his efforts. The open hostility of the French crowds had been particularly distressing: when he tried to visit the Halle d'Études of the Académie Française he was pelted with bread pellets by the students, and he overheard one of the artists saying that he would like to stick a dagger into him. Denon addressed him to his face not as *Ambassadeur*, as his formal status required, but as *emballeur*, 'packer'. But his position among the occupiers was assured, and he gained so much respect among the allied negotiators that other Italian cities began asking for his help in getting their own treasures back. His greatest coup was to forge a working relationship with the Austrian emperor, Francis II. Under the peace treaties, the Austrians were to be given permanent control of Venice, and any Venetian works of art in Paris were thus technically now Austrian rather than Venetian. Francis would have been entitled to have had them in Vienna, but he acquiesced in the argument advanced by Canova, like Quincy de Quatremère before him: that the setting of a work of art was as important as its intrinsic quality. The horses were to be returned, under the auspices of the Austrians, to Venice, and even before they had left Paris Francis was consulting with Canova over where they should be placed.

So the horses were scheduled to be taken down from the Arc du Carrousel. On 25 September, an *aide-de-camp* of the prince of Schwarzenberg, the commander of the Austrian troops, visited Denon to tell him of the decision to dismantle the arch. This is a public monument, protested Denon, and falls outside any agreements that have been made. There was nothing he could do; but a rising tide of anger showed that the horses had captured the imagination of the French more than many of the other treasures. Crowds crammed the area around them in protest. It was cleared, and on 27 September Austrian troops closed off all the streets leading to the arch. When more crowds gathered along the *quais* by

the Seine, they were scattered by Austrian cavalry. Henry Milton tells how the only place from which the French themselves were allowed to view the dismantlement was the gallery of the Louvre, where they mingled with English visitors. That whole day was spent getting just two of the horses down. English engineers were sent up to help, and they were seen cavorting in the chariot. Rumours later spread that it was English soldiers who scraped the gilding off the horses, although we now know that the scoring was deliberately done in antiquity.

In its issue of 3 October the *London Courier* published a letter from a correspondent in Paris, reviewing the events of the past few days.

> I just now find that the Austrians are taking down the bronze horses from the Arch. The whole court of the Tuileries, and the Place de Carrousel are filled with Austrian infantry and cavalry under arms; no person is allowed to approach; the troops on guard amount to several thousands; there are crowds of French in all the avenues leading to it who give vent to their feelings by shouts and execrations . . . the number of cannons of the bridges has been increased.

By 1 October the horses were off the arch and the figures of Victory and Peace and the chariot were seen lying on the ground in pieces. The monument was sacked, its bas-reliefs pulled off, but the statue of the emperor designed for it was left untouched in the Orangerie of the Louvre. Louis XVIII is reported to have observed the unhappy scene from the windows of the Tuileries. Henry Milton concludes his own description: 'Justice, policy and good taste all imperiously demanded that this ill-devised trophy should not be suffered to exist, but it was impossible not to feel some pity for the humiliation and misery of the French.'

On 16 October Canova was able to write in a letter:

> The cause of the Fine Arts is at length safe in port . . . we are at last beginning to drag forth from this great cavern of stolen

goods the precious objects of art stolen from Rome . . . yesterday
the Dying Gladiator left his French abode and the [Belvedere]
Torso. We removed today the two first statues of the world, the
Apollo [Belvedere] and the Laocoön . . . the most valuable of the
statues are to go off by land, accompanied by the celebrated
Venetian horses.

Some of the works from Venice, in particular a Veronese ceiling,
proved too difficult to move and remain in the Louvre to this day.
The winged lion did eventually return, but only after an unhappy
experience. While being dismantled from its position in the
Esplanade des Invalides, it was dropped and broke into fragments,
to the jeers of the watching French crowds. Finally reassembled and
hoisted back on to its pedestal in Venice, it was high enough up for
the repairs and restorations not to be noticed. Other works from
Rome were left in Paris; about half the paintings taken, for instance,
never returned, and there were some who criticized Canova for not
doing more. Those who appreciated the complications of his
mission knew better. An oration in his honour read before the
Roman Academy of Archaeology in 1816 proclaimed that his
restitution had prevented the loss of Italy's creative genius.

Meanwhile the Arc du Carrousel stood empty for only a few
years. The memory of the horses was so powerful that a minor
victory by the French over the Spanish in the 1820s was used as an
excuse for recreating the *quadriga*, complete with replicas of the
Venetian horses. This remains intact in Paris today.

After his mission was successfully completed, Canova recog-
nized the help he had been given by the British by creating four
'Ideal Heads', three of which he sent to Hamilton, Castlereagh and
Wellington respectively. That for Hamilton was inscribed: 'Antonio
Canova made this gladly for William Hamilton a man of
distinction and a friend in acknowledgement of his exceptional
goodwill to himself and of his patronage in the recovery of artistic
monuments from France'. Hamilton returned the compliment by
asking Canova to come to England for a proper viewing of the

most famous antique sculptures in existence, those brought by Lord Elgin from the Parthenon in Athens. How these helped reinvigorate the debate over the horses of St Mark's is the subject of the next chapter.

16

GREEK OR ROMAN? THE
NINETEENTH-CENTURY DEBATES

Before St Mark still glow his steeds of brass,
Their gilded collars glittering in the sun;
But is not Doria's menace come to pass?
Are they not bridled? Venice, lost and won,
Her thirteen hundred years of freedom done,
Sinks like a seaweed, into whence she rose!
Better be whelm'd beneath the waves, and shun,
Even in destruction's depth, her foreign foes,
From whom submission wrings an infamous repose.

BYRON, *Childe Harold's Pilgrimage,*

canto IV, xiii

THE HORSES RETURNED TO VENICE BY LAND, AND IT SEEMS
to have been a rough journey. At some point the decoration which
had covered their collars, and which can be seen clearly in the
engravings of the Zanetti cousins, was lost. It would have been all
too easy for souvenir seekers to have prised it off – it may even have
been removed in Paris. More dramatically, there are reports that the
horses' heads became detached (they had been cast separately and
the join to the bodies concealed by the collars) and so it was that

when they arrived in Venice on 7 December, having crossed the lagoon on a raft, they were taken to the Arsenale for repair. As we have seen, Canova had been asked by the Austrian emperor where they should be placed; he had suggested that they might stand two either side of the main entrance to the Doge's Palace on the waterfront, gazing in fact straight across at Palladio's Church of San Giorgio. He was opposed by the president of the Venetian Academy, Count Leopoldo Cicognara, who insisted that, as an ancient symbol of Venice's pride, they be put back on St Mark's. Francis, anxious to avoid upsetting Venetian opinion, acquiesced.

On 13 December 1815 the Austrian governor of the Venetian provinces, Count Peter von Goess, officially handed the horses, still in the Arsenale, over to the mayor of Venice. The emperor was present, together with his chancellor, Prince Metternich, and his role was commemorated in an engraving in which Francis is presented as a classical hero: nude but with a robe hanging loosely from his arms over his body, he stands on a sea shell which floats in front of the Doge's Palace and the Campanile, with the four horses, plumed and delicately posed, beside him. The theme is that of an *apotheosis*, the translation of a hero to heaven, a scene well known in classical art with the hero normally ascending upwards in a *quadriga*. It seems an appropriate way to have honoured Francis in this era of enthusiasm for classicism. In reality, the horses came round the eastern end of Venice on a raft on which the standards of Austria and Venice were displayed. A 21-gun salute heralded their departure from the Arsenale in the north of the city, massed troops awaited their arrival at the Piazzetta. They were then pulled along the Piazzetta towards St Mark's between ranks of soldiers and hauled into place to the accompaniment of musket shots and cannon fire. An oil painting of the event, formally commissioned by Metternich from Vincenzo Chilone, one of Canaletto's pupils, shows the horses waiting by the portal of St Mark's for their elevation back on to the *loggia*.

Canova was not in Venice to witness the horses' return. He had gone straight on to London from Paris and stayed there until the

Francis restores the horses to Venice, which awaits their return as the sun rises behind the clock tower. A watercolour of 1815. In fact, the restoration went hand in hand with the economic collapse of the city. (Museo Correr/Venezia)

first week of December. By early January 1816, however, he was in Rome to see the Vatican collection arrive safely home – after all, he was officially responsible to the pope for its rescue – and here he was created marquess of Ischia in recognition of his achievement. The occasion marked the end of a tumultuous six months. Following his diplomatic successes in Paris, he had been fêted in London: he had been honoured at a dinner at the Royal Academy, received by the Prince Regent (who slipped him £500 in a gold snuff box) and subjected to a whirl of social engagements and meetings with the leading British sculptors of the day. One of the highlights of his visit was his viewing of the Elgin marbles. Traditionally they had been credited to Phidias, or at least to a

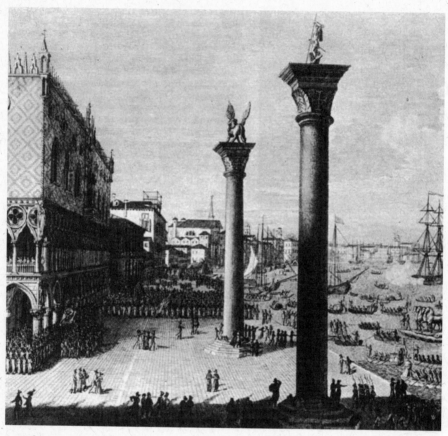

After repairs in the Arsenale, the horses were taken round the eastern end of Venice by barge so that they could be ceremoniously welcomed at the Piazzetta. They arrived on 13 December 1815, eighteen years to the day after they had been removed. (Mary Evans Picture Library)

workshop acting under his control, and this bathed them in an aura of quality. In 1803 Elgin had taken drawings of his acquisitions to Rome specifically to show Canova, much of whose work was inextricably linked to classical models, and Canova had urged that they be left unrestored so that their original quality could be seen: 'It would be a sacrilege to touch them with a chisel.' It was an important moment in the history of taste. In the eighteenth century there had been a passion for restoration and many ancient

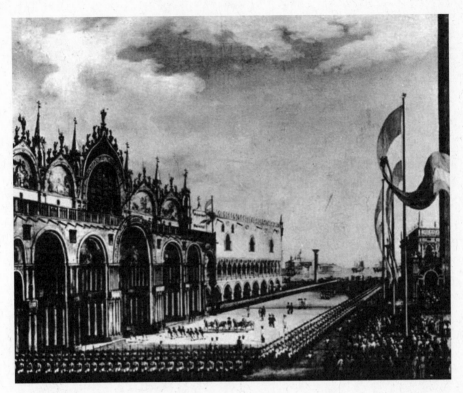

The horses arrive at St Mark's before being restored to their place on the *loggia*. Oil painting by Vincenzo Chilone. (The Art Archive)

sculptures had had spare arms and legs fitted to them to make them 'whole'. Now damaged sculptures acquired a romantic cachet, and the Elgin marbles were never added to.*

The marbles had arrived in London in fragments between 1802 and 1812, although it was not until 1806 that the British public started to become aware of the importance of the collection. Installed first at a Park Lane mansion leased by Lord Elgin, they were then

*In fact, quite the opposite. There was an assumption that Greek sculpture had originally been left in its white marble and unpainted. In the 1930s a misguided attempt to recreate originality led to some of the marbles being scraped down to improve their whiteness!

transferred to a shed at the back of Burlington House on Piccadilly, where it was possible to apply to view them. By the time Canova had arrived in London the marbles were well known, and there were impassioned debates over whether they should be bought from Lord Elgin for the nation. As the first major set of sculptures from the fifth century BC to be seen in western Europe, they were hard to assess against the well-known but much later favourites of the Roman collections. Some even doubted their age — a Mr Payne Knight, for instance, a prominent member of the Society of Dilettanti, insisted that they were Roman work from the time of Hadrian and of little interest. As the view of an adviser to many aristocratic collectors of antiquities, his judgements carried weight and he clung to them with determination, even suggesting at one point that the quality of the metopes, the panels which ran along the entablature above the columns, was so low that those who had carved them did not even deserve to be called artists. Most artists of the day, on the other hand, were bowled over by them, impressed by their simplicity and liveliness and above all their truth to nature. It had long been assumed, as in the Platonic tradition, that the 'ideal' statue of a human figure should be somehow more perfect than an actual human, just as Zeuxis' painting of an ideal woman described in Pliny's *Natural History* was composed of the finest points of five nude models. Yet here were sculptures which seemed to have been created directly from live models. (At one point two boxers were brought in to stand naked before them to make the point.) Instead of the bodies being beautifully proportioned, the muscles bulged according to the stress placed on them, sometimes on one side of the body only. The skin even contained veins, something that the 'idealists' had always said was incompatible with the 'noble grandeur' that Winckelmann had prescribed for this period of art. For those willing to look afresh at classical art they were a revelation.

When William Hamilton invited his friend Canova to come and see the sculptures in their temporary resting place at Burlington House, Canova can hardly have needed much persuading; but he was probably unaware of the extent to which he would be used in

the campaign to have them bought by the British government. Elgin had spent many thousands of pounds on transporting the marbles to England and the first offers from the government fell far below his expenses. The campaign to sell them had become embroiled in other complications. The influential Payne Knight continued to deny their importance, while the poet Byron, who was imbued with a love of Greece and a passionate commitment to its independence, virulently attacked Elgin for removing the marbles at all (he had actually been in Athens when Lord Elgin's agents were removing the metopes and he claimed that their clumsiness had led to some being damaged), even though at first his own opinion of the marbles as a whole was no higher than Payne Knight's. The end of the war, moreover, had brought an economic slump and there were others who pointed out the inequity of buying ancient sculptures when so many were starving.

In the event Canova helped break the deadlock by announcing that the marbles were superior to the statues of the Vatican which he had just saved, and that they had opened his eyes to the skills of the ancients before these had been debased by the desire of later generations for 'conventional and mathematical symmetry'. 'Everything here breathes life, with a veracity, with a knowledge for art which is the more exquisite for being without the least ostentation and parade of it, which is concealed by consummate and masterly skill.' It had been worth coming to London, he told Lord Elgin, simply for the purpose of seeing them. A rival frieze which had also arrived in London, taken from the temple of Bassae in the Peloponnese and dating from the later fifth century, a generation after the Parthenon, had been bought by the British government at auction for £15,000. In that case, said Canova, the Elgin marbles are worth £100,000. His remarks were quoted by virtually every witness who appeared before the parliamentary select committee which was considering the purchase. Eventually it was agreed to buy them for the nation for £35,000, and this sum was accepted by Elgin even though it was well below what he had spent on shipping and displaying them.

As we have seen, as early as the fifteenth century the Venetian horses had been attributed to Phidias, and it was inevitable that comparisons would be made between the Parthenon reliefs and the horses. It was perhaps unfortunate that the issue was taken up by the painter Benjamin Haydon. Haydon, later well known as a painter of history scenes, had arrived in London in 1804 to study at the Royal Academy. He was only eighteen at the time, an unsettled young man, but totally convinced of his own genius. He was furious when in 1806 (he was still only twenty) his entry in the Academy's annual exhibition was placed in a side room of Somerset House rather than being exhibited in the most prestigious gallery. The fact that it had been selected at all failed to calm the antagonism between him and the Academicians which smouldered for the rest of his life. In 1808 he visited the marbles and, as he wrote later in his autobiography, was overwhelmed by them. 'I felt as if a divine truth had blazed inwardly upon my mind and I knew that they would at last rouse the art of Europe from its slumber in the darkness.' Like others, he was enthralled by their truth to nature and he became obsessed by the details of the human bodies, spending hours in Burlington House copying wrists and feet. One feature which inspired him particularly was the head belonging to a horse from the *quadriga* of the moon-goddess, Selene, which 'overflowed' from the end of the eastern pediment. Writing to Elgin in February 1809, he enthused: 'that horse's head is the highest effort of human conception and execution; if the greatest artist the world ever saw did not execute them [the marbles as a whole] I know not who did – look at the eye, the nostril, and the mouth, it is enough to breathe fire into the marble around it.'

Like every artist and connoisseur brought up on the superiority of the Vatican figures, Haydon was presented with the dilemma of relating the Parthenon sculptures to them. Over the next few months he gradually came to revise his view of the Apollo Belvedere, which he had followed Winckelmann and conventional opinion in applauding. By 1816 it had become to him no more than a work from late antiquity, a period 'when great principles had given way to minute

and trifling elegances, the characteristics of all periods of decay'. As was typical with Haydon, the exaltation of one work of art required the denigration of another, and it was now that the Venetian horses came to be caught in his sights. He had seen a cast of one of them, and in an article in the *Annals of Fine Arts* for 1819 reproduced a drawing he had made of it alongside the Parthenon horse which so excited him. Having assumed that the horses of St Mark's were by Lysippus, in other words a mere hundred years later than the Parthenon, he lamented how 'the great principles of nature could have been so nearly lost in the time between Pheidias and Lysippus'. He then launched into a diatribe. The great crime of the Venetian horses was that they were not true to life. No horse, says Haydon, could

Benjamin Haydon placed the head of the horse from the Parthenon pediment (left) alongside one of the horses of St Mark's in order to denigrate the latter (1819). (Charles Freeman)

have sunken eyes as they did, because it would not have been able to see danger. The eyes of the Parthenon horse are alert to what is around them; those of the Venetian horses are not. The nostrils 'of the Venetian horses seem wrongly placed, the upper lip does not project enough and there is an evident grin as it if had the snarling muscles of a carnivorous animal . . . it looks swollen and puffed as if it had the dropsy.' How could Raphael and other painters who were inspired by the horses possibly think that by copying them they were emulating nature, 'the great source of all beauty and truth'? Haydon was, of course, turning his back on the Platonic tradition and returning to one which saw nature, rather than idealized versions of it, as the source of inspiration for great art.

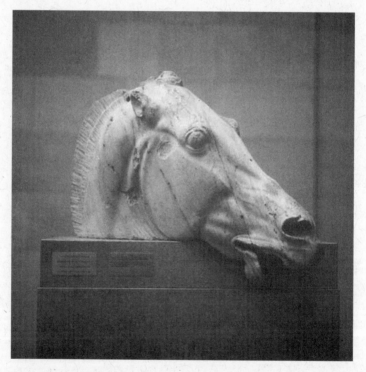

The head of one of the horses drawing the chariot of the moon-goddess Selene, from the eastern pediment of the Parthenon, 430s BC. This was the head idealized by Haydon (see previous page). (Ancient Art & Architecture Collection)

Haydon took his campaign to Europe. His article in the *Annals of Fine Arts* was translated as '*Comparaison entre la tête d'un des Chevaux de Venise et la tête du Cheval d'Elgin du Parthénon*', and in this form it came to the attention of Goethe. At first Goethe, who as we have seen had examined the horses at close quarters on his visits to Venice twenty-five years before, rejected Haydon's denigration as unjust. Then he saw a cast of the Parthenon horse and had to acknowledge that it was the equal of those in Venice (he had his own cast of one of the horses' heads to compare it with). On the other hand, he refused to make a comparison of quality. While accepting that 'the artist [of the Parthenon] had created the original ideal of the horse . . . among intelligent people there could be no question that through both of these works we are presented with a new conception of nature and art.' He echoed the comments of others when he argued that comparisons with an ideal and comparisons with truth to nature were equally valid ways of assessing the quality of a work of art. Such an approach had its advantages in that it enabled those who had been conditioned to see the Apollo Belvedere and its companions as the high point of ancient art to keep their enthusiasm intact while remaining receptive to the Parthenon sculptures. The two groups of works represented the pinnacles of two different kinds of art. However, from now on the Apollo Belvedere began to fall from favour. It was acknowledged as a copy of something earlier, perhaps not even a good one at that, and unable to stand comparison with the original work of so many centuries before.

Haydon's attack, then, failed to win wider support, but in Venice a fresh battle was breaking out over the origins of the horses, one which reflected wider debates over the classical past in a Europe now caught up in the throes of nationalism and romanticism. In an earlier chapter it was noted that Venice had been happy to draw on the pasts of both Greece and Rome, but by the early nineteenth century the debate over the rival merits of the two cultures reached a new intensity. It is a Venetian, Giovanni Battista Piranesi, who deserves the credit for reviving interest in the architectural

achievements of Rome. Born in Venice in 1720, the son of a
stonemason, Piranesi absorbed Roman history as a boy and by
1740 he was on his way to Rome 'to admire and learn from those
august relics which still remain of Roman majesty and magni-
ficence, the most perfect there is of Architecture'. His famous *Vedute*
(scenes) of Rome, his *Capricci*, made up of imagined Roman
buildings, and his meticulous measurement and drawing of
surviving Roman buildings gave him an international reputation,
enhanced by the ease with which his prints (of which there were
eventually over a thousand) could be bought in Rome and taken
home by travellers on the Grand Tour. Goethe's first views of Rome
had been through Piranesi's prints, and their impact was such
that he was disappointed to find that Roman buildings appeared
much smaller than he had imagined from Piranesi's grandiose
reconstructions.

Crucially, Piranesi became the champion of ancient Rome against
Greece. When challenged by travellers who had visited Athens and
who maintained that Greek architecture was superior to Roman,
Piranesi replied that Roman architecture was much more creative
and richer in variety, and had a magnificence in its conception which
the Greeks could not match. One only had to look at the range of
Roman buildings, from aqueducts to bath houses, amphitheatres to
sewer systems, he said, to see the point. Understandably, Piranesi
was furious with Winckelmann for championing the Greeks so
exclusively. 'Must the genius of our artists be so basely enslaved to
the Grecian manners, as not to dare to take what is beautiful from
elsewhere, if it not be of Grecian origin?' he inveighed. There was
also much to be found, he argued, in Egyptian and Etruscan art; in
one of his more outrageous and unbalanced judgements, Piranesi
went so far as to suggest that the Greeks themselves had borrowed
from Etruscan art and then debased it!

By the time Piranesi died in Rome in 1778 he had established
that Roman architecture had to be taken seriously and that Greece
was not necessarily the canon by which taste should be set. His
prints had their impact. All over Europe and even in America

Roman-style buildings appeared (the dome and the arch are the most common pointers to a Roman inspiration). His achievement merged into the revived sense of Italian nationalism which was animated by the plunderings of Napoleon. As we have seen, Napoleon's legacy was an ambiguous one in that he destroyed elements of the Roman past by removing so many original works of art from their Italian settings, but he also recreated Roman ideals of imperial power in his capital. This clash between destruction of the Roman past and 'classical' rebuilding could be seen in Venice itself. In an attempt to create an imperial palace in the city, Napoleon ordered the demolition of the west side of the Piazza San Marco, including Sansovino's Church of San Geminiano, so that the Procuratie Nuove, on the south side of the Piazza, could be extended round the Piazza and have a ballroom included in it. Thus on their return the horses found themselves looking down the Piazza towards a neoclassical building, one which, it has to be admitted, was not totally out of harmony with the rest of the square. (Its bays echo those of Sansovino's Library.) The height of the ballroom required the new building to be vaulted, and the vault itself was faced on the side overlooking St Mark's with, appropriately enough, statues of Roman emperors.

The 'Roman is best' theme was also developed by the director of the Venetian Academy, Count Leopoldo Cicognara. Cicognara, an Italian aristocrat born in 1767 in Ferrara, devoted his early life to art and good living, but he was a man of the Enlightenment and his political sympathies were liberal. He had supported the ideals of the French Revolution, at least until the moment when Louis XVI was executed. Even then, his attachment to France revived and persisted long enough for him to welcome the French revolutionary armies to Italy. He even dedicated a treatise, *Il Bello*, 'The Beautiful', to Napoleon himself. In 1808, with Venice now part of Napoleon's kingdom of Italy, he was made president of the Venetian Academy, and he lived out the rest of his life in the city. It was he who insisted that the horses be returned to the *loggia* on their return, rather than being placed by the waterfront as Canova had suggested.

In the years preceding Napoleon's overthrow Cicognara had embarked on a major history of sculpture, one in which he tried to place styles and achievements within the context of political events. An important influence on his view of classical history was Edward Gibbon's *Decline and Fall of the Roman Empire*, in which the English historian had argued that the adoption of Christianity had brought about the fall of the empire. Gibbon had said little about art, but Cicognara linked the decline in classical art, as Gibbon had linked the decay of the empire to 'the triumph of barbarism and religion'. Christians, he argued, had always hated fine art and it was they, not the Goths, who had been responsible for destroying it as the empire collapsed in the fifth century AD. Had not Pope Gregory the Great ordered that all pagan art be thrown in the Tiber? (It is now known that this story was a much later fabrication; Gregory, a Roman aristocrat, tended to be more moderate in such matters.) Was not the sack of Rome by the Christian Emperor Charles V in 1527 far more destructive than the sack by the Goths? (This was a deliberately provocative point but one which contained some truth in that the Goths' 'sack' of Rome in 410 had been comparatively restrained.)

Implicit in Cicognara's argument was the assumption that Roman art did not contain the seeds of its own decay and that it deserved recognition in its own right, a view which supported Piranesi's interpretation. Cicognara valued the horses of St Mark's precisely because, as he argued, they were Roman art. In a treatise on the horses published in Venice in 1815 he perpetuated the idea that they came from the time of Nero, but backed it with evidence that went beyond mere tradition. He argued that the almost pure copper of which the horses were made, together with their gilding, argued for a date in the early centuries AD, while what he saw as their 'heavy' style suggested Italian rather than eastern models. The most likely setting for a *quadriga* in this period was a Roman triumphal arch. This and the evidence of Tacitus, he argued, combined to make the reign of Nero the most likely date for their manufacture.

The argument that the horses were of Roman origin was also put

forward in another pamphlet, issued in 1817 by one Count Girolamo Andrea Dandolo, a youthful descendant of the family responsible for their seizure. Dandolo claimed that these were chariot horses, had been on Nero's triumphal arch and had then been taken to Constantinople. He identified the chariot with that mentioned in the *Parastaseis Syntomoi Chronikai* as bearing a sun-god and standing in the Milion in the city. The head of Nero (the original charioteer) had, said Dandolo, been taken off and replaced with one of the sun-god.

These views were soon challenged. When the horses had been in Paris, the consensus among the French connoisseurs had been that they were Greek. One Joseph Leitz argued from the style of their manes that they were by either the sculptor Myron or Polyclitus, the master of proportion. Myron, who came from Eleutherae, on the border between the Attic plain and Boeotia, in central Greece, was active between 470 and 440 BC, and thus has the honour of being the earliest sculptor to whom the horses have been attributed. Copies of several of his sculptures, notably his discus thrower, survive, but there is nothing in his work which can convincingly link him to the horses (although it is known that 'animals' were among the pieces he produced). Leitz's attribution seems to be another case of the horses being linked to a prominent name on the assumption that they 'deserved' a great sculptor. A Greek origin (Lysippus again) was supported by a M. de Choiseul-Daillecourt in 1809, and a different one – the horses from Chios mentioned in the *Parastaseis Syntomoi Chronikai* as the set brought to Constantinople – by a M. Sobry in 1810.

So Cicognara's assertion in his treatise of 1815 that the horses originated in Rome was bound to excite a reaction from the 'Greek' supporters; and it came, in 1816, in the shape of a pamphlet by a German enthusiast for Greece, August Wilhelm von Schlegel (1767–1845). Schlegel was a polymath, a translator of Shakespeare (he managed to complete translations of seventeen of the plays), the founder of Sanskrit studies in Germany and, with his younger brother Friedrich, a spearhead of a German national Romanticism

which found its roots in ancient Greece. Winckelmann, of course, wrote in German, and the erotic intensity of his writings had gained him a wide readership among intellectuals, including Goethe. So the 'superiority' of the Greeks over 'the decadent Romans' became part of the received wisdom of Germany's cultural elite, a principle embedded in German intellectual life. It gained particular force as a model for German renewal after the traumatic defeat of Prussia, the largest of the German states, by Napoleon at the battles of Jena and Auerstadt. The inspirational figure here was Wilhelm von Humboldt, a nobleman from Brandenburg who was briefly head of the education section of the ministry of the interior and founder in 1810 of the University of Berlin. Humboldt believed a spiritual transformation was essential if Prussian confidence were to be restored and that it was to be found in the ancient Greeks. Not only did the commitment of the Greeks to their cities provide the model for civic involvement, but their culture was infused with the finest art and poetry. In Greece man had been ennobled by his religion – not humiliated, as in Christianity – and Greek thinkers had established the foundations of ethics. In short, Greece provided everything that was needed for revival. Through a study of ancient Greek (which Humboldt made central to the curriculum and compulsory for those wishing to enter university), this great culture could be explored and absorbed.

It was hardly surprising, then, that a leading German intellectual such as Schlegel would be determined to claim the horses for the Greeks; but this was more than a romantic assertion. Schlegel attacked Cicognara's treatise systematically. He pointed out, rightly, that the Greeks also created sculptures of *quadrigae* as commemorations of their successes in the games. There had been one, for instance, on the Acropolis in Athens. With less supporting evidence, he argued that the Greeks gilded their statues and copied different breeds of horses, so that one could not identify art as Roman simply because it depicted 'heavy' horses. As for an actual sculptor, he opted for Lysippus, as Haydon had done, thus placing the horses in the Greek world of the fourth century BC. He even suggested that they might be a victory monument from the Olympic Games.

For all the arguments back and forth, the problem remained that the horses were simply not datable on the evidence that existed at the time. Their creation was still being attributed to sculptors from the fifth century BC to the first century AD. Comparisons of style and literary texts were being used freely in support of widely varying conclusions, all advanced with far more conviction than the evidence allowed. Nor were the arguments confined to the aesthetic; in both Germany and Italy, powerful nationalist forces acted to shape and prejudice the debate.

In Venice the growing strength of Italian nationalism became evident in 1822 when Canova died, probably of stomach cancer, in a room overlooking the Piazza San Marco. It fell to Cicognara, a staunch admirer and friend of the great sculptor, to preside over the funeral arrangements. Cicognara had kept his post as president of the Venetian Academy under the Austrian rulers, but his known anti-clerical feelings and his championing of Italian nationalism had made the authorities deeply suspicious of him. Canova's own position was less clear – he had been more receptive to the Austrians, who had supported his campaign for the restoration of Venice's treasures, and he was more sympathetic to Catholicism – but among the people as a whole he was seen as representing the forces of Italian nationalism. The Austrian authorities in Venice were caught in a dilemma. They could hardly deny Canova a fine funeral, but they feared popular unrest. So strict rules about how the ceremony should be conducted were laid down. No one could wear black, the colour associated with the *carbonari* (literally, 'the charcoal burners'), the revolutionary associations which campaigned for the expulsion of Italy's foreign rulers, and an exact funeral route was specified.

But the nationalists were not to be thwarted. Cicognara and his supporters turned out in green, the colour of the royal house of Savoy, which was seen as a focus for Italian unity. The funeral was held in St Mark's – nowhere else was fitting – but Cicognara managed to circumvent the instructions about the route of the funeral procession and had the coffin brought into the Academy,

where he made an impassioned speech over it. (Canova's heart was later enshrined in the Academy and is now buried in the Church of Santa Maria dei Frari; the rest of him went home to Possagno, to lie in a massive neoclassical temple he had designed himself.) An outpouring of sonnets and pamphlets lamenting Canova's death showed how deeply he had penetrated the Italian consciousness, and his monument to Alfieri in Florence became a patriotic shrine. 'May these precious names, so dear to the fatherland of Alfieri and Canova, united for ever and respected by Time the destroyer, uphold and witness to remote posterity the glory and splendour of Italy,' wrote one admirer. No wonder, then, that the nationalists insisted that the horses, saved as they had been from the French, were Italian in origin.

FRAGMENTED IMAGINATIONS: THE REINVENTION OF VENICE

WITH THE FRENCH GONE AND THE AUSTRIANS RETURNED, Venice suffered a period of economic collapse. Over 90 per cent of the servants who kept the great palaces running are said to have lost their jobs. The Austrians developed their own port at Trieste just along the coast, and it was only in the 1830s, when Venice was given the status of a free city, that some form of recovery began. A new, wealthy Venetian bourgeoisie emerged, and in 1846 the city was given a further boost by the building of the railway bridge across the lagoon. Well might Gustav von Aschenbach, the narrator of Thomas Mann's *Death in Venice*, complain that 'to come to Venice by the station is like entering a palace by the back door'; but the loss of the city's cherished isolation also led to new commercial links and the first mass tourism. It was in the 1840s that the total number of tourists visiting the city exceeded the resident population (around 120,000) for the first time. There was now a realistic chance of economic survival.

However, the relationship between the Austrians and the Venetians continued to be an uneasy one. It was not that the Austrians were particularly oppressive; it was rather that they were bureaucratically inept and insensitive to the liberal nationalism which was sweeping through Italy as it was through many other

parts of Europe. When a severe commercial depression hit Europe in the mid-1840s and spread to Venice, the Austrians proved incapable of providing any effective relief. Discontent grew, and on 18 March rioting in the Piazza led to the deaths of eight Venetians.

The simmering unrest was galvanized into outright revolt by one of Venice's great heroes, Daniele Manin. Manin, in his mid-forties by 1848, was a lawyer and the son of a lawyer. He had a mind of extraordinary energy which had absorbed not only six languages, including English, French and German, but the ideals of the Enlightenment. However, in a Venice under Austrian rule his talents and ideals appeared to have no hope of fulfilment – until the events of 1848 gave him his opportunity. The Venetians had never been a revolutionary people, their government over centuries having been rooted in the search for consensus; but it was just this propensity that Manin exploited. He persuaded the middle classes to throw in their lot with the poor and expressed their shared demands in simple but highly emotive oratory. He set the revolution in action with a speech from a table in Florian's coffee-house, and on 24 March was declared, again in the Piazza, president of a new Venetian republic. Its foundation was celebrated with a 'Te Deum' in St Mark's; and the cry of 'Viva San Marco!', last heard in 1797, echoed across the Piazza.

The republic was to last seventeen months, the city bravely holding out against the Austrian armies grouped around the lagoon until bombardment, famine and eventually cholera forced its surrender in August 1849. While Manin had many great qualities, in the end he failed to create a strategy for the city's survival against a revived Austria (while the poor warmed to him personally, he remained at heart a bourgeois who would never risk a true revolution). Over the course of those seventeen months, however, the horses of St Mark's had overseen some of the most dramatic scenes in Venetian history. The Piazza had found a new role as the focus of revolutionary fervour. Any Venetian could reach it in half an hour, and it had the capacity to hold most of the population. Here the great speeches of the revolution were made and news from the outside

world passed on; and, as the Austrian guns began to reduce the western districts of the city, refugees sheltered in its colonnades. It was here from a balcony on 13 August that Manin made his last speech to the people of the city before going into exile, and here also that Hungarian whitecoats entered the city to reoccupy it.

Venice in the 1850s was a sad place. 'The former queen of the seas', lamented one of its defeated revolutionaries, 'has become a slave girl and the winged lion no more than a water rat.' Many of its middle class had fled, and those who remained tended to see their future in collaboration with the Austrian overlords, while outside the city in the Veneto the Austrians subdued peasant unrest with mass executions. One gets a sense of the unease and the compromises involved from a diary account by the German composer Richard Wagner, who visited the city in the late 1850s and coached an Austrian band to play two of his overtures. 'Several times,' he writes,

at the end of dinner I was surprised to hear my overtures all of a sudden. When I sat at the restaurant window [overlooking the Piazza] abandoning myself to the impressions of the music I did not know which dazzled me most – the incomparable square in its magnificent illumination filled with countless numbers of moving people, or the music which seemed to be wafting all these phenomena aloft in a resounding transfiguration ... But there is one thing utterly lacking here which one would otherwise have expected from an Italian audience: thousands of people grouped themselves around the band and listened to the music with intense concentration; but no two hands ever forgot themselves to the extent of applauding, for any sign of approbation for an Austrian band would have been looked upon as treason to the motherland.

Venice was united with the rest of Italy in 1866, not through its own efforts but as the result of the good offices of Louis Napoleon, emperor of the French, and the international diplomacy which

followed the defeat that year of Austria by Prussia. The city's incorporation into Italy was not, initially, a great success. While the body of Manin, who had died in exile in Paris in 1859, was welcomed back to Venice on the twentieth anniversary of the revolution with enormous fanfare – thousands of gondolas followed the funeral barge along the Grand Canal and Manin was buried in an arcade on the northern side of St Mark's – the Venetians, who had enjoyed the vote in the short-lived republic, were not to regain it until just before the First World War. The imposition of a tax on flour by the Italian government led to riots.* Yet it was in these same years of the mid-nineteenth century that Venice was finding new meanings in the imagination of the European and American *literati* and bourgeois travellers. Everyone in European cultural life visited Venice at some time, and many gushed over its glories. 'It is a great Piazza,' enthused Charles Dickens on his first visit to St Mark's,

> anchored like all the rest of Venice, in the deep ocean. On its broad bosom is a palace more majestic and magnificent in its old age than all the buildings of the earth, in the high prime and fullness of their youth. Cloisters and galleries – so light they may be the work of fairy hands; so strong, that centuries have battered them in vain – wind round and round this palace, and enfold it with a cathedral, gorgeous in the luxuriant fancies of the east.

Many of Venice's myriad palaces (two-thirds of them under repair, as John Ruskin noted on a visit in 1845) were now available for rent or sale cheaply – a situation which led to a strange mixture of new inhabitants. John Pemble, in his study of Venice in the past

*Memories of Venetian independence still linger. On 12 May 1997, the bicentenary of the death of the republic, the Campanile was captured by eight men and a new Serenissima declared, albeit only briefly, before the authorities regained control.

two centuries, *Venice Rediscovered*, notes the arrival of 'a new gener-
ation of losers from the hectic casino of dynastic Europe'; but, in
addition to discarded royalty (including some from France), many
other kinds of exiles made their home here for a time. Some seemed
drawn by the city's air of nostalgia, finding an almost sensual
pleasure in mourning Venice's great past from one of its medieval
palaces. Meanwhile, Byron's romantic escapades consolidated the
reputation of Venice as a city of sexual extravagance. It was possible
to enjoy homosexual liaisons which would have been impossible in
more stuffy and oppressive societies further north; a wealthy man's
private gondolier was often also his lover. The English aesthete John
Addington Symonds, out on the Lido in the 1890s, caught the eyes
of one such. 'Angelo's eyes, as I met them, had the flame and
intensity of opals, as though the quintessential colour of Venetian
waters were vitalised in them and fed from inner founts of passion.'

Others found a vitality and gaiety in the city which were lacking
elsewhere in Europe. For the American Henry James, who was to
write two novels in which the city has a starring role, *The Wings of
the Dove* and *The Aspern Papers*, the Piazza contained more joy than
any comparable spot in the world. The Austrian Camillo Sitte saw
St Mark's as the ideal of urban planning. 'So much beauty is united
on this unique little patch of earth, that no painter has ever dreamt
up anything surpassing it in architectural backgrounds, in no
theatre has there ever been anything more sense-beguiling than was
able to rise here in reality . . . the loveliest spot in the whole wide
world.'

Yet Venice was a city always close to decay. The withdrawal of
wealth and the passage of time sucked the great palaces towards
destruction. The poet Shelley envisaged them under the waves
covered in seaweed. 'No time ought to be lost in visiting Venice,'
wrote a M. Valéry in 1835, 'to contemplate the works of Titian, the
frescos of Tintoretto . . . tottering on the very verge of destruction.'
John Ruskin noted the state of the Fondaco dei Turchi, the
warehouse where the Ottoman traders stored their products, in
the 1850s: 'the covering stones have been torn away from it like the

shroud from a corpse and its walls, rent into a thousand chasms, are filled and refilled with fresh brickwork, and the seams and hollows are choked with clay and whitewash, oozing and trickling over the marble.' The city became associated with death, especially of creative men. Wagner died here in 1883; as did Diaghilev (1929) and Stravinsky (1971). The mood was caught by Thomas Mann's haunting *Death in Venice* (1912), in which the themes of homosexuality and death are intertwined. The 'hero', Gustav von Aschenbach, harbours an unconsummated love for a young Polish boy, Tadzio, against the background of a cholera epidemic which the authorities are desperately trying to conceal from the city's visitors. In the closing sentences of the story Aschenbach collapses and dies, his last moments absorbed with watching Tadzio at the edge of the sea, 'in front of the nebulous vastness'. Few books have caught the ambiguities of the city so evocatively.

It was the emotional use of Venice by expatriates which gave rise to intense debate about the maintenance of the city. However much the romantics wallowed in the sense of decay, one could hardly let the city collapse into the lagoon. Should one restore or conserve? If one chose to restore, how far should one go? The word *repristino* was used to describe the process of renewing a building, but for many romantics (notable among them, as we shall see, Ruskin) this risked becoming *lucidatura*, a more radical cleaning which destroyed the patina of ages. The restoration of the crumbling Fondaco dei Turchi in the 1860s was so extensive that one can hardly recognize the subjects of the 'before and after' photographs as the same buildings. For new buildings, composite styles which mixed Byzantine with gothic, *venezianita* as they were known, developed. This was becoming an ersatz city, not least in the contrast between the luxurious new hotels on the Lido and the crumbling, picturesque vistas which their pampered guests had come to view.

With Venice taking on so many exotic roles in the imagination, antiquities so solid and enduring as the horses of St Mark's were bound to fade into the background, and we find them reappearing as mere bit-players in a greater drama. Thus, for example, the

popular poet Samuel Rogers, in his verse tales of Italy (published between 1822 and 1828), wove them into his melodramatic tale of Enrico Dandolo setting off from the porch of St Mark's on the Fourth Crusade:

> He sailed away, five hundred gallant ships,
> Their lofty sides hung with emblazoned shields,
> Following his track to fame. He went to die:
> But of his trophies four arrived ere long,
> Snatched from destruction – the four steeds divine,
> That strike the ground, resounding with their feet,
> And from their nostrils snort etherial flame
> Over that very porch.

A copy of these poems, illustrated by the artist William Turner, was given in 1832 to a young Englishman for his thirteenth birthday. Thus began John Ruskin's love affair with Venice. Ruskin visited the city for the first time in 1835, with his family, and returned on his own in 1845. The first volume of his celebrated *The Stones of Venice* was published in 1851. Venice gave Ruskin, always a man full of his own frustrations, a cause, an outlet for his aesthetic yearnings. Exploring the mass of surviving architecture, much of it in decay in what was now an impoverished city, he was drawn irresistibly to the glories of Venetian gothic. Just as Winckelmann had associated great art with liberty, so Ruskin made Venetian gothic and Venetian greatness inseparable. Venice's decline had begun in the 1420s, he argued (a view for which one could find some supporting historical evidence), at the same time as its art began to abandon gothic for the Renaissance. For Ruskin, the significance of gothic art was not that it was pleasant to look at; it was important because it brought out the creativity of the individual artisan, who had the freedom to create his own interpretations of style. Ruskin revelled in the incongruity in architectural style and the juxtaposition of different colours. He hated the way in which the Venetians seemed to discard their heritage. 'Off go all the

glorious old weather stains, the rich hues of the marble which nature, mighty as she is, has taken ten centuries to bestow,' he wrote to his father as he observed a cleaning of St Mark's. The Renaissance was the creation and preserve of intellectuals, who had tried to impose order from above. In *The Stones of Venice*, Ruskin claimed that he had 'no other aim than to show that the Gothic architecture of Venice had arisen out of, and indicated in all its features, a state of pure national faith, and of domestic virtue; and that its Renaissance architecture had arisen out of, and in all its features indicated, a state of concealed national infidelity, and of domestic corruption'. In his index of Venetian buildings Ruskin did not even include Sansovino's Loggetta, seen by many as one of the most charming pieces of Venetian architecture. Palladio aroused particular scorn for his cold formality.

For Ruskin, the horses are Greek, and he uses them in his campaign against the austerity of the Romans. They are, in fact 'symbols to Europe of the destruction of the Greek empire by the Romans'. In *The Stones of Venice* they make their appearance towards the end of the crescendo of prose with which he describes St Mark's.

> Beyond these troops of ordered arches there rises a vision out of the earth and all the great square seems to have opened from it in a kind of awe, that we may see it far away – a multitude of pillars and white domes, clustered into a long low pyramid of coloured light; a treasure house, it seems, partly of gold, and partly of opal and mother of pearl, hollowed beneath into five great vaulted porches, ceiled with fair mosaic . . . and above them, in the broad archivolts, a continuous chain of language and life – angels, and the signs of heaven and the labours of men, each in its appointed season upon the earth; and above these, another range of glittering pinnacles, mixed with white arches edged with scarlet flowers – a confusion of delight, amidst which the breasts of the Greek horses are seen blazing in their breadth of golden strength.

Faced with this explosion of coloured prose one can, perhaps, have some sympathy with Henry James' view that 'one hour of the lagoon is worth a hundred pages of demoralised [Ruskinian] prose'; but while Ruskin was ending his days in his home overlooking Lake Coniston in the English Lake District (he died in January 1900), his books inspired another writer to become obsessed with Venice. Marcel Proust first discovered Ruskin as an enthusiast for French gothic architecture, but it was through Ruskin that he set out, in May 1900 with his mother, for Venice 'in order to have been able before dying, to draw close to, touch and see the embodiment of Ruskin's ideas on domestic architecture in the Middle Ages in palaces that are crumbling, but which are still rose-coloured and still standing'. Proust, like others, catches the mood of a city of transient beauty on the brink of collapse. In an early work, *On Reading Ruskin*, he meditates on the columns in the Piazzetta and suggests that standing 'with all their slender impenetrability' among the rush of the Venetian crowds they set aside 'the inviolate place of the past, of the past familiarly risen in the midst of the present' – the theme which haunts so much of Proust's work. It is hardly surprising that Venice comes to pervade *À la recherche du temps perdu*, in which the visit of May 1900 is recreated. The narrator of the novel, mourning the death of his beloved Albertine, comes to Venice with his mother. She herself is in mourning for her own mother. Standing in the Piazzetta, she remarks how much her mother would have liked the order of Venice – the two columns, which her son had told her came from a palace of Herod, and, fitting in as if in spaces kept specially for them, the pillars from Acre and the four bronze horses. Here is Venice in which the horses have become an integral part of the whole, so neatly slotted into the city that it was almost as if they had been made for it.

There is a different atmosphere in a poem, 'San Marco', by the German poet Rainer Maria Rilke. Through his patroness, Princess Marie von Thurn und Taxis, whose castle on the coast at Duino, near Trieste, inspired his famous elegies, Rilke came to know Venice as a city of transient aristocrats. He was haunted by the contrast

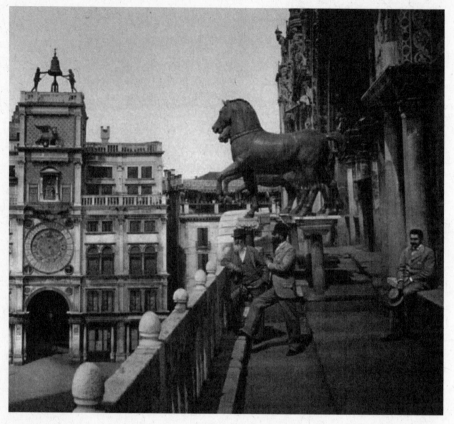

A photograph of the horses on the *loggia*, dating from the time that Rilke wrote his poem 'San Marco'. (Alinari Archives, Florence)

between the glitter of contemporary society and the brooding weight of the past. In 'San Marco', written in recollection in Paris in 1908, he contrasts the shining gold of St Mark's with the darkness of the Venetian state. For him, the horses come to symbolize the past. Up on the *loggia*, he muses:

> How can all this endure?
> Passing along the narrow gallery
> hung like a catwalk from the canopy
> you find the shining city still secure

yet somehow wearied by her history,
so nearly crushed beneath the *quadriga*.
(trans. Stephen Cohn)

Even if they were now only symbols of the past, the horses could not escape being caught up in the turmoil of the twentieth century. The first threat was an unexpected one. For centuries the great Campanile had stood where the Piazza met the Piazzetta, and architects had always declared that it was totally secure. On 14 July 1902 the tower collapsed almost without warning. Part of Sansovino's Library was torn down and his Loggetta shattered into fragments. The façade of St Mark's was saved partly because the rubble, some eighteen thousand tons of it in total, piled up against the Colonna del Bando. The gilt angel which had lorded it over the city from the top of the tower came to rest in the central portal of St Mark's, while a fine, snow-like deposit settled on the horses as well as all the surrounding surfaces. It was a miracle no one was killed; the atmospheric impact of the collapse was so powerful that a ship in the lagoon almost capsized. (It was said that one sea captain was so traumatized by returning to a Venice without the Campanile to welcome him that he went mad.) The horses may also have suffered from the impact, for on 29 August it was reported that one of them was 'tilting over to a considerable degree, causing the horse itself to lean outwards'. It had to be propped up in a wooden cradle until it could be removed for repair, and was finally back in place in April 1904 just in time for the feast day of St Mark and the start of the rebuilding of the Campanile. Despite the claims of some purists that the Piazza looked better without the Campanile and the cries of the radical Futurists that the whole of Venice would be better off under the lagoon, it was reconstructed exactly as it had been before. Faced with the choice, Venice had reasserted continuity rather than change. *Dov'era, com'era*, as the phrase went: where it was, as it was.

A much greater threat to Venice came when Italy joined the First World War in 1915. With the Austrians as the main enemy and the

front not far away in north-eastern Italy, the horses were clearly under threat. Immediately war had been declared they were taken off the *loggia* and stored between sandbags in the Doge's Palace. The precautions were justified. There were no fewer than forty-two Austrian air raids on Venice and one of the thousand bombs dropped fell right in front of the basilica, which by now was fully boarded up.

Nineteen seventeen, in particular, was a terrible year for Italy. There were mass demonstrations and strikes; mutinies increased in number; and in October the Italian line in the north was broken by the Austrian and German armies. As an Italian retreat began, even Venice was threatened, and in November the horses were sent off on a long journey, first by boat to the mouth of the River Po and then inland by water until they reached a rail connection for Rome.

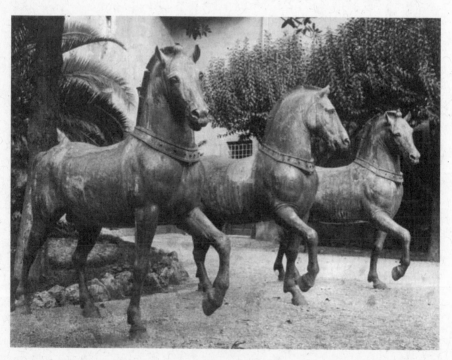

Three of the horses in the gardens of the Palazzo Venezia in Rome, December 1918, before their return to Venice. (Alinari Archives, Florence)

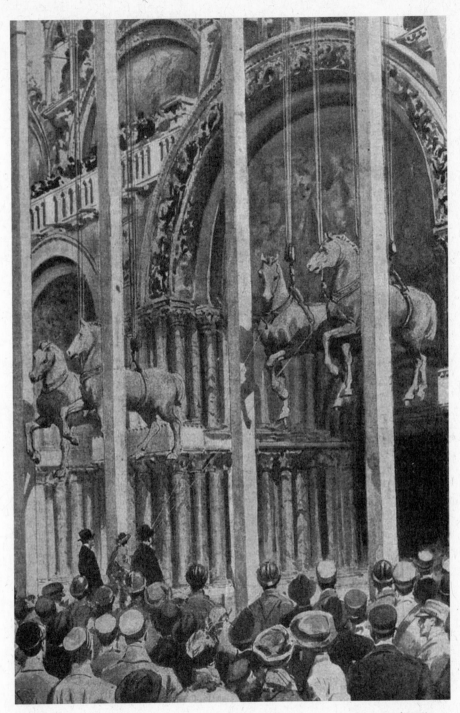

The horses being restored yet again to the *loggia* in 1919. Drawing by Achille Beltrame, published in the newspaper *La Domenica del Corriere*. (The Art Archive)

As we have seen, many legends suggest that the horses either came from Rome in the first place or at least spent part of their life there before being taken to Constantinople; so it may have been a home-coming for them. They were certainly given an appropriate resting place, in the Castel Sant'Angelo, the mausoleum originally built for the second-century emperor Hadrian. With the end of the war they were briefly transferred to the Palazzo Venezia in the centre of the city so that they could be seen by the public before being returned to Venice — where it was reported that they arrived back considerably dented! It was not until November 1919 that they were reinstalled on the *loggia*.

The horses were taken down again in the Second World War, but as Venice was not immediately threatened by the fighting, they spent most of the war years in the cellars of the Doge's Palace. They were not in place to see history repeat itself when Armando Gavagnin echoed Manin in declaring a new republic from a table-top at Florian's after the downfall of Mussolini. (It lasted only forty-five days before the Germans reasserted control.)

A new threat to the horses then came from the atmosphere. They had always been vulnerable because the copper in which they had been cast was porous and in parts very thin. With the growth of industrial activity around the lagoon after the Second World War, the air became increasingly polluted with the emissions from coal, oil and chemical plants. The atmospheric concentration of sulphuric acid increased with a rise in humidity, and condensation or rain brought the acid to rest on any exposed metal surface. Tests on the horses in the mid-1970s showed that chemical reactions were taking place in the copper and that the gold leaf was becoming separated from the metal as acid ate between the gilding and the bodies of the horses. To test the severity of the effects, three of them were given a wash in 60 litres of water and the process repeated (60 litres is about the amount of rainfall they would encounter in an average heavy summer downpour). The results showed that acids and salts on the surface of the copper were dissolved by the water, and that each horse lost on average 20 grams

of copper and 150 milligrams of gold as it ran off. This appeared to be solid evidence that the surface was deteriorating and formed the background to a campaign by the company Olivetti to have the horses placed under cover. After an exhibition, in which one of them starred as a centrepiece, had toured Europe and the United States, in 1983 the horses were placed in their present setting inside St Mark's.

18

DENOUEMENTS

HAVING ARRIVED AT THE POINT WHERE THE HORSES ARE
stowed under cover in St Mark's, it is time to sift through the
evidence on their dating. As we have seen, almost every century
from the fifth century BC to the fourth century AD, a span of nine
hundred years, has its supporters. It is not only the variety of
dates – and places – which surprises, but the assurance with which
each scholar proposes his or her own conclusion. Let us take a
sample of such attempts from the past hundred years. There has,
for instance, been some support for a casting in or near Rome. The
German historian Lehmann Hartleben, writing in 1927, compared
the Venetian horses with bronze horses excavated at Herculaneum
(the neighbouring city of Pompeii, destroyed with it by the
eruption of Vesuvius in AD 79) and 'because of their imposing
structure, their prominent bellies and lightly modelled chests'
identified them as Augustan, in other words with the end of the
first century BC. In her *Art in Ancient Rome* (1928), Eugenie Strong
echoes Hartleben in seeing the horses as Augustan and proposes
that they were made in Rome to adorn either a triumphal arch in
the Forum or the Arcus Tiberi on the Via Sacra, the 'sacred'
processional way which ran through the centre of the ancient city.
Gisela Richter, in a book on animals in Greek sculpture also

published in 1928, sees them as Roman works which were inspired by the Parthenon frieze. All this confidence – and yet there is not a shred of evidence that the horses originally came from Rome.

One of the most exact datings of all, but from a very different period, was proposed by Sidney Markman, a professor of Fine Arts at the National University of Panama. In his *The Horse in Greek Art* (1943), Markman rejected outright any claim to Roman origin. He argued that they were the same horses as those from Chios which stood on the hippodrome gates in Constantinople. He then assumed that there was a progression in the way horses were portrayed in the art of the Hellenistic period, from the less to the more 'dramatic'. Relying on this single theme, he took as a starting point the head and shoulders of a monumental marble horse from the celebrated mausoleum at Halicarnassus (modern Bodrum in south-western Turkey), dating from about 350 BC (and now in the British Museum). The proportions of the St Mark's horses are apparently the same, but they are 'much more dramatic and developed'. Markman then took a fully 'dramatic' horse, one shown rearing up in the frieze on the famous Great Altar from Pergamum, which he dated from between 180 and 160 BC (modern scholars are not so sure; it may be much earlier). On the St Mark's horses, this 'dramatic effect is there only in part' – and so they had to be fitted in chronologically between the two other sculptures. As the way the skin is sculpted on the Venetian horses 'is not a fourth century characteristic', they cannot be placed before the end of the fourth century. Markman eventually, on stylistic grounds alone, settled on a date of 310–290 BC, which he put forward with complete confidence. Yet one group of scholars responded to Markman's analysis by saying that they could not see any resemblance at all between the St Mark's horses and the 'huge muscular horses' of the *quadriga* of the mausoleum or the horses on the Pergamum altar.

An even more exact date within these twenty years was proposed in the 1960s by a German scholar, J. F. Crome. Crome argued that the horses were not those from Chios but those which stood in the Milion in Constantinople alongside the chariot of the sun (the view

taken in this book). On the basis of documentary evidence that Constantine looted Delphi for statues to bring to his new capital, Crome suggested that they might have come from there. Indeed, a pedestal beside the sanctuary has been found which appears to have supported a *quadriga*. Even more exciting was the discovery that the pedestal bore an inscription which showed that whatever had stood there was a votive offering of the Rhodians. Crome then remembered that in Pliny's *Natural History* Lysippus was said to have made a chariot of the sun for the Rhodians. The horses, argued Crome, were none other than those from this chariot, erected in Delphi as a thanks offering for the famous victory of the city of Rhodes over Demetrius Poliorcetes, who had besieged it in 304 BC.

This all seemed rather fanciful, especially as alternative sources suggested that Lysippus' chariot was in Rhodes itself (and Pliny's account can be read to support this). Pausanias makes no mention of a chariot of the sun by Lysippus in his description of the sanctuary at Delphi, and it is unlikely he would have missed out such a major work. Again, it is likely that the chariot would have been recorded alongside the other works of art listed in early Byzantine sources as having been removed by Constantine from Delphi.

In his 1981 study of the horses, *I Cavalli di San Marco*, Vittorio Galliazzi rejects Crome's thesis but is happy to accept that the horses come from the school of Lysippus, and so date from the late fourth century BC, or, alternatively, may have been cast from a Lysippus original. Although no horse sculptures by Lysippus survive, Galliazzi takes as his model the horses shown on the so-called Alexander sarcophagus from Sidon (now in the Archaeological Museum in Istanbul). This dates from about 310 and is probably the sarcophagus of the last king of Sidon, who chose to associate himself with Alexander and so had scenes of Alexander in battle sculptured in reliefs on the side. The war horses are shown rearing in battle and look somewhat more sturdy than the St Mark's horses, so the comparison is not an exact one. Galliazzi goes on to suggest that the horses are those described as having been brought

from Chios by Theodosius II (although he assumes in his reconstruction that the heads of each pair look outwards, while Niketas Choniates described them in the twelfth century as 'eyeing each other').

So, even confining oneself only to the span of three centuries or so on which modern scholars have focused, how can one begin to home in on a more precise date? Many of these scholars started by 'reading' styles into the horses. Crome, for instance, claimed that they had 'Persian' characteristics, incorporated by Lysippus to highlight the relationship between the people of Rhodes and those of Persia, which was, he argues, consolidated by their conflict with the Macedonian Demetrius Poliorcetes. Markman analysed the degree of 'drama' he saw in the horses. Galliazzi found the aesthetic language of Lysippus there. Some have argued that a certain nervousness is characteristic of horses of the Hellenistic period, and have then proceeded to suggest that the horses of St Mark's either are nervous, and thus Hellenistic, or are not nervous, and thus from a different period! One is left feeling that any assessment of the style of the work seems to come as much from the heads and eyes of the observer as from the horses themselves. There are as many scholars convinced that they are Roman in style as there are convinced that they are Greek or even Persian. Each scholar seems to be able to highlight some characteristic – often only one – which is then used to define the style, and hence possibly the date, of the horses as a whole.

There is a good reason why it is so difficult to sort out the style of a classical sculpture. As soon as the two great civilizations of Greece and Rome encountered each other, their art became mixed. The Romans recognized that the Greeks could, in the words of the poet Virgil, 'cast more tenderly in bronze and bring more lifelike portraits out of marble' than they could, and their response was to imitate Greek art, either by making direct copies of Greek originals or by creating Roman statues which incorporated Greek styles. The Emperor Augustus provides a particularly good example of a patron whose enthusiasm for the classical Greek art of four centuries

before his time was reflected in the art he commissioned. So the reliefs of the Augustan Ara Pacis, the altar of peace in Rome which dates from the end of the first century BC, echo the reliefs of the Parthenon; and Augustus himself, in the celebrated Prima Porta statue, shows himself off as a Greek hero. So long as Greek art held aesthetic or cultural value, there was every incentive for its styles to be incorporated into later classical art. Recent scholarship shows how traditional styles were being reworked, or ancient works restored, well into the fourth and fifth centuries AD, and surviving alongside Christian art. This is one reason why the horses have proved so difficult to date. Styles from the classical Greek and Hellenistic periods reappear over the Roman centuries.

We noted earlier how the horses' proportions were distorted for visual effect. In addition, one cannot escape the feeling that elegance has been 'built' into them, especially into their expression and the gracefulness of their heads. An example of this elegance is the short 'Greek' mane. This mane appears in Greek art as early as the eighth century BC and is found as late as the fourth century AD, in the horses drawing Constantine's *quadriga* on his triumphal arch in Rome, for instance – even though we know from contemporary accounts that in real life the Romans valued 'a mane thick and falling on the right side', as one fourth-century authority on horses put it. In Rome itself, horses are often shown with flowing manes – as in the examples of Marcus Aurelius in his triumphal chariot and the bronze statue of him on horseback – and one can see the same in Roman mosaics which show horses running free. Clearly the short Greek mane is an idealized artistic convention, presumably used largely for aesthetic reasons or to give a horse a cultural status. It does not, in itself, help to date the horses.

Even though it is difficult to relate the horses of St Mark's to any datable style or breed, one can perhaps find some clues in their individual characteristics. They are strong and sturdy, and this may place them in the Roman era when we know that horses were bred for size and enough was understood about nutrition for chariot or cavalry horses to be fed on high-protein foods. This can only be a

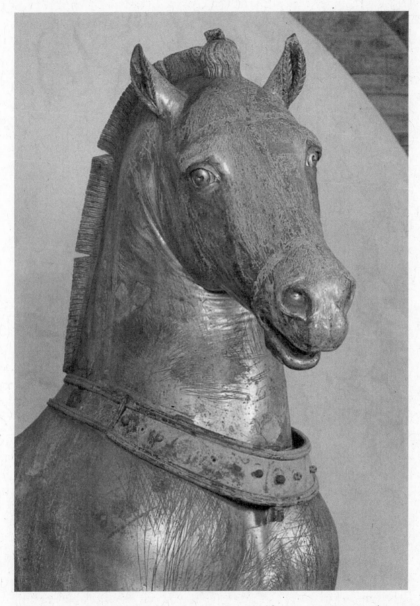

This close-up of one of the heads shows the half-moon incision in the eye, which led to Filippo Magi suggesting a date for the horses of the second or third century AD. (1998, Foto Scala, Firenze)

tentative suggestion, supported perhaps by the negative argument
that horses from the earlier Hellenistic period tend to be more
detailed and expressive, as Hellenistic art is in general. If evidence
from the manes does not get us far, are there any other stylistic
details on the horses which appear at a definable date and are not
known earlier? An Italian scholar, Filippo Magi, writing in the early
1970s, made a particularly influential discovery. While many
aspects of the horses' eyes are copied from real horses, one feature
is not, and that is a half-moon cut into each eye. The feature seems
to have been introduced purely for effect, to create a 'gleam' at the
top of the cornea. Magi argues that this feature is never known
before the second or third centuries AD. There are no other
examples of horses with this cut, but the eyes of human figures on
Augustus' Ara Pacis do seem to have been reworked in the early
300s AD by Maxentius, the rival of Constantine in the western
empire, with, in this case, concentric circles carved into the irises
to create the same sort of effect. Magi went on to examine the
horses' ears, which he considered to be an elegant stylization rather
than a representation of an actual horse's ear. The closest examples
in style that he could find came from the second century AD – they
are very similar to those on the horses of Marcus Aurelius on the
Capitoline Hill, for example.

So far we might edge towards a tentative conclusion that the
horses are Roman but in a Greek style (as the manes in particular
suggest). Perhaps something more can be learned from the casting
itself. We know that the horses were cast by the indirect lost-wax
method, which allows copies to be made from existing sculptures.
So it is possible that the horses are much later copies of earlier
originals. On the other hand, the indirect method can also be used
for a one-off casting, as simply the most convenient way of casting
a large statue, perhaps from a plaster model made for the occasion.
The Riace warriors from fifth-century Delphi, cast by the indirect
method, appear to have been made for a specific monument, that
celebrating the Athenian victory at Marathon. So the horses may
have been cast from an original model made for the purpose, and

the use of the indirect method does not in itself help us with dating.

Can any progress be made from examining the metal in which the horses were cast? The vast majority of figures from the ancient world are cast in bronze. In one study of surviving objects from this period which appeared to be of copper or bronze, those found to be of copper made up only 2 per cent of the total, and there were no examples at all of copper mirrors or armour. As we have seen, it was discovered as early as the eighteenth century that the St Mark's horses were, in fact, cast in almost pure copper, with lead and tin making up only 2 per cent of the total. A typical percentage of tin in bronze is 10 per cent and sometimes it is as high as 20 per cent. There is a good technical reason why large copper statues are so rare. Copper liquefies at 1,083 degrees Celsius and solidifies again at the same temperature. So, if it is used for casting, it has to be heated to well above 1,083 degrees so that the metal can run into the deeper recesses of a mould before solidifying. The addition of 13 per cent of tin or 25 per cent of lead, or an appropriate mixture of the two, brings the melting point of the alloy down to 1,000 degrees. Furthermore, an alloy of this mix has the property of staying in liquid form until it cools to 800 degrees, making it much easier to fill larger and more detailed moulds. In other words, to cast a large statue in copper is not only more hazardous, because of the higher handling temperatures, but is also a much less efficient method of filling moulds.

We have only to remember the casting in bronze of the Perseus by Cellini to appreciate just how complex and dangerous a task casting the horses in copper must have been. Studies have shown that each was cast in several pieces, with the legs and heads made as separate castings (the joint between head and body being concealed by the collar) and the tails added separately, and that a large number of 'gates', into which the molten metal was poured, was needed. Along the backs of the horses these were only 25 centimetres apart. Examinations of the surface of the horses show that the metal must have cooled quickly and that the greatest

number of imperfections were at the entrance to the gates, the areas
which received the metal at its hottest. It was just here that cooling
made the metal most porous. With imperfections to be smoothed
over, joints to be made and the filling holes to be obliterated, the
horses needed many patches to make them complete, on average
about a hundred per horse. Completing the work must have needed
as much time and skill as the actual casting. (Despite their finished
look the horses have a mass of small defects, and have received
minor patchings-up throughout their history.)

So why go to all this extra bother of casting in copper? There are
clues to be found from examining other objects in the same metal.
One of the few surviving copper statuettes from the Roman period
is of a Hercules, found on Hadrian's Wall in northern Britain and
dating to perhaps the third century AD. In comparison to bronze
statues it is stiff and unnatural, rather crude, even. This appears to
reflect the difficulty of reproducing intricate detail in copper. Yet,
like the horses, it is gilded – and so is another piece of copper of
some 95 per cent purity, a horse's hoof found at Sparta in Greece.
It is the association of gilding with pure or almost pure copper
which seems significant.

Gilding involves fixing a layer of gold on to a core metal. It is
a skilled business, involving the beating out of gold leaf and then
its effective application to the surface of whatever is to be gilded.
In smaller statues this can be done by wrapping the leaf around the
statue and beating it into the shape – a process that was certainly
being done as early as 2000 BC in Egypt, where gold was plentiful.
On larger statues one could cut grooves around an important feature,
such as the face of a god, fix the edge of the leaf into the grooves
and then beat down the leaf over the features. Parts of two statues
with gold added in this way have been found on the Acropolis in
Athens, and there is an account in Pliny of the Emperor Nero
applying gold to a statue of Alexander the Great, although this so
offended taste that it was later removed. Attempts were also made
to fix the gold leaf directly on to the metal, probably with a thin
layer of mercury applied to the statue as an adhesive, but these

appear to have been unsuccessful, with the leaf gradually working itself free over time. It certainly would not be a suitable method for a statue designed to be positioned outdoors, where the battering of the elements would soon have dislodged the gold.

A breakthrough appears to have been made in China in the third century BC (or at least, these are the time and the place of the earliest known example), when gold was mixed with boiling mercury to form a paste which could then be applied to the metal. The mercury was then heated off, leaving the gold in place. The procedure is known as fire gilding. An alternative method is known by which mercury was first applied to the surface, then gold added and the two allowed to dissolve in each other before the mercury was heated off. Both processes gave the same finish, but the use of the paste made it easier to add further layers.

There was, however, a problem with using mercury: it reacts with tin or lead, so the method is not successful when applied to bronze. Analysis of surviving bronzes which have been gilded shows that they are never gilded by the mercury method, and a twelfth-century account of gilding by one Theophilus makes the point explicitly: copper and silver, he says, are more easily gilded (by the mercury process) than bronze in that bronze is disfigured by white stains when the mercury is heated off. An examination of the gilding of the St Mark's horses shows that mercury was used to provide an initial gilding and that either at the same time or later further gold leaf was applied (four coatings in one section of a tail). Significantly, where bronze patches had been applied to fill in holes or imperfections, the gilding has not taken.

While the gilding process using mercury is found in China in the third century BC, there are no examples in the classical world until the Hellenistic period, from which a few bracelets and finger rings in gilded copper survive. The cost of mercury and gold appears to have been prohibitive for any larger statue. Sometime in the second or third century AD new sources of mercury, or perhaps better means of extracting it, appear to have been discovered in the Roman world and for the first time it proved possible to fire-gild large

statues. It was clearly the best way of applying gilding – much more effective than merely allowing a thin layer of mercury to evaporate – and by the end of the Roman period fire-gilding had become the normal method. Indeed the technique continued to be used until it was superseded by electroplating in the nineteenth century. Thus we arrive at the argument put forward by the conservationist Andrew Oddy: the horses were cast in copper because it was planned from the beginning that they would be fire-gilded. It follows that they cannot be dated before the second century AD and may well have been made in the third.

Some supporting evidence dating the horses to these centuries can be found in the gilding. The layer of gold is very thin, 0.0008 millimetres, and it is marked by scratches. In the past there have been claims that these are the result of vandalism, attributed as we have seen variously to barbarians and even to the English engineers who removed the horses from the Arc du Carrousel in Paris. However, studies have shown that the lines are regular and shaped to follow the contours of the horses. They are clearly deliberate, and it is now appreciated that they were incised to destroy the glare which the sun shining on a pure gold surface would have created.* There is an example of similar scratching on a glass plate coated in gold which has been dated to about AD 275. It depicts a knight on horseback, and the gold on the horse has been hatched in a very similar way to that on the St Mark's horses. Some further supporting evidence for a date in the second or third century can be found in the plates attached to the horses to cover up imperfections. These have been cut in rectangles in a way which is similar to patches on second- and third-century bronzes, including the Marcus Aurelius.

Evidence is thus coalescing in favour of a date for the horses' creation between the second and fourth centuries AD. This is well

*One can see the same effect on Ghiberti's celebrated Gates of Paradise in the baptistery in Florence (1425–37). Here the gilding has been scraped away on the plainer empty surfaces, the sky and the walls.

into the Roman era; so how do we reconcile this with the horses' unmistakably Greek characteristics? In the second century AD, a period known as the Second Sophistic, there was a revival of interest in the ancient Greek world. In the words of the art historian Jas Elsner, we see the emergence of 'a sophisticated antiquarian classicism drawing on eclectic sources to demonstrate its scholarship, taste and expertise'. One set of reliefs, now in the Spada Palace in Rome, represented Greek myths in what Elsner calls a 'mood of tranquil contemplation', and one gets the same feeling when looking at statues of Hadrian's favourite, Antinous. There is a deliberate attempt to idealize using Greek styles. While remaining aware of the problems, explored earlier in this chapter, associated with following gut feelings about styles, we may certainly note that the horses seem to fit happily into this category of work.

So why were they cast? This was clearly a prestige commission. Gilding must have been planned from the beginning, forcing the casters to use copper as the underlying metal. They would have needed extraordinary skills to have seen the project through to its triumphant conclusion. The horses' long legs and short backs suggest that they were designed to stand above spectators, implying a setting such as a triumphal arch. This inference is supported by what remains of the harness and collars. A racing chariot has a yoke which is attached to the horse either by a girth around the withers or in some cases directly on to the collar. No trace of any such arrangement has been found on the St Mark's horses, suggesting that they could have been designed just to stand in front of a chariot, in fact to be detached from it. This would have been appropriate if they were intended primarily as a symbol of triumph. If we follow this line of analysis to its logical next stage, that they were made for a triumphal arch in the second or third century AD, then an imperial commission is likely. Ever since the reign of Augustus it had been difficult for anyone other than the emperor or a member of his immediate family to celebrate a victory with a triumphal arch.

Incidentally, this would seem to provide further evidence against

the horses coming from Chios. There is no evidence of any link between that island and an emperor of this period – the last recorded visit there by an emperor was one by Tiberius in the early first century AD, and Chios did not enjoy any special privileges after the first century. One would be hard put to find a reason why a sculpture of this quality would be made on the island in the third century or transported there from elsewhere. Nor is it only this set of horses which can probably be ruled out. As we have already noted, the group of horses described as being in the hippodrome itself, the set with the female charioteer and running figure, appeared to have been yoked. This leaves the set of horses at the Milion as being the most likely candidate for the St Mark's group.

At this point it is worth looking again at how the Milion horses and their chariot were described in the eighth century.

> At the golden Milion a chariot of Zeus Helios with four fiery horses driven headlong beside two statues has existed since ancient times . . . And the chariot of Helios was brought down into the Hippodrome, and a new little statue of the Tyche of the city was escorted in the procession carried by Helios. Escorted by many officials, it came to the Stama and received prizes from the emperor Constantine, and being crowned it went out and was placed in the Senate until the next birthday of the city.

In other words, the 'four fiery' horses were detached or detachable from the chariot of Zeus Helios, as the St Mark's horses appear to have been detachable from theirs. There is also a suggestion that the statue of Tyche, which appeared at the foundation ceremonies in AD 330, was 'new' in comparison to the rest of the monument. Is it possible that the 'ancient times' referred to by the chroniclers means the pre-Constantinian city?

We cannot, of course, be sure that the chroniclers would have known enough about the earlier history of the city to make this distinction between Constantine's foundation and the earlier Byzantium. However, it is an idea worth developing. If we are

looking at an imperial commission in the city during the second or third century AD, then the only emperor who had a reason to celebrate a victory over Byzantium, as it then was, is Septimius Severus, emperor AD 193–211, whose troops took the city in 195. Septimius loved to celebrate his victories, the greatest of which was over the Parthians when he captured their capital on the River Tigris, Ctesiphon, in January 198. His triumph was recorded on an arch in Rome which still stands, close by the Capitoline Hill. Its reliefs show the emperor in battle, and we know from coins that a bronze *quadriga* stood on the summit with the emperor in the chariot and no fewer than six horses in front of him. Septimius, the first emperor from northern Africa, was also obsessed with establishing a dynasty. On the day of his victory at Ctesiphon he proclaimed his eldest son, Caracalla, Augustus and his younger son, Geta, Caesar.* They are mentioned alongside him on a dedication on the arch in Rome. (When Geta was later disgraced his name was obliterated, and only traces of it now remain.) Coins also show the two sons on horseback beside the *quadriga*, one either side of the horses. In a triumphal arch in Septimius' home town of Lepcis Magna they are beside him in a triumphal chariot. Two statues are also noted as standing alongside the horses at the Milion.

The dating of the horses to no earlier than the second century AD seems to be conclusive and this must shape speculation about their history. One must work within the general area of an imperial commission in the century and a half before AD 330, but any historical reconstruction will be highly speculative and the following is to be seen as such.

Septimius' troops conquer Byzantium in 195. The city is ordered to be rebuilt and a triumphal arch and a fine gilded *quadriga* put in hand to record the emperor's victory. This is a city with a Greek heritage and there are skilled Greek craftsmen available to

*'Augustus' and 'Caesar' reflected the imperial hierarchy, the former title carrying more prestige than the latter.

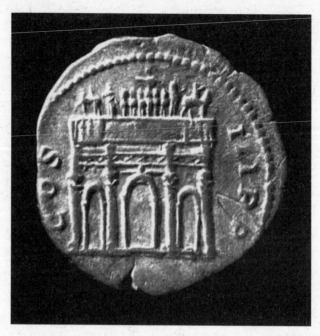

Early third-century AD coin showing Septimius Severus' triumphal arch in Rome, with the emperor driving a six-horse chariot and attended by his sons Geta and Caracalla. Did he erect a similar arch, with a *quadriga*, in Byzantium to celebrate his conquest of the city in AD 195? If so, was this the arch for which our horses were made? (Hunterian Museum, Glasgow)

fulfil the commission (perhaps recruited specially for the rebuilding). So they are happy to work with Greek styles and, having been told the *quadriga* must be gilded, take on the awesome challenge of casting in copper. The emperor will be driving the *quadriga* but his two sons will also be commemorated with statues alongside it. When Constantine arrives in the city he preserves the *quadriga* and either places a sun-god in it or refashions the existing statue and gives it a new statue of Tyche for the foundation ceremony. The detached horses are left at the Milion each time the anniversary is celebrated and so they remain there through the eighth century and thereafter, until the sack of 1204.

Ideally, to support this reconstruction, we need to have evidence

of a triumphal arch on which the *quadriga* would have stood; but there is no direct evidence of one from Septimius' reign. Niketas Choniates does mention a triumphal arch standing in this area in the twelfth century, but it is difficult to know whether he means the Milion or a separate monument. It is not impossible that the Milion itself was a triumphal arch, reworked in Constantine's time from an earlier one, but this is certainly a claim too far on the present evidence. We also have to be cautious about seeing Septimius' two sons in the two statues alongside the *quadriga*. We know that personifications – of Victory, for instance – could be associated with *quadrigae*. Even with these qualifications, we may have come as close as we ever will to the horses' origins.

19

ENVOI: THE HORSES AS
CULTURAL ICONS

THE AMERICAN ART HISTORIAN ROBERT NELSON TELLS THE
story of a visit to his father's grave in a middle-American city in
Texas. He made his way down rows of bungalows towards the
cemetery, where his father's remains lay under a marble plaque on a
lawn not far from an oak tree. There was a gateway which marked the
transition between the bustling world of the living and the more
sober one of the dead. On top of it, he saw, were copies of the horses
which he knew stood, many thousands of miles away, above the
entrance of the basilica of St Mark's. They were 'the size of large
dogs and made of some strange material, suspiciously synthetic in
appearance'.

Nelson was shocked by their shoddy presence and reflected on
what effect the owners of the cemetery might be aiming to achieve.
Were they trying to make the entrance look grander, or somehow
give it a higher status – in the way that lions were placed by the
entrance to the New York Public Library? Or was this a means of
celebrating 'the key value of the local Texas culture', the horse?

By now, having followed the horses through their varied history,
we can hardly be surprised by their appearance in yet another
display. We live in an age where cultural icons are transferred from
one context to another with bewildering rapidity. Most such icons,

of course, are transient: a song lasts a month, a fashion in dress perhaps a year, an artist's popularity among the *cognoscenti* perhaps ten. Yet in the horses we see icons that are still usable in a fresh context many thousands of miles away from their home two thousand years after they were made. What is the secret of their success?

There are some icons which survive because they represent a pinnacle of human achievement. The Egyptian pyramids are a good example. It is still virtually impossible to grasp that such vast and complex monuments could have been planned and put together in a pre-technological age. (So nearly impossible, in fact, that some fantasists have conjured up sophisticated vanished civilizations to which their construction is credited.) More difficult to assess are those icons which seem to evoke a satisfying response from the brain across time and culture – the Taj Mahal in India, or the symphonies of Mozart, for instance. The philosopher Plato would have been quite at home with this phenomenon. There is beauty on this earth, he said, and it provides us with a sense, albeit an inadequate one, of what the Idea or Form of Beauty, on its eternal plane of reality, might be. In fact, Plato argued, our souls retain a recollection of the Form of Beauty, and contact with great works of art – a Mozart symphony, or Giorgione's nude *Sleeping Venus* – stimulates its revival. Nowadays we would be more likely to find the exploration of the underlying reasons for our brains' responses to music and art being conducted by psychologists, wiring up their subjects to the sound of a Mozart symphony, rather than by philosophers; but there is no doubt that music can act to bring order to the mind. Art is psychologically satisfying for us at quite a profound and perhaps even universally shared level, and this explains why some works of art attract across cultures and time.

How central to the horses' meaning is their aesthetic appeal? They cannot fail to have some impact. They are undeniably elegant. However, their 'beauty' has not been universally acknowledged, even if one discounts the prejudiced condemnations of Winckelmann (the horses as decadent because they are gilded) and Haydon (they

cannot be allowed to compete with his beloved Parthenon marbles). The height of their popularity as art came during the Renaissance, when they benefited from the adulation bestowed on all classical art. Nowadays we are more cautious in adopting so idealized a view of the classical past; but even if we do not follow Renaissance taste uncritically, the horses are still remarkable – for their aesthetic appeal, but also for their age, the quality of their casting, and the very fact of their survival when the vast majority of classical bronze and copper statues have been melted down.

In addition to any significance it derives from aesthetic power and antiquity, every icon has its own history, and here the horses score highly. They are easily recognizable as prestige items, were designed for public display and, above all, have proved transportable. This means they have been eminently usable as symbols of plunder and triumph. Certainly this is why they were brought to Venice, and later to Paris, and it may have been the reason why they were in Constantinople in the first place. They have benefited in particular from the settings in which they were displayed – the hippodrome, St Mark's and the Arc du Carrousel, vantage points from which they have watched over an extraordinary panorama of European history.

These are far more than simply four horses taken as plunder. For fifteen hundred years, from 1000 BC to AD 500, a team of four horses represented status. (So much so that some emperors portrayed themselves with six or even ten horses, to push their status still higher!) In the Greek world the chariot drawn by four horses reinforced the role of the games, at Olympia and other sites, as aristocratic gatherings. The gods, and even the citizens of Athens in their most arrogant representation on the Parthenon frieze, travelled in *quadrigae*. In the Roman period a *quadriga* drew the victor in his triumph in Rome and *quadrigae* were adopted by the emperors as their symbol of eternal victory. So they are infused with meanings from the classical world.

In later centuries, however, the horses' significance proved ambiguous enough for them to take on other roles. They could

stand as a religious emblem, as '*quadriga* of the Lord', and this could justify their position on a Christian basilica while at the same time, a few miles away in a fresco in the Scrovegni chapel in Padua, Giotto could portray them as a symbol of pagan idolatry. Were they even placed on the *loggia* to endow the Piazza with the aura of a ceremonial hippodrome in which the doges asserted their imperial authority? Perhaps; but times moved on, and by the fourteenth century the horses had acquired a new role as a symbol of Venetian national pride.

If we are to understand the continuing success of the horses as icons, then, we must grasp that it is precisely because they have proved so adaptable to the history which they have watched evolve around them that their power has endured. Some reminder of this long history is to be found in an evocative nineteenth-century poem, 'I Cavalli di San Marco' by Giacomo Zanella.* In it, each horse speaks in turn, reflecting back on their past. The first horse remembers the great times when the bell of St Mark's welcomed back thousands of ships from as far afield as Egypt and Scandinavia. The nobler citizens were brought back precious stones coloured with the sun of Asia to weave into their hair, and even the poor of the city could wear silk. The recollections of the second horse are more cultural. He has memories of Byzantium, the hippodrome, the theatres full of statues and the imperial palaces by the sea. Now, in Venice, there is the architecture of Palladio and Bramante to admire, and the great palaces of merchants. At the height of the city's artistic achievement Titian could be watched walking among the admiring crowds, while humanists such as Pietro Bembo were to be seen deep in conversation.

*Zanella (1820–88) was a priest, an Italian nationalist, a poet and a scholar who taught at the University of Padua, a hotbed of nationalism, until thrown out by the Austrians in 1853. On the liberation of Venice in 1866 he returned to Padua as professor of Italian literature. The poem was written to commemorate the marriage of Giovanni Rossi, the son of a friend, to one Signorina Maria Bozzotti in April 1877.

The third horse remembers Venice's political and naval power. He wishes he could have been with the doges on their expeditions to the east and at the great battles between Venice and the Turks. Even today, he goes on, the name of Venice is remembered from the Aegean to the Byzantine waterways. Although the flags of the city's enemies are now destroyed, memories of their being dragged in as icons of victory still linger. Finally, the fourth horse reflects on how, on his return from Paris, he saw the yellow and black flag of Austria fluttering on the standards before St Mark's. He turned his head away and could not even neigh until the moment he heard the crowd roaring for Manin. The people of Venice cannot be tamed and the virtue of the old days cannot be extinguished. Yet, if ever a challenge so great as that of Lepanto arose, he wonders, would the spirit of the lion of St Mark still be alive in the youth of the Adriatic?

For the time being the horses have lost their proud vantage point; but it is not impossible that they will be restored to the *loggia* of St Mark's. In July 2001 Vittorio Sgrabi, the under-secretary for culture in the Italian government, announced that the scientific evidence that the horses had suffered from pollution did not stand up. The intricacies of decision-making in the Italian national and regional bureaucracies make immediate changes unlikely, but it is possible that the horses will one day be triumphantly presented yet again to the people of Venice.

*

In November 1966, freak weather conditions sent the sea surging through the openings into the Venetian lagoon. For some twenty hours, Venice was covered by 2 metres of water. As its inhabitants waited in darkness there were some who feared that the waters would never recede and that this was indeed the end of the city. Venice is fragile. Its population dwindled in the 1990s and it is continuously assailed by two forms of waves: those of the *acqua alta*, the floods, and those of the tourists whose daily influx now exceeds the number of residents. Its death has been predicted in almost

every generation; an anxiety that it will crumble into the lagoon pervades its history. Yet somehow it endures. The horses, in their porous copper, are equally fragile – but they endure too. In Aldo Palazzeschi's novel, *Il Doge*, published in 1967, Venice is in a state of collapse and at one dramatic moment the basilica of St Mark's disappears, just as the Campanile had done in 1902. The doge appears on the balcony of his palace, attended by the four golden horses, and like a sun-god of old he disappears with them into the sky. When all else has gone, the horses are the saviour of the last remnants of Venice's pride.

BIBLIOGRAPHICAL NOTE

I list here the books which made the writing of my own easier and more pleasurable. I have not listed those consulted for general background information. I am also grateful for material or observations provided by Michael Vickers, Lydia Fetto, Tony Harvey and Terry Harris, and for the help given with the translation of the Zanella poem by Ferdinando Giugliano.

Anyone researching the horses of St Mark's is deeply indebted to the catalogue to the 1979 exhibition of the horses, *The Horses of San Marco*, by a variety of authors, all translated for the English edition by John and Valerie Wilton-Ely (London, Thames & Hudson, 1979). It contains a large number of essays which have been quarried for this book, and most translations of impressions of the horses come from this source. Specific studies of the horses include Vittorio Galliazzi, *I Cavalli di San Marco* (Treviso, Editrice Canova, 1981), although Galliazzi's dating of the horses is challenged by recent research on copper casting. Michael Jacoff, *The Horses of San Marco and the Quadriga of the Lord* (Princeton, Princeton University Press, 1992), sets out the case for a religious rationale for the placing of the horses on St Mark's.

On ancient Roman circuses I have used John Humphrey, *Roman Circuses: Arenas for Chariot Races* (London, Batsford, 1987); and on Byzantium, Cyril Mango, *The Oxford History of Byzantium* (Oxford, Oxford University Press, 2002). For the Byzantine circus, two

books by Alan Cameron, *Porphyrius the Charioteer* (Oxford, OUP, 1973) and *Circus Factions* (Oxford, OUP, 1976), proved especially helpful. On the Fourth Crusade, I consulted Donald Nicol, *Byzantium and Venice: A Study in Diplomatic and Cultural Relations* (Cambridge, Cambridge University Press, 1988).

Books on Venice overwhelm. For recent historical surveys, see John Martin and Dennis Romano, *Venice Reconsidered: The History and Civilization of an Italian City-State, 1297–1797* (Baltimore and London, Johns Hopkins University Press, 2000; essays on aspects of Venetian history and historiography) and Élisabeth Crouzet-Pavan, *Venice Triumphant: The Horizons of a Myth*, trans. Lydia Cochrane (Baltimore and London, JHUP, 2002), the second indeed a triumphant overview of the city's history. On architecture, Richard Goy, *Venice: The City and its Architecture* (London, Phaidon, 1997), and Deborah Howard, *The Architectural History of Venice*, 2nd edn (New Haven and London, Yale University Press, 2002), are both excellent. On Venetian ritual, Edwin Muir, *Civic Ritual in Renaissance Venice* (Princeton and London, PUP, 1981), is the standard introduction to ceremonial life in the Piazza. I have also drawn on Debra Pincus, *The Tombs of the Doges of Venice* (Cambridge, CUP, 2000). Quotations from Goethe's *Italian Journey* (1786–8) are taken from the Penguin Classics edition translated by W. H. Auden and Elizabeth Mayer.

For background to the reception of ancient art in general, see Roberto Weiss, *Renaissance Discovery of Classical Antiquity* (Oxford, OUP, 1973), Francis Haskell and Nicholas Penny, *Taste and the Antique* (New Haven and London, YUP, 1981), and Francis Haskell, *History and its Images* (New Haven and London, YUP, 1993). Specifically on Venice, Patricia Fortini-Brown, *Venice and Antiquity* (New Haven and London, YUP, 1996) proved essential.

On the Renaissance in general, John Hale, *The Civilisation of Europe in the Renaissance* (London, HarperCollins, 1993), is a fine overview. On Venice in particular, see Patricia Fortini-Brown, *The Renaissance in Venice* (London, Weidenfeld & Nicolson, 1997). Excellent on the painting is Bruce Cole, *Titian and Venetian Painting 1450–1590* (Oxford, Westview, 1999).

On Canova, a good starting point is C. Johns, *Antonio Canova and the Politics of Patronage in Revolutionary and Napoleonic France* (Berkeley and London, University of California Press, 1998). On Napoleon's Paris, Marie Louise Biver, *Paris de Napoléon* (Paris, Plon, 1963), has full details of the building of the Arc du Carrousel for those who can read French.

For Venice over the past two hundred years, Margaret Plant, *Venice: Fragile City, 1797–1997* (New Haven and London, YUP, 2002), is outstanding – like other Yale publications, not least for the quality of its illustrations. See also John Pemble, *Venice Rediscovered* (Oxford, OUP, 1996), and Tony Tanner, *Venice Desired* (Oxford, OUP, 1992), which deal with the responses to the city of outsiders and writers.

INDEX